COLORED PENCIL

Techniques for Achieving Luminous Color and Ultrarealistic Effects

PAINTING BIBLE

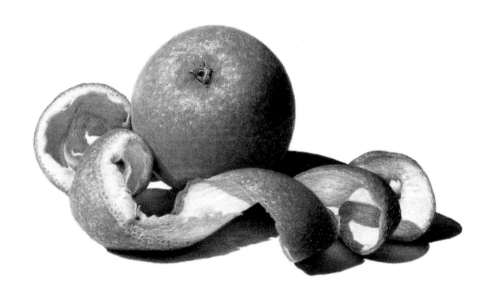

Alyona Nickelsen

Watson-Guptill Publications
New York

Copyright © 2009 by Alyona Nickelsen

First published in 2009 by

Watson-Guptill Publications, an imprint of the Crown Publishing Group,

a division of Random House, Inc., New York

www.crownpublishing.com

www.watsonguptill.com

Library of Congress Cataloging-in-Publication Data

Nickelsen, Alyona.

Colored pencil painting bible : techniques for achieving luminous color

and ultrarealistic effects / Alyona Nickelsen.

p. cm.

Includes index.

ISBN 978-0-8230-9920-7 (pbk.)

1. Colored pencil drawing—Technique. I. Title.

NC892.N53 2008

741.2'4—dc22

2008031712

Executive Editor: Candace Raney

Editor: Alison Hagge

Designer: Patrice Sheridan

Production Manager: Alyn Evans

Following Spread: Alyona Nickelsen, *Sincerely Yours*, 2006, Prismacolor Premier colored pencils on 250 gsm white
Stonehenge paper, 9 x 11 inches (22.9 x 27.9 cm)

Printed in Singapore

First Printing, 2009

1 2 3 4 5 6 7 8 / 15 14 13 12 11 10 09

As every child has a mother and father, this book has its parents as well. Although I suffered the labor and gave birth to the long-carried idea (and I have to admit it was one heck of a job), this project never would have been possible without the direct participation and true devotion, advice and support, and care and love of my beloved husband, Tom. His wisdom and experience helped my ideas mature and take the shape of a book. This work, as well as my art, is dedicated to my better half.

Acknowledgments

Any dream on its journey to reality needs its first believers. I was lucky enough to meet some wonderful people who believed in my dream and helped it come true: I want to thank Steve Doherty, the editor in chief of *American Artist* magazine, for pointing me in the right direction when I shared with him my book-writing obsession. I also owe sincere thanks to Candace Raney, for seeing the idea behind my scattered and enthusiastic words and my crazy Russian accent. I am also eternally grateful to Alison Hagge, for her amazing talent, the bottomless depth of her knowledge, her vision and intuition, her patience, and her passion during our long journey to shape my thoughts into the polished gem that this book has become.

Thanks also to my son, Roman, for understanding the scope of my task through his unique teenage perspective. Thanks to my mom for her stoic grandeur during her chemotherapy while I sat next to her, typing away on my laptop. Thanks to my dad for his supportive efforts during what has become the most difficult time of our lives. Last but certainly not least, thanks to my dear friend Ester Roi for helping me to believe in my own strengths.

I consider this book to be a miracle that could only have happened in this great country and with God's blessing. His grace has helped me to overcome enormous pressure, bizarre circumstances, and numerous challenges and allowed me to still accomplish this task.

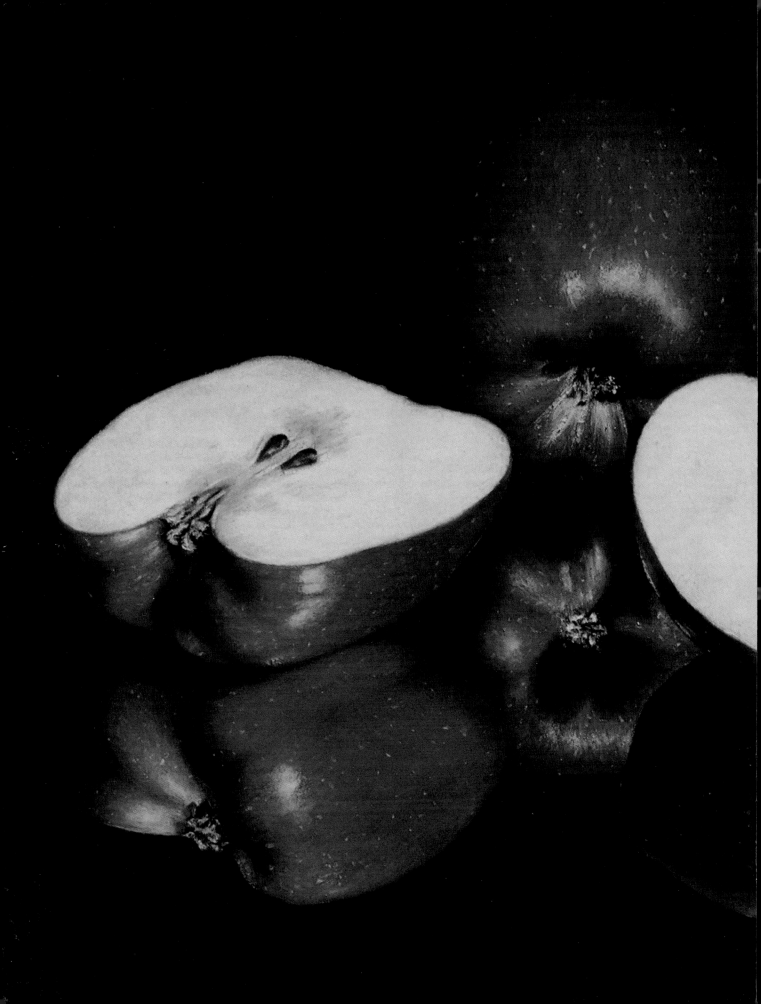

Contents

Foreword

The Colored Pencil Society of America (CPSA) was born in 1989 out of a self-serving necessity. My need to network with others and establish a reputable image and acceptance for the media was the catalyst for the formation of this organization. However, this once-fledging group has quickly learned how to fly. As of 2008, CPSA boasts a worldwide membership of more than 2,000 artists and has twenty-three district chapters across the country.

In the beginning, we were all self-taught, experimenting as we went along. Each of us was a pioneer in creating colored pencil art. During that time, there were no classes, books, articles, or networks from which to glean information. Once we found each other, however, we learned a universal language, common applications, and standard techniques. We discovered that we had a shared enthusiasm and we learned to push the medium to unlimited heights.

How fortunate, Dear Readers, that you are in an era when accomplished and talented artists such as Alyona Nickelsen make your artistic development easier. Regardless of your experience, whether you're a novice or a professional, *Colored Pencil Painting Bible* will bring you to a new level of understanding of the medium. From the first page to the last, you'll recognize Alyona's passion for working with colored pencil. She articulates her motives and practices, taking you step by step through the process and generously sharing her trade "secrets." To her credit, her innovative color choices, unpredictable yet balanced compositions, and personalized vision can elevate an ordinary orange into a work of art and engage you in the mystery of its creation. With Alyona as your guide, you are sure to enjoy the artistic journey that follows.

VERA CURNOW

Founder, *Colored Pencil Society of America*

cpsa.org

Alyona Nickelsen,
Breaking Away (detail),
2005, Prismacolor
Premier colored pencils on
250 gsm white
Stonehenge paper,
11 x 8 inches
(27.9 x 20.3 cm)

Introduction

I'd like to begin with a real-life excerpt from a dialogue I had recently with a viewer of my work:

What do you call your artwork style?
Colored pencil painting.

Is it a painting?
Does it look like a drawing?

But how do you paint with pencil?
Very patiently.

Colored pencils have been around since long before I was. Traditionally used for trivial tasks, colored pencils have garnered little respect through the years. Recently, however, new methods and techniques have been invented. Increasingly, colored pencil artists are participating in authoritative organizations such as the Colored Pencil Society of America (CPSA), the United Kingdom Colored Pencil Society (UKCPS), and the Japan Colored Pencil Society (JCPS). Colored pencil art now competes handily with fine art mediums traditionally employed by the masters and can be found in some of the finest galleries of the world.

My own finished artworks do remind judges and art lovers of oil paintings, but they are fashioned in pure colored pencil. On these pages I will share with you the exclusive methods I use to create my own colored pencil paintings. I call them *paintings* not only to differentiate them from the much-maligned word *drawing* but also to bestow on them their own hard-won right to be likened to oil-based works, as each of these images has been rendered with the same care and attention as works done in that medium.

Alyona Nickelsen,
Ripe Point of View
(detail), 2004,
Prismacolor colored pencils on 250 gsm white Stonehenge paper,
11 x 8 inches
(27.9 x 20.3 cm)

No book can cover all subjects and issues, so I will narrow my discussion to a description of the main topics that distinguish colored pencil painting as a technique. I would advise beginning artists to refer to books that cover in great detail subjects such as composition, color theory, basic drawing, perspective, and anatomy. These subjects are relevant to all artists, regardless of the medium in which they work. And, of course, you cannot master your skills without great and patient practice. Theory is only a door that opens the many possibilities of colored pencil artwork; as with life, you must walk through the door yourself.

I understand the needs of the colored pencil artist from my own learning experience. In this book I have tried to answer all of the questions I have had since I purchased my first set of colored pencils. I hope this will save you a few years of research. However, please do not look to this book for instruction on how to paint all of the existing flowers on Earth and the like. Rather I will teach you to see, understand, and render any subject in any composition by using a primary set of rules and techniques that I have discovered through many hard hours of my own research and experimentation.

And now, to answer a few questions:

Why do you use so many examples of fruits and vegetables in this book? First of all, I *like* fruits and vegetables. But more than that, I am concentrating here on the task of teaching you a technique to master the colored pencil medium. Fruits are perfect objects for showing shapes, color transitions, and values. Besides, they are readily available, are patient and immobile subjects, and don't change quickly.

Why use colored pencil? If you want to make your art look like oil, why not just use oil? If you want to paint, why not just use a brush? I see many skeptically raised eyebrows when this subject is broached—especially from those who traditionally consider only oil paintings as a real art and (I might add) arrogantly dismiss other mediums as amateurish and hobbyist. If artists were to stop being as quixotic as they are and follow such suggestions, many beautiful pastels and watercolors would never have seen the light of a modern gallery. Colored pencil today has the destiny of being a pioneer. It takes enormous effort to open the road that the medium deserves, but the endeavor itself imparts a great sense of pride when the artist successfully competes with more traditional mediums.

For all of us artist types, colored pencil has been a familiar friend since childhood. We were all taught in school how to handle a pencil and how to make simple drawings. Because of this experience we have a sense of control and confidence when we hold pencils in our hands. We have all had our own little discoveries. One of mine happened when I was just three and my yellow pencil accidentally overlapped the blue and magically turned into green. This was my very first step into color theory. I love to be in complete control of my work, and I love colors. This is one of the reasons why the exacting control and brilliant colors afforded by colored pencil make it the perfect medium for me.

Colored pencil has many hidden qualities and endless possibilities. Thus, it shares its secrets differently with various artists, dependent on their own personalities, likes, and dislikes. Traditionally, colored pencil has been a perfect tool for preliminary sketches. You can quickly make color studies and have an immediate understanding of how your finished painting will look in any other medium. But for artists with a true passion, colored pencil can far surpass quick sketches and is an amazing way to produce an airbrush effect, a watercolor-like

wash, or an oil painting finish. Colored pencil painting is a brand new approach to challenge the viewer's eye. Make them determine the medium themselves!

Colored pencil painting is affordable compared to oil painting, which requires expensive paints, sundry brushes, and other equipment and supplies. Colored pencil is also a clean medium, so it is easy to start and finish your drawing session: You don't have complicated setups and cleanups as you would with oils. It is also very comfortable for traveling. Your colored pencil studio will not take much space, and you can continue to work even when seated with your family. Your finished artwork is lightweight, and you can save on shipping expenses when participating in shows across the nation. But if you want to present your work in the manner of an oil painting, there are many ways to do so, as I will discuss later in this book.

Interest around the world in colored pencil art is growing at an explosive rate. Manufacturers are improving the quality of colored pencil materials and are even beginning to listen to artists' needs. With the help of modern technology, information about techniques is becoming widely available. This evolutionary force is building the tidal wave that is converting thousands of artists each year into colored pencil enthusiasts. I have personally had a tremendous response to my own demonstrations, lectures, and publications. I am working and creating new art daily, and my research continues to fill the pages of my next colored pencil painting techniques book, even as you read this one. If you have questions and I didn't answer them in this book, make sure to keep an eye on my Web site, as new information is added frequently.

You can read this book in the traditional manner—from the beginning to the end—or you can use it as a reference for your work when you have a question. The last two chapters include demonstrations and exercises that will help you begin developing your very own colored pencil skills. I have included a line drawing for each of the projects here. However, if you would like to have larger-scale outlines, you can easily download them from my Web site. While all of the demonstrations and projects provide color suggestions, you can substitute your own selection of colors or match them with different brands.

The appendix features a colored pencil light-fastness table. Colored pencil manufacturers supplied the results of their lightfast testing at my request. Now, you can clearly see which pencils are most vulnerable to UV light, and you can use them accordingly. Before the publication of this book, this information was not available in any other book, and it will be updated frequently on my Web site, as new data is added.

The unique aspects of this book make it a must-have reference work for every colored pencil artist. It is a compendium of my knowledge of colored pencils. I hope you will consider it as your shortcut to mastering a relatively new medium, a medium about which knowledge, sadly, has heretofore been scattered and poorly organized. My own search for artistic individualism started this long journey and pushed me to a road chock-full of surprises and disappointments. After endless testing and experimenting, after adapting, denying, sorting, and organizing everything I could find, I have answered many of my own questions and discovered many more. So, this work is my own treasure trove of discoveries—for you to use and enjoy.

As they say, "If you give a hungry man a fish, you feed him for a day, but if you teach him to fish, you feed him for life." Happy fishing!

Reviewing the Materials and Basic Setup

When I began using colored pencils, it became immediately apparent that high-quality materials and tools made a big difference. This statement is true for every medium. However, it is particularly the case if you are attempting to make fine art with colored pencils, since many materials available on the market are actually student-grade and are not intended for the fine artist.

Alyona Nickelsen,
Glowing Nostalgia,
2003, Prismacolor colored
pencils on 250 gsm white
Stonehenge paper,
8 x 11 inches
(20.3 x 27.9 cm)

Quality materials are crucial for rendering successful work using my highly realistic techniques. For example, some lesser-quality papers cannot hold more than a few layers of pencil. If you attempt to apply additional layers, your pencil will simply slick away from the surface without leaving any pigment and without changing what was already established. By comparison, my favorite paper (Stonehenge) not only holds twenty layers of pencil, but it also withstands rigorous erasures and other abuses that are a normal part of my working methods. Plus, as with other fine-art mediums, it is important to use archival-quality material if you want your work to last.

The information provided in this chapter is intended to give you some solid basic advice and get you pointed in the right direction. Selecting appropriate materials and tools involves knowledge about quality as well as preferences about unique characteristics. After learning about and experimenting with what is available, you will be prepared to make your own decisions about the brands and tools that best suit your own needs and style.

Essential Materials

Paper, pencils, and solvents constitute what I refer to as the "trinity"—the three essential items without which we wouldn't have the unique medium of colored pencil painting. Each of these three materials provides a critical function, and the characteristics of each item will have its own effect on the look of your final artwork. The paper needs the right tooth, brightness, and weight; the pencils must have the desired translucency, firmness, and binder; and the solvent must suit your technical methods. In other words, selecting the right materials is key to having your final artwork look the way you want it to look.

Paper

As with artists of any medium, colored pencil artists experiment and use various supports for their creations. You can see colored pencil work rendered on wood, glass, marble, plastic, or even dry vegetation, such as gourds. Of course, the choice of support is entirely up to the personal inclination of the artist. Because my own choice has been white Stonehenge paper and I am well qualified to comment on its use, this chapter describes paper as the application support.

Countless brands and types of paper are available to artists these days. It is easy to get lost in this ocean of information, and consequently choosing a paper can be quite a challenge. But, as with most things, the best place to start is at the beginning. First, you must gather as much information as possible, and then you must make an informed decision.

Since we live in the information age, facts are readily available in books and magazines and, of course, on the Web, but in the end, you will need to simply try the brands that are most attractive to you. You could start by determining which brands are popular with artists you particularly admire, as artists who produce excellent results tend to choose their paper products carefully. Once you have narrowed down your list, you could order samples from various paper manufacturers/distributors to help you develop opinions of your own.

Paper manufacturers design their products with specific uses in mind—watercolor, drawing, pastel, printmaking, and so forth. As a result, the names of various papers reflect their primary purpose. Since the colored pencil painting technique is so new, there is currently no paper on the modern market specifically designed for its use. Therefore, colored pencil painting artists need to search through existing paper for stocks that are suitable for our own rigorous needs. Most of the papers on the list below are considered drawing and printmaking papers. However, some paper that is commonly used for watercolor

Paper suitable for my colored pencil painting techniques must be white, weigh 90 to 300 pounds, and have a smooth, velvety finish with no visible patterns.

techniques could also be used for colored pencil painting.

When working on your selection, you will need to keep a few important issues in mind. First of all, always use archival paper for your final artwork. *Acid-free* is the key term to ensure that your paper will not lose integrity or turn yellow over time. (If you have ever purchased a print from a flea market and then later noticed that the paper is getting so yellow that you can hardly make out the image, you understand what acid can do to paper over time.) Furthermore, papers vary in weight, texture, and color, so let's look at each characteristic in turn.

The weight of the paper is an important consideration. The heavier the paper, the thicker it is. Paper must be thick enough to withstand the application of liquid (odorless mineral spirits, in my case) without buckling. At the same time, it must be flexible enough to allow my roughening technique to work. Generally, papers with weights that range between 90 lbs. and 300 lbs. are suitable for the techniques discussed in this book. Please note that these numbers are given in a traditional measurement of paper reams (about five hundred sheets) in pounds. This measurement creates some inconsistency because it could vary depending on the size of the paper. The alternative, and more accurate, measurement of paper weight is in grams per square meter (or gsm). To give you a rough sense for the equivalency, Stonehenge 90-lb. paper translates to 250 gsm. To be clear about the weight of each particular brand of paper, contact the manufacturer or use the conversion charts available online.

It is also important to pay attention to the texture of a paper, sometimes referred to as its "tooth." This can be thought of as the microscopic hills and valleys on the surface of the paper. Finishes for paper vary greatly and can range from ultra-smooth to very rough. If a paper is too rough, more layers of pencil will be required for you to completely cover the surface, and it will use up your expensive art pencils faster. By contrast, smooth paper will accept only a few layers of pencil; after that, the pencil medium will simply slick away from the surface. A good choice for the colored pencil artist is a medium-textured paper with no visible patterns. If you make your selection from watercolor brands, note the following common terms that signify the finish of paper: rough (R), which is typically highly textured; cold-press (CP), which has moderate texture; and hot-press (HP), which has a smooth surface. Of these, hot-press paper is most suitable for colored pencil painting techniques because of its mild texture.

The color of the paper will affect the look of your final artwork and the range of values you can use in the process. You may think that "white is white," but in fact a wide range of tones falls under the heading "white" (such as "off-white," "radiant white," and "warm white" to name a few). Furthermore, the whiteness of the paper is either created by a manufacturer's process (called bleaching) or by using naturally white fibers. Of course, naturally white material is preferable, but it costs more. Bleached paper can be used for fine artwork but only if it is properly conditioned.

The ideal way to store paper is to lay it flat in an acid-free environment. If stored next to materials that contain acids, these acids will, over time, leach into the fibers of the paper and cause damage. Drawer units with anodized aluminum or powder-coated steel files are good for paper storage. Wood files can be used if the interiors of the drawers are sealed with a water-based polyurethane coating and lined with a suitable barrier material, such as Mylar or lignin-free board.

Warm or moist air accelerates paper deterioration. Temperature should not exceed 70°F, and relative humidity should not exceed 60 percent.

High temperature and high humidity allow mold growth. Very low humidity, below 25 percent, may cause paper to become brittle. To prevent paper damage, temperature and humidity should remain constant. Most important, do not store paper in basements, attics, bathrooms, or over heat sources. In addition, dust in the air can soil delicate, porous paper surfaces and is difficult to remove safely, so probably the most practical way to preserve paper is to enclose it in protective sleeves made of appropriate acid-free materials.

Below is a list of popular paper brands. The texture and weight of these papers are suitable for my own colored pencil painting techniques. All paper is 100 percent cotton, mold made, and acid free.

Arches 300 gsm, hot-press, bright white, watercolor paper, mold made, acid free, 100 percent cotton, no chlorine bleaching. Made in France.

BFK Rives 270 or 280 gsm, white, vellum surface, printmaking/drawing paper, acid free, 100 percent cotton, no chlorine bleaching. Made in France.

Fabriano Tiepolo 250 or 290 gsm, white, velvety surface, drawing/printmaking paper, acid free, 100 percent cotton, no chlorine bleaching. Made in Italy.

Lenox White 250 gsm, white, vellum finish, drawing/printmaking paper, acid free, 100 percent cotton, no chlorine bleaching. Made in USA.

Pescia 300 gsm, white, smooth surface, drawing/printmaking paper, acid free, 100 percent cotton, no chlorine bleaching. Made in Italy.

Saunders Waterford Series 190 gsm, white, hot-press, watercolor paper, acid free, 100 percent cotton, no chlorine bleaching. Made in England.

Somerset 250, 280, or 300 gsm, white or radiant white, satin or velvet surface, drawing/printmaking paper, acid free, 100 percent cotton, no chlorine bleaching. Made in England.

Stonehenge 250 gsm, white, two-sided surface; smooth and velvet, drawing/printmaking paper, acid free, 100 percent cotton, no chlorine bleaching. Made in USA.

Strathmore Bristol 260 gsm, white, vellum surface, drawing paper, acid free, 100 percent cotton, no chlorine bleaching. Made in USA.

My personal choice is white Stonehenge paper. It is inexpensive, archival, and has just enough tooth to allow me to render smooth surfaces. It stands up to the many pencil layers needed to produce a rich effect. Plus, it does not buckle under washes of mineral spirits and is thin enough for the various techniques I use.

Pencils

With the burgeoning interest in the colored pencil medium, manufacturers have begun to innovate—improving their color selections, reformulating their pencils to increase their lightfastness, and even creating new types of pencils (such as woodless pencils, watercolor pencils, water-soluble pencils, pastel pencils, and so forth). However, perhaps the biggest single change from twenty years ago is that these days a great many colored pencil lines are marketed directly to the fine artist. This gives us more choices, but, as always, we need to buy with care. Keep your eye on the market by perusing catalogs and company product announcements. Request samples of new products

A wide variety of colored pencils are on the market these days. Most brands carry both open stock and boxed sets, a few of which are shown here.

Colored pencils come in numerous forms—from traditional wooden pencils that can be sharpened to a fine point to chunky, woodless sticks that have broad, flat edges.

that interest you directly from the manufacturers, and experiment with them before stocking up.

Colored pencils are available not only in various brands but also in assorted qualities. Student-grade pencils are often cheaper, but they are suitable only for non-art projects, quick sketches, and preliminary studies. Artist-grade pencils are more expensive, but they have qualities that are appropriate for fine art creation. Please keep in mind that artist-grade pencils are divided between lightfast and not lightfast. Lightfast pencils usually are more expensive and have a smaller color selection. Non-archival pencils have a wider color selection and are more affordable, but artwork made from them requires extensive preservation.

Colored pencils come both in sets and as open stock. There are advantages to both. Sets usually provide a lower per-pencil cost, but the choice of colors is not your own. Buying a set can be a great way to bulk up your supplies when you're just starting. However, selecting individual pencils is better after you have already begun to build your colored pencil collection. As you work,

you will naturally begin to select and use colors specific to your own needs. Those colors will require occasional replenishment. You will need access to an open stock source. Suppliers can include local art stores and Internet sites. When using online orders, remember to keep an eye on your stock. Make sure that you do not run out of pencils while waiting for your next shipment.

Colored pencils come in various forms, including wax based, oil based, pastel, and water soluble. Pastel and watercolor pencils technically are intermixable with wax-based and oil-based pencils and can produce a successful result. However, I consider pastel pencils and watercolor pencils to be closer to pastel and watercolor mediums, respectively. As such, they require different kinds of support (paper), tools, and methods of application; in turn, they produce different results. In this book I concentrate on the wax-based and oil-based varieties of colored pencils. Both of these pencils are mixable and completely compatible with each other. You can successfully use both types in the same project with full confidence of a good outcome.

Pencils can be either hard or soft. Hard pencils hold a point better and are great for rendering precise detail, sharp lines, and delicate shadings. Soft pencils are great for all sorts of layering, burnishing, shading, blending, and so forth.

The following is a list of the most popular brands of artist-grade colored pencils on the market. Please refer to the colored pencil lightfastness table provided in the appendix of this book for more information about the individual colors available within each particular line of pencils.

Caran d'Ache Luminance wax-based pencils, developed in compliance with the ASTM standard for colored pencil lightfastness, available in 76 colors.

Caran d'Ache Pablo oil-based pencils, available in 120 colors.

Derwent Artists wax-based pencils, available in 120 colors.

Derwent Coloursoft wax-based pencils, available in 72 colors.

Faber-Castell Polychromos oil-based pencils, available in 120 colors.

Lyra Rembrandt Polycolor oil-based pencils, available in 72 colors.

Prismacolor Artstix woodless version of the main Prismacolor line in the form of chunky stick, wax-based, available in 48 colors.

Prismacolor Lightfast wax-based pencils developed in compliance with the ASTM standard for colored pencil lightfastness, available in 48 colors.

Prismacolor Premier wax-based pencils, available in 132 colors.

Prismacolor Verithin hard version of the Prismacolor Premier line, wax-based pencils, available in 36 colors.

Talents Van Gogh wax-based pencils, available in 60 colors.

My personal choice is a mix of Prismacolor colored pencil products from their Lightfast, Premier, Verithin, and Artstix lines. These pencils are comparatively affordable and are available in most art supply stores. Prismacolor offers various sized sets as well as open stock. They have a large selection of colors, and the quality of the pencils is very good. Occasionally, I incorporate other brands when I need a specific color that is missing from the Prismacolor lines. Please note that the specific colors (such as Tuscan red, greyed lavender, limepeel, and so forth) listed throughout the book refer to the Prismacolor line.

Solvents

If you were to look at the typical colored pencil artwork created twenty years ago and compare it with a contemporary image also created with colored pencil, you would undoubtedly notice a significant difference. There has been an evolution from the classical look of a drawing to the modern appearance of a painting. The differences are striking, and they surprise most viewers. Paper surfaces are now completely saturated with rich and vibrant colors. Solvents are an important component of this change.

Traditionally, solvents are associated with the toxic paint thinner that has a very distinct noxious odor—that of turpentine. However, the technology is changing, and manufacturers are contin-

ually developing odorless products as alternatives to the more infamous products. Today, a wide variety of brands and types of odorless solvents are appropriate for colored pencil painting techniques. These include odorless turpentine alternative, odorless turpenoid, citrus solvents, and odorless mineral spirits.

Best Klean This is an alternative to turpentine. It is an odorless petroleum distillate that serves as a paint thinner and a cleaner for brushes. It has no color, evaporates quickly, and leaves no residue.

Odorless mineral spirits (OMS) A petroleum-based solvent that is used for diluting paint, making mediums, and as a brush cleaner. As the name suggests, it has neither the noxious odor readily associated with other solvents nor the citrus odor of citrus-based solvents.

Turpenoid natural This is a nontoxic and non-flammable alternative to traditional solvents. It is a brush cleaner and conditioner for painting mediums specially formulated with organic ingredients. It has a light yellow color but doesn't stain the paper. It evaporates slowly (twice as long as odorless mineral spirits).

Weber turpenoid This thin, colorless, refined turpentine substitute has no odor, evaporates quickly, and leaves no residue.

Zest-it This is a nonflammable, nontoxic, and biodegradable alternative to turpentine. It is made from the zest of citrus and was originally designed for cleaning brushes and thinning paint. It has a distinct citrus smell, evaporates slower compared to traditional solvents, and leaves no residue.

As OMS significantly speeds the colored pencil painting process and eliminates pencil strokes, it is the only solvent that I use. Specifically, I prefer the brand Gamsol. It can be used for both oil-based and wax-based mediums. OMS is less toxic compared to mineral spirits because the harmful aromatic solvents have been removed and it doesn't permeate healthy skin, as does turpentine. Plus, it dries quickly and leaves no yellow residue.

Using odorless solvents vastly expands an artist's repertoire of colored pencil painting techniques.

TIP: Dipping a needle-sharp point of a pencil directly into a solvent will soften the binding and allow you to deposit a significant amount of pigment on a very small area of your paper.

Helpful Tools

Colored pencil painting is considered by many to be a slow medium. It can seem like an enormous task to cover the entire paper surface with the tiny point of a pencil. However, if the artist is familiar with the proper tools and techniques, this does not need to be the case. The trick is to be completely versed with the tools that can be used during the creative process, so that you can most fully benefit from them.

Historically, master artists spent years studying their materials. They kept their own research as closely guarded secrets. While I too have spent years studying these materials, I am happy to share the results of my research. Knowledge makes the entire process easier and helps you to be more productive. The following tools are very useful for the colored pencil painter:

Acetate film This provides an efficient way to prevent pencil smudging and smearing, to keep dirt from the surface of your art, and to create a barrier between the oils on your hand and your artwork. It is a good habit to keep a sheet of acetate under your hand while you are working.

Artist tape This can be used both to secure your paper to the drawing board and to make straight edges on your painting. Please do not confuse household masking tape with artist tape. Because of its adhesive strength, masking tape will not peel easily from your drawing surface and is likely to tear the paper.

Battery-operated sharpener This is a helpful tool when you are working at a remote site or don't have access to an outlet.

Keep your rendering clean by using a drafting brush to remove erasures and other debris. Acetate film protects the drawing surface from being soiled or smudged.

Use artist tape to attach your paper to the drawing surface. Masking fluid is indispensable for temporarily protecting certain areas of your work.

Working with an Icarus Drawing Board

Artist-inventor Ester Roi has created a portable electric drawing surface she calls the Icarus Drawing Board. This exciting new product is based on the principle that a wax-based medium becomes softer or even melts when it is exposed to heat and immediately solidifies when it is returned to room temperature. This drawing board features two working zones—a warm zone and a cool zone—both of which greatly facilitate the process. Its drawing surface measures 20 x 26 inches and comprises tempered glass equipped with a precision temperature-control system. By shifting your artwork between the two zones, you can take full advantage of the intrinsic properties of wax-based mediums such as colored pencils or crayons. When colored pencils are used on the warm zone, their waxy cores become soft and malleable. This allows blending, mixing, burnishing, and covering of large areas to be accomplished in a short amount of time and with little effort. The cool zone allows the wax-based medium to return quickly to its initial hardness, which is more suited for line drawing, layering, fine detailing, and finishing touches. The warm-and-cool techniques, pioneered by Ester Roi, can be combined in a variety of ways to create both exciting textures and realistic surfaces.

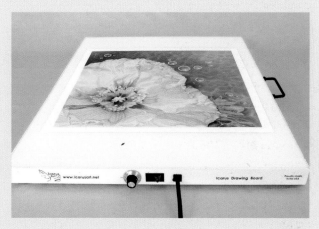

The Icarus Drawing Board was designed by Ester Roi especially for artists who use wax-based media. For more information, check www.icarusart.net.

Colorless blender This is a required tool in the colored pencil painting technique. Currently, only a few pencil manufacturers offer versions of this tool, and each calls it a slightly different name: colorless blender (Prismacolor); burnisher and blender (Derwent), and "Splender" colorless blender (Lyra). Although each blender has a different consistency, the general idea is the same: This tool is designed to move colored pencil pigments around the surface, smooth pencil strokes and color transitions, and not add color. Colorless blenders contain the same binding materials as the main pencil lines, but they have no pigment.

Cotton pads This tool is useful for applying OMS to large areas of a painting.

Drafting brush This tool efficiently cleans away colored pencil crumbs and residue from erasures.

Drafting tools A clear plastic ruler, a triangle, templates in a variety of shapes, and cutout shields are old-school drafting tools that you may not have thought had a place in fine art. However, when you create realistic images, you must be precise. You can use these tools for measuring, creating straight lines or curves, and repeating patterns and shapes. They are also invaluable when managing perspective relationships and shapes.

Electric sharpener This tool is vital for anyone who works with colored pencils. However, make sure to keep some graphite pencils around, as sharpening colored pencils tends to build up layers of wax that can be difficult or impossible to remove from the blades; grinding graphite pencils will clean and lubricate your electric sharpener.

Erasing tools A variety of erasing tools is required, not only for the negative painting technique but also for their original use—fixing mistakes. These tools include Magic Tape, mounting putty, kneaded erasers, and an electric eraser.

Drafting tools provide the precision necessary for realistic rendering.

Final Fixative This protects your work from accidental smudging and provides a barrier between your work and layers of varnish, if you decided to present your work with no glass (in the manner of an oil painting). Final fixatives are available in matte, gloss, and semigloss finishes. Some final fixatives also offer a degree of UV protection.

Graphite transfer paper This tool can be used to transfer an initial sketch of your work to the final drawing surface. Graphite transfer paper looks like carbon paper but doesn't have a wax base. As a result, it creates an easily erasable graphite line. Because graphite will be visible through the translucent layers of colored pencil, you will need to use a kneaded eraser to lift the drawing inch by inch as you're working, before you apply the colored pencil.

Hand sharpener This tool is best used for emergencies only, as hand sharpeners have a tendency to break your pencils unless they are very sharp.

Masking fluid/masking paper These tools can temporarily protect areas of your painting. Use masking fluid for smaller areas, such as highlights, and masking paper for larger features.

Because traditional graphite erasers don't work with colored pencil, this selection of erasing tools is essential for colored pencil painting techniques.

Creating a Color Chip Catalog

Creating a color chip catalog is an extremely important step while you are getting familiar with and, indeed, mastering your medium. I believe that this is necessary for understanding how each color behaves in practice, and it provides you with a reference for future use. Remember that your color chip catalog is a work in progress; as new colors and brands come to the market you will want to add them to your collection. However, you should start working on it now and become familiar with the pencils that you already have. Don't wait until you collect a large set to start creating this invaluable tool.

Use a standard binder and clear plastic slide (or trading card) protective sleeves. (It is preferable to use archival sleeves to protect your color swatches over time.) Each opening in these sleeves will contain a sample scribbling for each pencil of each brand together with a brief description (pencil name, color name, details about its base (wax or oil), lightfastness rating, hardness or softness, and so forth). This method allows you to easily reorganize your chips by color, by brand, by lightfastness, or any other grouping you can imagine. It will provide a clear understanding of the sorts of colors that are available in your collection. Since color and texture can vary with the paper used, it is best to use the paper you choose for your projects instead of scribbling on regular scratch or writing paper.

Your catalog could show various pencil brands and individual color swatches but also how each pencil looks when applied with different pressures, burnished with white, and treated with odorless mineral spirits. Below is a sample that uses Prismacolor Premier indigo blue. This color learning aid is discussed in greater detail on pages 25, 30–31, and 68–70.

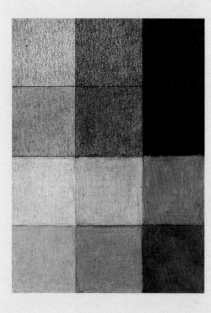

I applied Indigo blue using a light, normal, and heavy touch respectively in all four rows. For the swatches in the second row, I followed this with an OMS wash. I burnished the swatches in the third row with white. And finally, I performed a complete color fusion technique on the swatches in the fourth row.

Metal tea strainer This indispensable tool is used for creating powder from your colored pencils. Place the strainer over a clear small plastic cup and rub the pencil against the inside of the mesh. The mesh will shave the soft colored pencil medium into a fine powder, which will fall through the spaces and be collected in your container.

Pencil extender This is the tool to use when your pencil is too small to be held in your hand or too short to be sharpened by your pencil sharpener; it can save you a great deal of money and frustration.

Plastic cups with lids These handy containers are helpful for a variety of tasks, including holding small amounts of OMS and collecting pencil

shavings. Don't forget to place a sticker on the cup that identifies its contents.

Pumice stone With this tool you can create a rough surface in selected areas of your paper. You will need to use a smooth object, such as a table-spoon or a wooden sculpting tool, to press the paper against the pumice stone when working with my roughening technique.

Q-tips These are useful for applying OMS to small areas of a painting.

Sandpaper A small sheet of fine sandpaper can help you restore the point to the pencil without requiring extra sharpening.

Stylus pens This tool is used for both the negative painting technique and the scoring patterns technique. Keep various sizes on hand.

Super glue When your pencil becomes too small for the pencil extender, you can still use even the tiniest stub by super-gluing it to the end of a new pencil. I have used this method successfully for years; it has saved hundreds of pencil ends that would otherwise have gone into the trashcan. Just make sure that the glue is completely dry before you attempt to sharpen your pencil; other-

A pumice stone, together with a smooth sculpting tool, provides an effective device for roughening designated areas of your paper.

wise it could break inside the sharpener and damage the mechanism.

Tracing paper This is extremely handy for scoring patterns, for placing your signature, for transferring outlines, and so forth.

Tweezers A pair of small tweezers is helpful for removing masking fluid from preserved highlights. This is especially true when you are working with complicated patterns and clusters of small highlights.

Waterbrush This essential tool is a plastic container with a small brush at the end. Originally designed for watercolor painters who frequently worked in the field, waterbrushes can also be filled with a solvent such as OMS, which allows small amounts of liquid to be applied to the painting surface. Waterbrushes come in various shapes and sizes.

Workable fixative This tool is handy for layering colored pencil. When the paper tooth is completely

The shape and size of the stylus pen will determine the appearance of the impression it produces.

Setting Up Your Work Space

Once you have all of your materials, you will need to organize your work space. Because this medium is fairly neat, colored pencil artists can work just about anywhere—from a spacious studio designed specifically for this purpose to one end of the kitchen table. You don't necessarily need a lot of space, but you do need excellent lighting, a comfortable chair, and a proper drawing board (on which you will tape your paper).

Quality of light is crucial when you work with colors. I personally prefer to work during the day when natural sunlight is available. Many artists also prefer natural light from a north-facing window, since it stays constant during the day. However, when that is not possible to manage, I use a standard lamp equipped with an artist's daylight lightbulb.

After working on a flat surface for a while, you can lose the knack of seeing correct values, perspective, and proportions. The best way to counter this is to place your work vertically (or almost vertically) and step back. An adjustable drawing board can be very helpful for this purpose, and, of course, it is a convenient surface on which to draw.

The next task at hand is organizing your pencils. At first, looking at the entire set of colored pencils might make you wonder how you will ever remember all of them, or, more important, how you will manage to choose the right colors for the right job. And, if you work in layers, you will also need to know the order of the colors. These tasks can seem daunting and nearly impossible to master at first, but the process is not as scary as it seems. The best practical way to study and understand your pencils is to divide them into yellows, oranges, reds, purples, blues, greens, browns, and grays.

The most convenient way I have found to store my pencils is to lay them flat. Thus, I can instantly see the color of the pencil and reach for it without stabbing my hand with a sharp pencil point. I use flat clear plastic containers to separate my pencils. A liner on the bottom of each container prevents the pencils from rolling around. (Rubberized shelf matting works well.) When you are working on a project, you will notice that only some of your pencils will be necessary for any given task. To minimize confusion, separate the pencils used for the term of your project. You can reorganize them afterward.

filled with the pencil medium, applying a spray coating of workable fixative will allow you to apply two to three additional layers of colored pencil.

X-Acto knife This important tool is critical for the sgraffito technique to perform tasks such as creating tiny highlights and thin lines. However, an X-Acto knife only works properly when it is equipped with a sharp blade, so make sure to change your blades frequently and keep extra blades on hand. A dull blade cannot only ruin your work, but it can also be dangerous.

TIP: Some watercolorists use a rubber cement pick-up eraser to lift masking fluid. Although it could be practical occasionally in colored pencil, please keep in mind that use of this tool involves some rubbing and could destroy a portion of the layering that surrounds the protected area. I prefer to use tweezers.

Presentation Materials

Colored pencil work is usually done on paper, and, obviously, paper is susceptible to and has to be protected from water, dust, and scratches. After finishing your artwork, you should spray it with a few layers of a final fixative that is especially formulated for colored pencil, then you can either coat the image with varnish or you can frame it in the traditional manner. Each approach has its own benefits and downsides, but both will protect your image from the most common hazards.

Glass, Plexiglas, and Varnish

The traditional method for displaying work produced on paper is to place it under glass. This makes a lot of sense when you think about protecting a surface as fragile as paper. Use of regular framing glass methods may also be the easiest and most affordable option. However, using something as fragile as glass for protection adds a degree of inconvenience when shipping your art to shows and galleries around the world.

Most shows require artwork to be presented under Plexiglas to prevent any damage during shipping and installation. Plexiglas is lighter than glass and is not as prone to breakage. However, Plexiglas is easily scratched, so you have to be very careful when handling it.

Regular glass and Plexiglas may be used to temporarily serve your conservation and protective needs. For example, these materials work perfectly for a single show, when there are special requirements for framing but you have different plans for the future display of this particular piece. For permanent display of your work it is advisable to choose a UV-protective product. Although this is more expensive than its non-UV counterpart, it will provide good protection of your artwork from ultraviolet light damage. Choose materials that best meet your particular needs to best protect your paintings.

Displaying artwork under glass sometimes creates a prejudicial opinion that your art has a lesser value than a work created on canvas, as it is delicate and based on paper. Therefore, some gallery owners are not particularly fond of displaying pieces behind glass. Mounting your work on a sturdy surface (as described in the sidebar on the facing page) and covering it with a few coats of varnish presents your art like an oil painting and can help open gallery doors to your creations. Furthermore, varnish will shield your colored pencil paintings from scratches, dirt, and dust.

Mats and Frames

The best protection for your finished colored pencil painting is proper framing. Many galleries have their own individual requirements for framing, or they may even have their own framing service. However, if you do not work with a gallery and you need to present your artwork framed for a juried exhibition, a group or solo show, or a client, the easiest and least expensive method is to frame it yourself. A neutral mat board and a simple, elegant wood frame will satisfy the taste of most jurors, viewers, and clients; it is always best to frame your work in a manner that will not distract from your artwork.

If you choose to do the framing yourself, I advise you to invest in the following framing equipment and materials. Many of them are significantly cheaper when purchased in bulk quantities.

Archival matting materials This includes mat boards (in a variety of neutral colors, such as black, gray, white, and off-white), backing boards, archival tape, corners, and strips, which you will use to attach your artwork to the board. Make sure to order only high-quality, acid-free materials, as any material that contains acids and touches your art will cause yellowing in the short term and damage in the long term. Also make sure that the thickness of the mat is sufficient to separate the artwork from the glass or Plexiglas.

Butcher paper This is available in rolls and will cover the back of your framed painting.

Hanging hardware Two small screws should be inserted into each frame; they will be connected by picture wire.

Mat cutter Choose a cutter that is appropriate to the size of your usual work and make sure it has a straight cutting head, a beveled cutting head, and additional blades for the cutting heads.

Wooden frames Although I understand that there are often artistic reasons to create art in unusual formats, this will be more expensive and may require custom framing solutions. If you want to spare yourself from these problems, try to format your art to conform to standard frame sizes (18 x 24 inches, 30 x 40 inches, and so forth). Determine the formats that you most frequently use, and keep a number of ready-made frames on hand.

While framing your artwork is a relatively simple procedure, I have two pieces of advice: First, make sure to practice with the mat cutter on a scrap piece of mat board until you get the hang of cutting straight and beveled lines. This will save you money, time, and loads of frustration. Second, be sure to measure your artwork

carefully before you cut your final mat. If in the end you decide not to do the framing yourself and to use the services of the local frame shop, make sure to confirm that they use archival materials.

Mounting Paper on a Sturdy Surface

Completed artwork can be mounted on a variety of sturdy surfaces. One option is a specially prepared archival surface, such as a gesso board or cradled art board. Masonite board, which is significantly cheaper, can also be used. However, since Masonite is not archival, it will need to be primed. To do this, first, lightly sand the board to open the pores. Then, cover it with a couple of layers of gesso (such as Golden gesso). Wait until the board is thoroughly dry and then lightly sand it and apply another coat. Apply four to six coats, as needed. Remove any dust with a tack rag.

To mount your artwork to the board, you can use various adhesives, such as Grafix Double Tack Mounting Film, Golden Heavy Gel Medium, or Lineco Neutral pH Adhesive. After applying the adhesive to the board, carefully place your artwork on top. Go over the surface with a clean roller to make sure that no air bubbles are trapped beneath the paper. Then cover the paper with a sheet of cheap but clean butcher paper, and apply a heavy weight to the entire surface until it has completely dried.

chapter

2

Laying Down a Solid Foundation

Competition in the art world is intense. To be successful, an artist must master the materials of his or her craft, have a deep understanding of the theoretical basis of art, and be able to express a unique vision. Even then, in an ocean of mediums, techniques, and styles, it takes extreme effort to stand out and attract the attention of gallery owners, media publishers, and art collectors. This is especially true if the artist decides to offer work in a new medium. It is thus imperative that the colored pencil artist uses only the best-quality materials, executes his or her work at the highest technical level, and presents fresh and well-organized compositions.

Even the neatest idea will suffer if the technical execution is sloppy, and no technique can cover flaws in compositional decision. Studying the fundamentals of art—including basic compositional rules, color theory, and the nature of light—will help you to bring your artistic creations to an entirely new level. This knowledge will allow you to be the first critic of your own work and to notice mistakes while there is still time to fix them. Also, it will allow you to be more objective when judging the value of your own work and to understand the path to creative self-improvement.

This chapter provides a brief overview of the main elements and rules of design—a tip of the iceberg, really. It is meant to get you pointed in the right direction, but truly "getting there" will require more in-depth study all of these subjects.

Alyona Nickelsen,
The Color of White,
2004, Prismacolor colored
pencils on 250 gsm white
Stonehenge paper,
8 x 11 inches
(20.3 x 27.9 cm)

Elements of Design

Instead of using words, artists employ a visual language—which includes lines, shapes, values, colors, textures, patterns, and focal points—to communicate. When we put together these visual elements, we are creating our sentences. When we create our visual composition, we are telling our story. Like any writer, visual artists must not only have a good story to tell, but we must also be good storytellers. For this, we must know our language well.

Lines and Shapes

What could be simpler or more familiar than a line? We have all created thousands of lines in our lives—while doodling on the side of our homework, creating a rough draft of a diagram for a business presentation, or giving driving directions to a new bakery for a friend. We draw lines (straight and curved) in different directions, and when we connect these lines we create shapes.

In a composition, lines can be similar to one another—in terms of their length, direction (horizontal, vertical, diagonal), and kind (straight, curved, wavy, zigzag). They can also be placed at regular intervals. (Think of the lines that appear along the planks in a picket fence that is viewed straight on.) Alternatively, lines can be varied and placed in an unpredictable sequence. The same is true for shapes. Similar elements tend to create harmony in a composition. Dissimilar elements create contrast. Too much harmony creates monotony; too much conflict creates chaos. The key to creating a compelling composition is to strike a balance.

Let's examine for a minute the major lines and shapes that appear in *Summertime* (to the right). Lines A and B are both straight and their

sizes are roughly similar, but they create a contrast of directions. The curve of line C creates contrast to lines A and B—in its type, size, and direction. Yet the curve of line C is similar to other elements of design, specifically shapes E and D, which are also similar to each other. This group of elements together creates an appropriate conflict and harmony in the composition.

The appearances of lines and shapes carry an emotional message to the viewer. Straight convey a sense of accuracy, directness, solidity, and stiffness.

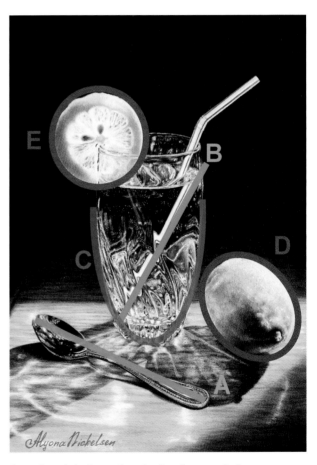

A number of similar and contrasting lines create the necessary balance in this composition. This painting, *Summertime*, appears on page 91.

Avoiding Bad Composition

Some opine that composition is subjective. This is true to a certain extent. There is definitely a place for personal taste and preferences. But all of the visual arts are governed by universal rules based on mathematical principles, the anatomy of the human eye, and the brain's ability to accept and digest visual information. Very often people look at a piece of artwork and they can tell immediately if they like it or if they feel that "something is not quite right" with the picture. They can't always explain why they have a particular response; they just do. Without the artist having knowledge of visual presentation, this human reaction always appears to be just intuition or a "gut feeling." The better you know how the rules work, the better you will be able to manipulate shapes and colors on the page and the easier it will be for you to find the shortest way to the heart of your viewer.

When we speak of composition, there are no landscapes, portraits, or still lifes. All visual artwork is an abstract piece that consists of different shapes, values, and colors. It doesn't matter if you prefer to work in one genre and don't know anything about the others. Quality design and composition are the same in every genre.

Some would say, "Where is the creativity if you have to follow rules?" But you can follow the rules and be creative at the same time. For example, when cooking, if you want to prepare, let's say, a fruit salad, you know that it is supposed to be something sweet, you know which basic ingredients to put in (fruit, not meat), and you know what is involved in the preparation of these ingredients. The rest is up to you—the taste, the look, the consistency, the decoration, and so forth. Now, imagine being completely free of any kind of rules and adding some gravy to your fruit salad. The result would be disastrous—even for the most open-minded of taste buds. Having a general set of rules helps prevent such severe incidents of bad taste, anarchy, and complete chaos in your work. You can be creative and yet remain within a certain set of rules. For any visual artwork, in any medium, these rules are universal, and following them makes your artwork appeal to a viewer.

Coming up with an inventive idea for a painting is the first step in the creative process. Of course, the second requires that you properly present this idea in your artwork. It doesn't matter if you imagined what you would like to paint or if you were inspired by a composition that already existed in life; you must create a design for your presentation. It is very seldom that you will discover a perfect composition in which you don't have to change anything—be it the lighting, cropping, background, and so forth. Without a good design, your idea will be lost during the translation from the vision within your head to the surface of your paper.

It is crucial for you as a realistic artist to be fluent in the language of lines, shapes, values, colors, and so forth so that through their manipulation you can truthfully represent a three-dimensional reality on the two-dimensional surface of paper. Only after you know how to do things properly can you purposely break the rules to create your own successful composition—and in so doing preserve unity, harmony, and balance so that you can tell your unique story to the observer.

Curved lines create a feeling of compromise and agreement, flexibility, and indecisiveness. Incorporating both types of lines helps to balance communication with the viewer. Lines can be continuous (like a river) or consist of isolated objects (such as a row of trees).

The direction of the lines in an image also plays a role in the artist's statement. Horizontal lines bring a sense of gravity and passiveness to the piece. Vertical lines create balance and aspiration. Diagonal lines add a component of transition and movement.

In representational visual art, lines and the shapes created by them are simple two-dimensional tools that help us to re-create our vision of solid objects and the edges that would exist in a three-dimensional world. In other words, think about the edge of your hand. There is no edge around it. Really, it is just a curve, but to show your hand on paper we will need to create a line that bends in a shape that resembles the shape of the hand. If in further rendering we leave this line as a distinct and visible contour around the hand, it will be a far-from-realistic representation of the hand. In realistic art, we do not make the contour prominent but rather suggest its presence with changes in value.

Values and Colors

Lines and shapes create a flat, two-dimensional representation of what we see in our daily lives. By adding value and color, we are able to transform our flat drawings into the third dimension and give them life. We create the illusion of depth—and enhance the realism of the image.

Simply put, value is the determination of how dark or light a color is when that color is compared with a midrange gray. Value is key to any successful realistic rendering. Realism is possible if the wrong colors and the right values are used,

but not vice versa. (You can paint an apple blue and it will still look real if you use a range of values to correctly show the shape, shadows, and highlights.) Without value, color just fills the space inside the shape created by connected lines, making it look like flat, colorful spots. When we use value, we transform our images from two-dimensional drawings to representations of three-dimensional objects and spaces. Value brings depth into play.

Color and value will be discussed in greater depth on pages 24–33, but let's take a minute now to look at how value is used in *Desert Rose* (to the right). The blooming cactus flower serves as the focal point for this composition. The flower, identified as value A, falls at about 6 on the value scale of 10 (where white is 1 and black is 10). Value A is in great contrast with value B (the dark cactus that serves as a backdrop) and is similar to value C (the blurry background at the edge of the picture plane). All together these three values create a necessary value pattern (6, 9, and 5 respectively), each emphasizing and contrasting the others. A lighter value looks brighter against dark background and vice versa.

When reading a story, none of us likes to be bored by reading the same thing over and over. When we come across random text that doesn't seem to connect to the main idea, we roll our eyes. We want action, conflicts or problems, and successful resolutions. That is why you must keep

Flat color fills the shape created by the black line. However, adding value to the image adds depth, instantly turning the circle into a three-dimensional cone.

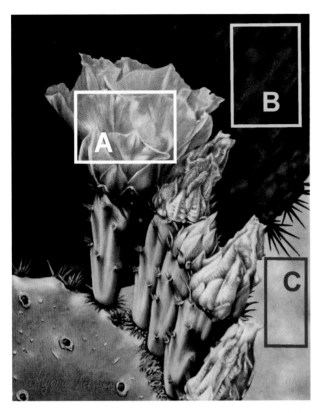

Placing contrasting values next to each other emphasizes their appearance and creates the illusion of depth. This painting, *Desert Rose*, appears on page 72.

balance in your art composition. Don't ramble on and on with the same lines, shapes values, and colors. Variety will keep your viewer interested in what you're saying, but you mustn't go overboard and create too much contrast.

Textures and Patterns

Human skin contains receptors that respond to touch, pain, pressure, and temperature. This information is then transmitted to the brain and a cutaneous (skin) sensation occurs. Texture is the tactile characteristic of a visual appearance that we perceive through our eyes and identify based on our life experiences. Our recognition of textures is based on the human ability to see patterns created of light and dark values. Various

materials and surfaces reflect or absorb light in different ways. These could be divided into four main groups of textures—rough matte, rough glossy, smooth matte, and smooth glossy.

In art, texture carries important information for the viewer, creates a visual impact, and is as important an element in design as line, shape, value, or color. Let's examine *Curve Appeal* (on the following page) to see one way that texture and patterns can be used in a composition. The areas defined as A, B, C, D, and E exhibit a great variety in both texture and pattern. The textures C, D, and E could be considered as similar because they are all reflective and smooth. However, texture D is wet and textures C and E are dry, which provides some contrast to their relationship. Conversely, textures B and A are both dry and nonreflective, which both gives them something in common with each other and creates contrast with the other three textures.

Looking closer, the lace doily (texture A) creates a complicated pattern that is in great contrast with the matte, black negative space of the background, but it is in harmony with complex pattern created by the cut crystal (texture C). The rough orange skin (texture B) is in harmony with the bumpy, uneven texture of the orange slices (texture D) and is in the contrast with the smooth surface of the knife (texture E). However, in spite of the great contrast between the various elements, they are bound together in a harmonious relationship because of the influence of other elements of the design, including lines (the similar lines of the knife and the folded doily), shapes (the similar shapes of orange and orange slices), and values and colors (the similar values and colors of orange and orange slices).

Conflict is like salt. The amount should be just right; otherwise you end up with a spoiled dinner. Think about it as a family relationship. The more we say "yes, dear" to each other, the more harmonious

our family life may appear, but as soon as we have opposite opinions we have a conflict. Too many "yes, dears" will create a boring monotonic coexistence, but too much conflict and opposition can end up in intense disharmony. So the correct answer is to strike a balance—balance in relationships, balance in life, balance in art.

Focal Points

The main subject of our composition is like the main character in a movie. (It doesn't matter if the subject is a person or an object.) Using lines, shapes, values, colors, textures, and patterns, the composition should describe the main character. Our choice of color pallet, its intensity and contrast, should create the mood of the story just as it would for a cinematographer. The main character (and the surrounding area) creates the focal

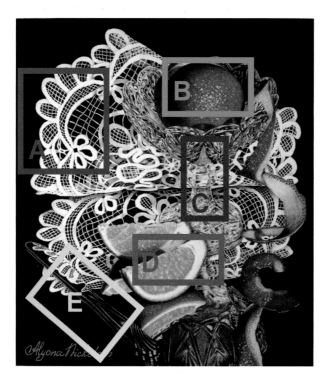

Using textures can enhance the message in a composition. This painting, *Curve Appeal,* appears on page 107.

point of the composition. When we introduce other subjects in the composition, we create an environment and support for our main character.

When you look at the picture, the first thing that jumps out is the focal point of the composition. The rest is support for that focal point. If nothing jumps out, you have a problem, and almost certainly you don't have a focal point. In other words, what is your story about? What you are trying to say cannot be clear to a viewer without a focal point. You must find the main portion of your composition and emphasize it. You can emphasize the focal point by putting it in a spotlight, defining it with brighter colors, increasing its size, giving it unique textures, and so forth. These efforts will all cause the main message to stand out and attract immediate attention.

If the eye of your viewer doesn't have a place to rest in your composition, you will overwhelm and confuse him or her. Busy backgrounds, filled with bright colors that compete with your focal point, will make your viewer tire quickly. There are a number of ways to avoid this potential pitfall. One of the most common solutions is to carefully consider the effects of negative space in your composition. Planned use of negative spaces can help highlight your main idea—and in effect both unite and balance your composition.

Let's examine *Sincerely Yours* (to the right) for a minute. The strong black background creates a quiet area, allowing the eye to glide playfully along the edges of the three pieces of fruit. The composition is structured as a loose triangle, with the cores of each of the two apple halves guiding the eye to the main apple in the center (which serves as the focal point for the image, as indicated below). The strong contrasting colors at the base of the central apple enhance the visual interest of this point in the composition; the bright highlights virtually touch the deepest shadows of the fruit. The reflection

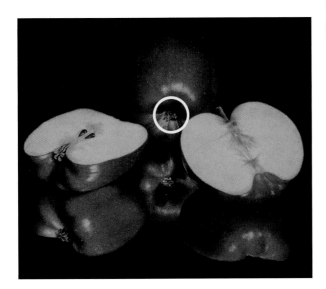

Negative space can highlight a main idea, thus uniting and balancing a composition, and lead the viewer's eye to the focal point. This painting, *Sincerely Yours*, appears on the contents page at the beginning of the book.

further engages the viewer's eye, allowing it to bounce back and forth between the real and the reflected fruit.

TIP: When rendering out-of-focus backgrounds or subjects, make sure that the edges are slightly blurred, as this will enhance the depth of field. A colorless blender works well for this purpose.

The placement of the focal point plays a pivotal role in your composition. A focal point in the dead center of a composition denies the development of the narrative mystery and tells us right away that "the butler did it." What is the point in looking further? Your viewer will probably just walk away from your artwork, wondering what it was all about. To be successful, your composition has to create a plot and supply some intrigue. This will keep the viewer's eye meandering and invite it back into the picture for a better look.

Striking the Right Balance

The key to creating a successful composition is striking the right balance. Here are a few tips to keep in mind:

Avoid obvious symmetry. Don't line up subjects within your composition on the same plane—either horizontally or vertically. Instead try to create a placement that suggests a certain randomness.

Avoid "kissing edges." This means that the edges of your objects shouldn't touch—either each other or the edges of the frame. It is better to have parts of your subjects overlap each other or go out of the frame than to touch one another.

Avoid having arrow-shaped objects point to the edge of the picture. You need to invite your viewer into the composition, not point the way to the door.

Avoid monotony. Similarity of lines, shapes, values, colors, textures, patterns, and so forth will create a dull composition. Contrast will make each quality more prominent.

Do not allow the background to compete with your focal point. The viewer's eye needs a place to rest. Your composition needs to have a main idea, and all other components have to support that idea. If you can get rid of a component or simplify it without hurting your main idea, you should do so.

TIP: After creating the reference photo for your composition, write a couple of paragraphs about it—what it is about and what you meant to show. This will help you to organize your thought process prior to rendering the final image.

Color without Confusion

Recognizing value is a fundamental part of human life. Without this ability a person is considered blind. Recognizing color is not as vital. Even people with a real disability such as monochromacy (complete color blindness) are able to maintain a normal existence. Nonetheless, the discomfort that accompanies the loss of color sight extends well beyond just the enjoyment of masterpieces in a museum.

From the beginnings of civilization humans have collected their life experiences and color-coded them for future reference. For instance, red/orange/yellow equates with fire, warm, and warning, while blue/green connotes water, cold, and calm. These color references go far beyond purely practical use, however. Because color impacts us emotionally, it delves deeply into our souls and minds and thus reflects our individuality. By studying color, its qualities and behaviors, we not only better understand ourselves but also learn how to convey our individual messages to the world and unveil our own inner vision.

Additive and Subtractive Color Mixing

So what exactly is color, and how do we see it? Our eyes receive light through receptors in the retina called cones; in turn, our brain perceives the various frequencies of light as colors. The science of color (or colorimetry), which is still not well understood, suggests that three types of retinal cones respond to different parts of the visible spectrum (red, green, and blue). Presumably, the different cones absorb specific ranges of light and functionally overlap one another to form combinations. The brain in turn interprets these combinations as various colors of the visible portion of the light spectrum. For example, when cones that respond to red and green are stimulated equally by light of a particular frequency, the brain interprets the color as yellow. Similarly, when you add red and green lights together, you end up with yellow light. Red and blue lights give you the sensation of magenta. Combining blue and green lights creates cyan. Various proportions of different light combinations can produce virtually any color of light. The absence of all three primary colors is black.

According to additive color mixing, an object in and of itself does not actually have color. Rather, when light shines on it, the object absorbs some colors of the visible spectrum and reflects others. The color that the object reflects is the color that we see. For example, when you shine a white light on a green leaf, the leaf absorbs all of

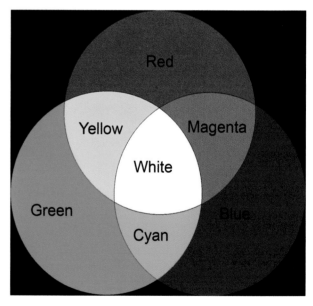

Additive color mixing, which governs the way our eyes (as well as our computers) work, states that red, green, and blue are the three primary colors. When these colors are present in equal parts, they create the appearance of white.

Creating Your Own Color Wheel

By its nature, each colored pencil is premixed, and only the manufacturer knows for sure what pigments (and in what proportion) went into the mix, whether black or white was added, and so forth. Disclosure of such information would be very helpful for artists, allowing us to easier classify our pencils. But because competition is what it is, not all of this information is available, and so we have to try to identify the color content of our pencils on our own. Therefore, before we can understand color mixing between pencils, we have to analyze what is in each individual pencil.

When you are done creating your color chip catalog (as described on page 11), try to place all of your chips into relationships according to the color wheel. This will not be an easy task. It will take some time, effort, and concentration. And it will be imprecise, as it will depend largely on guesswork (since you truly do not know exactly what originally went into the color mix). However, you will be amazed at the clarity of your understanding of your pencils after you have completed this task.

Your first step is to divide all your color chips into yellows, oranges, reds, purples, blues, greens, grays, and browns. Put aside the grays and browns. Next, differentiate the chips in each group that seem to contain white (tints) or black (shades) in the mix and separate these from the pure colors or mixes. Now place the chips with all pure colors or mixes of pure colors along the perimeter of a large circle according to the relationships of colors in the color wheel, using the diagram on page 27 as a guide. After you are done, mark each color chip with a letter that will identify each hue (Y for yellow, G for green, YG for yellow-green, and so forth) according to your best understanding.

Your next task is to place the color chips that contain white (tints) above each color of your circle and still maintain the relationship of the color wheel. As you did before, mark each color chip with the name of the color (Y for yellow, O for orange, BV for blue-violet, and so forth) and add the letter W to indicate that white was added to this color. You may notice that you will have two or more tints associated with the same pure color. If so, mark them with double or triple Ws, depending on how light they are. Or there may be no tints that relate to a particular color. In this case, make a note on the color chip, and in your work you will need to create your own tint just by adding a layer of white pencil.

The last step is to place all of the chips that contain black (shades) inside of the circle and according to color wheel relationship. Mark each color chip with the letters that identifies the color and add BK, indicating that this pencil contains black pigment. Again, sometimes you will have more than one shade of a color, and sometimes there will be none.

This is a great way to study your collection of colors and their relationships. You can intermix different brands of pencils, or you can create a separate color wheel for each brand. After this, you can place your color chips back into their plastic protective sleeves and use them for references in your future color mixes. Colors that are neutral (grays) or semi-neutral (such as browns) are created by mixing close to complementary colors; consequently they must be classified separately and marked accordingly for future references.

the frequencies of light except green and your eye experiences a green sensation.

The additive theory does not apply to all situations, however. For example, when color is printed—either by a professional printer (like the one that created this book) or by a personal-use printer (such as the one connected to your computer at your home or office)—the subtractive color mixing theory comes into play. In this case, the cyan, magenta, and yellow pigments or dyes from your color cartridges produce a wide variety of colors on the paper. Specifically, magenta works as a filter to absorb green and control how much green will be shown. In the same manner, cyan works for red, and yellow works for blue.

In subtractive color mixing, black is the mixture of cyan, magenta, and yellow in equal parts. *Why then,* you may wonder, *do we have black ink in our printers or paint tubes?* The answer is simple. Creating a perfect black requires complete absorption of all three colors from light. Unfortunately, we don't live in a perfect world. Our inks, dyes, and colorants are not as perfect as we may need, and the mixtures do not usually produce a dark enough black (it looks rather dark brown). To compensate for this problem, we add ready-mixed black dyes and pigments to the formula or use them separately in ink cartridges.

There are many reasons why an understanding of color mixing is crucial for visual artists. For example, you may want to substitute colors, control color properties (such as brightness and temperature), and create harmonious color schemes. Or you may simply want to create color mixes and not end up with muddy colors. So the next step is to look more closely at colors and how they relate to each other.

Hue, Value, and Chroma

All colors can be classified using the following three aspects of color: hue, value, and chroma.

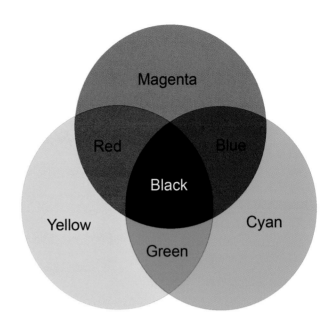

With subtractive color mixing, magenta, yellow, and cyan can be mixed to produce red, blue, green, and black. Professional printers are governed by subtractive color mixing.

Hue is the name of the color. Value is the degree of lightness of the color. Chroma is the intensity of the color. In other words, we can describe any color by naming it, telling how dark or light it is, and determining how much color it has in comparison with a midrange gray. Let's discuss each dimension in turn, beginning with hue.

If we place all of the colors visible to the human eye in a circle, we create a color wheel, as pictured on page 27. Each hue (color) has its own place in relation to all other colors. According to color theory, there are three primary hues—red, yellow, and blue—and these cannot be obtained by mixing any other colors together. The three secondary hues are green (a mixture of blue and yellow), orange (a mixture of red and yellow), and violet (a mixture of red and blue). Tertiary hues (of which there are six) are obtained by mixing a primary hue with one of its similar secondary hues. For instance, mixing yellow and green creates yellow-green.

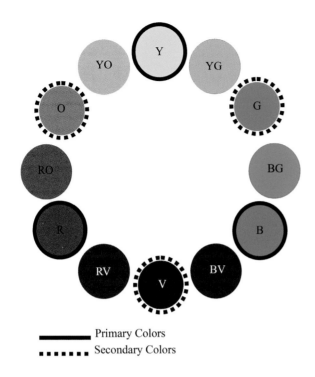

Primary Colors
▪▪▪▪▪▪ Secondary Colors

A twelve-color color wheel comprises the following colors (clockwise, from top): yellow (Y), yellow-green (YG), green (G), blue-green (BG), blue (B), blue-violet (BV), violet (V), red-violet (RV), red (R), red-orange (RO), orange (O), and yellow-orange (YO).

TIP: Don't be confused between hue and the name of a particular pencil in your collection. Different manufacturers tend to call the same hues different names and may use the same pencil name to identify different colors.

Hues such as red, orange, and yellow are considered warm. Hues such as green, blue, and violet are considered cool. If white is added to a hue, it is called a tint. If black is added to a hue, it is called a shade. Tone is a hue to which gray has been added. Gray is a neutral color and can be made by mixing black and white or by mixing two complementary colors. Complementary colors are colors that are opposite each other on the color wheel (red and green, yellow and purple, and so forth).

Complementary colors contrast with each other. Analogous colors are colors on the same side of the color wheel and are considered harmonious. Split complementary colors are created when you match one color not with its direct opposite but with the two colors immediately adjacent to its opposite. For instance, orange and yellow serve as split complementary colors to blue-violet. Diad, triad, and tetrad colors are located (respectively) two, three, and four or more colors apart from each other on the traditional twelve-color color wheel.

Now that we've discussed hue, let's move on to value. As we mentioned earlier, value is the determination of how dark or light a color is when that color is compared with a midrange gray. Getting the right value is one of the most important tasks to attain realism. The value-scale chart below features ten gradations. However, in real life the complexity of the value scale is dictated by the light source. The stronger the light source, the broader its value scale. So under a strong light source, such as the sun or moon, we have an enormous value scale, with literally hundreds of intermediary gradations.

The third dimension of color is chroma. Chroma is the level or measurement of color purity in comparison with a midrange gray. Therefore, because of the lack of any color, white, black, and all shades of gray are considered achromatic colors. In this manner, two hues could have the same value but have a different chroma.

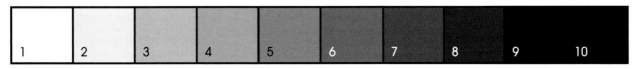

This value scale features ten gradations, with 1 representing white and 10 representing black.

Maximizing Your Use of Value

Artists who work in realism try to mimic the appearance of real life. But, unfortunately, the value range available to us is limited by the pigments of the medium we choose to use. If we simply compare the values of our pigments with the values that exist in reality, we are at a significant disadvantage. Therefore, we have to overcome these obstacles with the help of various artistic techniques.

TIP: Creating a monochromatic study (using black, white, and grays or different values of the same color) is very helpful to establish the value patterns in a composition before you start rendering in color.

The most important thing to remember is, as an artist, you must use *all* of the values available to you. The fewer values you use, the flatter your image will appear. Even very flat objects contain many values. Examine your own hand. You will see that this relatively flat object has many darks and lights and that these define its actual shape. When we use the entire range of values, we determine the shape of objects as they appear in reality. The smoother the transition between values, the more realistic our rendering is. When you use two values that are too far from each other on the value scale, the image appears like a duotone poster—graphic and unrealistic. This is true unless, of course, the real subject consists of highly contrasting values (such as a cut-crystal vase) or has well-defined value edges (such as cast shadows under a bright light).

I exclusively use white paper for my work. And I preserve the white of the paper for the brightest and lightest values in my composition. You can't go whiter than the white of the paper. So when you use colored, tinted, or black paper, you immediately limit the brightest possible value from your value scale. Even underpainting with white pencil will not give you the white of white paper. Therefore, if you choose to use something other than white paper, you will have to adjust all your other values accordingly.

Another method of overcoming limitations in values is to emphasize the values in your composition by placing neighboring objects with contrasting values. In other words, a light object will look lighter on a darker background and vice versa. Using the contrasting values of the background and the main object or two neighboring objects will intensify the impact of both.

TIP: Step away from your painting every once in a while, squint your eyes, and check your values. This technique blurs your vision and keeps you from being distracted by details. You can then clearly see the areas that need value adjustments.

And finally, remember that black in life is actually the absence of any color and is caused by an absence of light. However, any black in art is pigment that has been applied to a support; therefore, the pigment will still reflect light (and consequently not be a true black). We can compensate for this in two ways—by adjusting our value scale and by emphasizing our blacks by placing light (or contrasting) values nearby.

Using colored or black papers inhibit an artist's ability to obtain the brightest possible values. This is immediately apparent when the same red pencil is placed on white, off-white, and black paper.

Taking a Closer Look at Tonality

An important issue to keep in mind when creating a composition is its value key, or tonality. Tonality determines the overall darkness or lightness in a composition; changes in tonality can create various emotional impressions, imply different moods, and convey a variety of messages to the observer. Tonality is defined by standard terms such as high, intermediate, low, major, and minor. These terms indicate the general mood of the composition. By looking at the value scale we can infer certain facts. If the overall tonal values range from 1 to 3, it would be considered as a high tonal key. If the tonal values range from 4 to 7, it would be considered intermediate. And if the tonal values range from 8 to 10, it would be considered low tonal key.

The terms *major* and *minor* describe the overall contrast of the work. Major is work with considerable contrast, and minor represents work with little contrast. Therefore, the tonality of a composition could fall under any of the following six categories: high major key, high minor key, intermediate major key, intermediate minor key, low major key, or low minor key.

The personality of the artist certainly dictates which tonal keys he or she prefers to work with. For example, my work tends go almost exclusively into the low major and sometimes into the intermediate minor category (as with *Melody of Fallen Leaves,* shown below). The subject itself is also a consideration. For instance, if you want to picture a traditional happy wedding couple, you are unlikely to use a low minor key. The bottom line is that choosing the appropriate value key is the best way to convey your message for a particular kind of a story.

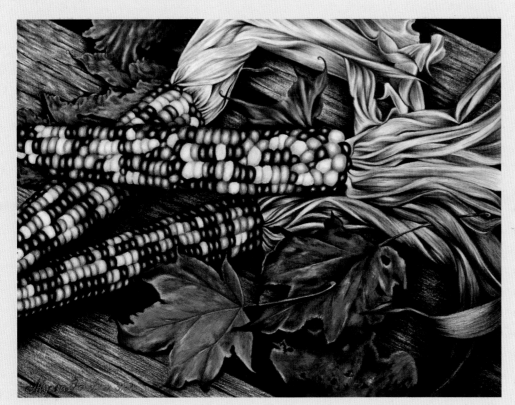

Alyona Nickelsen,
Melody of Fallen Leaves, 2004,
Prismacolor colored pencils on 250 gsm white
Stonehenge paper,
9 x 12 inches
(22.9 x 30.48cm)

Mixing Colors with Colored Pencils

The translucence of the colored pencil medium allows you to work in layers. This is a great advantage and a challenge at the same time. My personal technique involves not just layering different colors on top of each other but also mixing in between layers. As mentioned earlier, a typical final result is reminiscent of an oil painting. It has no sign of paper showing through the layers of pencil and has virtually no visible pencil marks.

It is vital for an artist who works in color to know how to mix colors. Color mixing can either be a great advantage or cause you to ruin hours of work with a single mistake. Because colored pencils are, in essence, premixed, this is especially true for the colored pencil medium. You will be required to navigate not only with primary, secondary, and tertiary colors but also with the many hues, shades, and tints premixed by various manufacturers.

TIP: While working on each drawing or study, make notes about your color mixes in a notebook specifically designated for this purpose. Record which mixes are successful and which are not. This will be essential in the future when similar situations arise.

This issue is complicated by the fact that different manufacturers sometimes call the same hue different names. Conversely, the same name can be used by two different companies to identify two different hues. Therefore, prior to using assorted brands of pencils to create your artwork, you should study your pencils well. As I mentioned on page 11, making your own color chip catalog will be very handy for this purpose.

I have been asked repeatedly how I mix my colors, how I know which pencil to use, when I use

This is a sample from my own color chip catalog. The top row shows Prismacolor Premier's canary yellow and indigo blue. The first column of the second, third, and fourth rows show indigo blue layered over canary yellow. The second column shows the reverse—canary yellow over indigo blue. The second row shows these layers in their pure states. However, the third row was burnished with white pencil, and the fourth row was altered with an OMS (odorless mineral spirits) wash. Notice how many different effects can be achieved by simply using these two colors.

various colors, and in what order. The answer to all of these questions is both simple and complicated at the same time. If you are working with colors, you need to understand your particular medium as well as have theoretical knowledge of color. By this I mean that you must be able to identify a color (either in life or in your reference image) and re-create it in your art (by mixing two or more pigments on the paper). With experience, you can teach yourself how to achieve various effects with specific combinations of colored pencil. This knowledge is an intelligent blend of color theory and trial-and-error practice.

Over time I have selected pencils that I use in almost all of my work; these have become my favorites, and I reject those that I almost never use. This is a very personal choice and process.

Your preferred and dismissed colors will depend on your own particular tendencies. To a certain degree, these are a reflection of your personality. And, of course, the colors you choose will depend on the subject matter of the composition at hand.

Another trick that I have developed over the years is to create acetate overlays for various colors. These can be positioned on top of your drawings while you're working to help you decide which particular shade of hue is appropriate for the next layer. For instance, as in the example shown below, if you are not sure about which green will create the desired layering effect over the cast shadow in your work, you can use your acetate with various greens to help you visualize the next step. This method can keep you from ruining hours of work just because you used one layer of the wrong color or unintentionally over-darkened your values. You can create this learning tool yourself for each color in any brand of colored pencil.

Print the template on your chosen drawing paper. With your colored pencils, create a swatch for each color family. Then scan your swatches back into your graphics program, adjust the color as necessary, and add the pencil names. Save your work as a GIF file with a transparent background.

Print each swatch on an overhead transparency. By placing the transparency on top of your rendering, you can get a sense for how colors and values will change your work before you actually begin layering.

Here is how to create your own acetate overlays: First, using a graphics program (such as Photoshop), create a simple template of eight (or more) squares, rectangles, or circles, similar to the example shown here.

TIP: Create multiple acetate overlays for the same color swatch. This way, you can lay them on top of each other to see the result of two or more layers of the same pencil or different combinations of pencils.

Knowing Your Color Facts

By understanding how the human eye and brain react to color, we can simulate reality more convincingly and create more compelling compositions. Here are a few color facts to keep in mind:

When you mix two bright colors together, you reduce the brilliance of both. The farther apart these two colors are from each other on the color wheel, the duller the chroma of the color created by their mix will be. Bright colors will stand out in a composition and attract attention, while dull colors will recede. Keep this in mind when planning accents and focal points especially.

True complementary colors, when mixed in equal amounts, will create a midrange gray. This freshly created neutral color will be more visually interesting than a premixed neutral, straight from the pencil. Very rarely do I leave any single color straight from a pencil unmixed in my artwork. The exception is when I want to show the prism effect of cut crystal.

There are almost no pure colors in nature. Light reflects and absorbs from the surfaces unequally, and instead "pure" colors are a mixture of reds, blues, and yellows in various proportions. For instance, red strawberries will not look realistic in your artwork if you use only a red pencil, without incorporating the other two primary colors (blue and yellow).

Positioning complementaries next to one another achieves maximum contrast. When complementary values (e.g., black and white) are shown next to each other, they create maximum contrast in value. When complementary colors (e.g., green and red or blue and orange) are shown next to each other, they create maximum chromatic contrast.

Black, which is a neutral with the strongest value, provides the highest contrast for all colors. Against a black background, light colors will appear paler than they would against a background of any other color; gray and white will look brighter and larger (called the "irradiation effect"); and other colors will appear more brilliant. Likewise, light values will emphasize the black, as it will never be pure and completely absorb all light.

Black can dramatically affect the appearance of a color.
Top: The same gray circle appears larger and brighter against a black background than it does against a white background; this is called the "irradiation effect."
Bottom: A black background increases the brilliance of a color, in this case red.

The placement of a color can change the way that color is perceived. This means that the same color will appear differently depending on its surrounding hues, their values, and chroma. The same object will also look different depending on the light source and the reflectivity of the surfaces. Excessive use of colors with strong chroma can tire the eye of the viewer. Alternatively, excessive use of colors with week chroma can be boring.

When color with a strong chroma dominates a neutral color, it will create the illusion of the complementary color in the neutral color. For instance, if you place a small gray object next to a large green object, the gray object will look reddish. If you place the same gray object next to a large red object, it will appear greenish.

When two adjacent colors have the same value, the dominant hue creates the illusion of a complementary color in the less-dominant hue. In the example shown here, red dominates over the orange. This creates the illusion that the orange contains some blue (its complement).

Warm colors advance, and cool colors retreat. This effect, called "color refraction," is caused by the way our eyes and brains respond to color. So, when we want to increase the illusion of depth in our compositions, we can add blues to subjects that are farther away and touches of red to subjects that should appear closer to us.

The same blue dot appears against various background colors. Notice how different it looks in each example. Colors affect each other. This is why it is important to plan your color selection in advance.

Notice how the strong chroma of the red background makes the orange circle appear to have some blue in it. The chroma of the green background makes the blue circle appear to contain some orange.

Fundamentals of Light

Everything we see in life we see because of light. Shadows are simply a function of light—either weak light or a complete lack of light. Thus everything that we portray in the visual arts is a depiction of various lighting conditions as viewed by the human eye. The accuracy of the representation of light in our art will greatly depend on our understanding of human anatomy, psychology, and the laws of physics and math.

At a primitive level, humans react to light. Not only does light immediately attract the human eye, but it is a powerful conductor of mood. When light in a painting is correctly handled, we can create an emotional bond with our viewers and bring our ideas across with amazing potency. It is thus that we energize them with bright sunlight, seduce them with flickers from a fireplace scene, or intrigue them with mystical wisps of moonlight. So when we portray light, we must pay close attention to the types of light sources being rendered (or implied); the placement of these light sources; the quality of the light these sources produce; the color, direction, and intensity of the shadows being created; and the way the various surfaces in the composition reflect, diffuse, and distort the light.

The quality of a light has a tremendous effect on the color of an object. Under bright light, colors look prominent. Subdued light dulls and distorts colors. Incandescent lightbulbs shift colors toward yellow. Overcast sunlight applies a blue tone to colors. Furthermore, all colorants (like pigments and dyes) absorb certain colors from the light source and reflect what is left to the human eye. This causes different colors to look different under various colors of light. For example, green appears black under red light, and red appears black under blue light.

Varying lighting conditions also directly affect the color of shadows. When light is warm—such as it would be for sunlight, candlelight, and most incandescent lights—the shadows it generates are cool. Conversely, cool lights—such as fluorescent bulbs, indoor light from a north-facing window, or even overcast light outdoors—produce warmer shadows. Of course, the correlation between the temperature of light and shadow is usually more complex. It includes numerous fluctuations and requires careful observation.

The direction of the light can also create dramatic effects. For example, if you place a strong light behind a flower, the petals will seem to glow. In addition, the actual structure of the petals will be visible, showing variations of depth and density

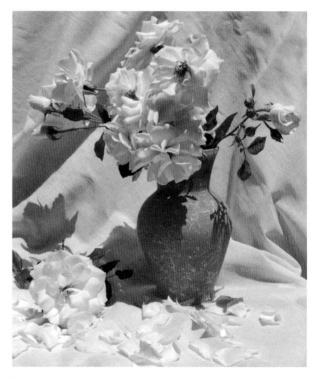

Strong sunlight at noon produces prominent and well-defined shadows. The great contrast of the elements in this composition generates a powerful statement.

as the petals interplay with the light source. Backlighting only works when a subject is translucent or transparent. When the subject is solid, it blocks the light completely and makes it appear very dark or black. (See pages 36–37 for more about transparency and translucency.)

Another example of dramatic lighting is when objects are lit by a single light source from the side. An example might be a still life setup that features a single, brightly burning candle. Often this scenario can generate a sinister mood, with intense light on one side of the objects and images buried in shadows on the other side. If this effect is not desired, the mood can easily be adjusted by adding a second, weaker light source. That will help define the shapes that are buried in the shadows and soften the emotional impact of the scene. Also, this form of sidelight is a perfect solution for emphasizing textures and surfaces.

Front light can be used to illuminate most compositions. However, this approach has one caveat: It will flatten the image, as it creates fewer shadows and diminishes the textures and details of the objects.

While arranging your composition, therefore, you must make a few basic decisions regarding which lighting will best suit your particular setup. First, choose the primary light source—whether it will be artificial or natural and what kind. Second, decide if you need a secondary light source. Third, determine the strengths and direction of the light source(s). And finally, examine all of the surfaces where the light ends up in your setup. The way surfaces look depends on opacity, transparence, or translucence of the materials from which they are made. Also, the texture (smoothness/roughness) of the surfaces will establish the number and appearance of highlights.

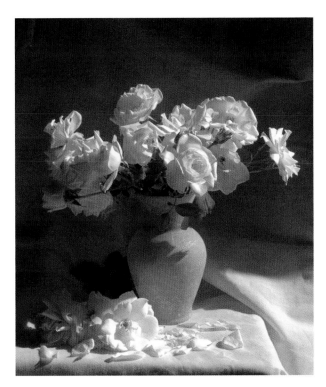

Sunset light forms mysterious shadows and brings a reddish color to the entire composition.

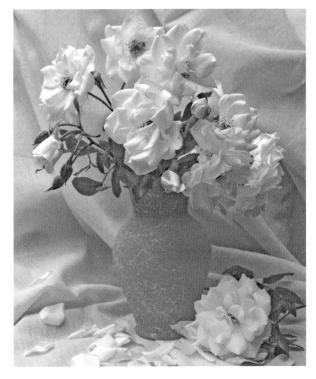

Diffused light during an early overcast morning creates delicate shadows and conveys a subtle mood.

Highlights

Highlights are an extremely important part of realistic rendering. So what are they, exactly? A highlight is a spot on the surface of an object closest to the source of light. Each highlight has its own unique shape, temperature, and value. Let's evaluate each quality in turn. As we do so, remember, it is better to have no highlight at all than an incorrectly implemented highlight.

The shape of the highlight is formed by the curve (or lack of curve) of the surface where the light landed. The strength of the light grows toward the center of the highlight. The edges of the highlight could be well defined or blurry, depending on the smoothness and reflectivity of the surface to which it belongs. Note that very often camera flash creates artificially sharp edges of highlights that must be adjusted in the actual rendering for a more natural looking object.

The temperature of the highlight depends on the temperature of the primary light source. If the light source is cool, the highlights will be warm. Conversely, if the light source is warm, the highlights will be cool.

The value of a highlight is determined by two factors—the proximity of the highlight to the primary light source and the reflective properties of the surface of the object. The closer the highlighted spot is to the source of light, the brighter it will be (and the higher it will be on the value scale). Also, if the surface is shiny, the highlight will appear even brighter. Conversely, a highlight on an object that is far away from the light source or that has a dull surface will be less bright.

Transparency, Translucency, and Reflectivity

As we've discussed, light dictates how we see (and therefore how we render) objects. It is therefore critical to be aware not only of the various characteristics of light but also of the characteristics of the objects themselves and how these surfaces interact with light. This is particularly true when the objects are transparent, translucent, or have reflective surfaces.

The transparency or translucency of a material determines how much light can pass through it. However, even the most transparent materials, such as clear glass or plastic, will diffuse the light, change its quality, and distort the shapes and values of the surrounding objects. For instance, the objects and backgrounds behind a transparent vase will have a slightly changed value, darker or lighter, depending on the lighting, the curve of the vase, and the consistency of its material. At the same time, transparent objects tend to adopt the color of the surrounding environment. So if that transparent vase is in a room with a pink wall, it would be separated from the surrounding hues only by a set of values and highlights that mimics the surface of the vase.

The shape of the highlight repeats the curves of the ceramic vase. The well-defined edges and high brightness are created because of the strong source of light and the reflective surface of the vase.

Similarly, translucent objects will not only adopt the surrounding colors but will also modify the colors of the objects and backgrounds visible through them with their own hue. The shifts in colors and values will depend on how clear the material is (colored glass versus sunlit balloons, for example), the position of the translucent object relative to its surrounding (the closer the translucent object is to the background, the more visible will be the shift in colors and values), and the lighting condition (the stronger the light, the more visible it is and the more clearly you can see the changes in color and value).

When you portray a transparent or translucent object, treat it as an abstract set of values and colors created by distortions and surfaces curves, but keep the overall shape of the object in the back of your mind. You must accurately render each part of the puzzle. In other words, every value and color should make perfect sense if you refer to the original setup. At the same time you must preserve the shape, appearance, and relationships of the whole form without getting lost in the details. We will talk more specifically about that process later in this book when we discuss the rendering of cut crystal.

Reflectivity is the quality whereby a surface mimics the shapes, colors, and values of the surrounding objects and backgrounds. The smoother and less curved the surface is, the less distorted its reflection will be. The real object and its reflection will not be symmetrical images. The reflection will show a different angle of the same object and its surrounding from the point of view of the observer. If the reflective surface has some coloration, it will bring a shift to the colors of the reflection. The values of the reflections could also differ compared to the real object, depending on the amount of light reflected back to the eye of the observer. The best approach when rendering severely distorted reflections is to treat them as a set of abstract shapes

and values. Keep in mind, however, that the reflective surface has its own curve and volume.

Shadows

If there is no light, there will be no shadow. Light and shadow are inseparable in the physical world as well as in representative art. The method of using light and shadow to generate naturalistic imagery is called chiaroscuro (from the Italian "chiaro," which means light, and "scuro," which means dark). Great examples of artwork that utilizes chiaroscuro include those create by Rembrandt and Caravaggio.

Shadows are not just random dark spots on the ground or on objects. Rather, shadows are intimately connected both to forms (either the forms that that they are on or the forms that create them) and to the surrounding light. As such, every shadow has a unique structure, direction, temperature, and color.

Any object that is located near a light source will have a lighted area and a shadowed area and will generate a shadow. The body of shadow consists of two major parts—the umbra (a solid shadow created by an object blocking the light) and the penumbra (the less dense part of the shadow). Each light source produces different kinds of light and different shadows. Bright, strong light sources produce dark, well-defined shadows. Diffused light creates less prominent shadows.

The qualities of the shadowed areas of an object (called the "form shadow") depend on the curve of the object's surface, the object's position relative to the light source, and the strength and quality of the light itself. Together light and shadow define the shape and characteristics of the object, with the lightest value of the object being its highlight and the darkest value being the "core of the shadow." Keep in mind that occasionally true lighting conditions, such as

Understanding the Nature of Light

One of the primary aspects of successful realism is the naturalistic depiction of light. Here are a few facts to keep in mind:

The light produced by a light source has a particular intensity and color. Different sources produce light with different qualities, so before beginning a rendering of light, make sure that you understand the color, temperature, and intensity of the light.

Colors will look washed out under direct and strong light. In shadows, colors will have low intensity. The truest appearance of the colors will be halfway between the two, the so-called halftone.

Shadows help indicate where an object sits on a surface. Newton's law of gravity is in effect for all subjects on Earth, and it must appear so in

your work. Therefore, unless you intend to show objects floating in the air, don't forget to ground them in your composition.

The lightest value of the shadow should not be lighter than the darkest value of the lighted area. This is because any part of the shadow signifies the complete or partial absence of light, so naturally the absence of light would be darker than its presence.

Light not only affects the length and direction of a cast shadow but also its intensity and color. The less angular the light source is to the object, the longer its cast shadow will be and vice versa. The brighter the light is, the darker the shadow will be. Cast shadow loses its intensity and definition when it moves away from the object that created it. Shadow will have the opposite temperature to the primary light source. The local color of an object will also determine the color of the shadow.

Reflective light is not as bright as a direct light. Reflective light is reflected from the nearby surface onto the object, comes from the opposite direction of the primary light source, has the opposite temperature, is subtle, and is not as strong as the highlight.

The proximity of a light source directly affects the color of an object. An object under intense direct light will be washed out, and its shadow area will be dulled. This object will have its most intense color in the area halfway between light and shadow areas (in the halftone).

Alyona Nickelsen, *Blue Bayou*, 2006, Prismacolor Verithin colored pencils on 250 gsm white Stonehenge paper, 11 x 8 inches (27.9 x 20.3 cm)

strong direct light, can eliminate the form shadow and flatten the form. Therefore, in your rendering you will need to make an adjustment to preserve the appearance of the form.

The relationship between an object and its surroundings is expressed both in the qualities of the reflected light on the object itself and in the qualities of the shadow that the object creates (called the "cast shadow"). Areas illuminated by reflected light are always darker than areas illuminated directly by either primary or secondary light sources. The cast shadow always repeats the shape of the object itself and the surface upon which it lays. The darkest part of the cast shadow appears where the object is closest to the surface.

Shadow and light create edges—lost edges, soft edges, and hard, well-defined edges. Not only do objects themselves have edges, but values have edges as well. For example, consider the value edge created by the meeting of the form shadow and the area illuminated by the reflected light. As mentioned earlier, this value edge is generally referred to as the "core of the shadow." Hard edges are usu-

ally created with strong light and frequently appear in the foreground of a composition. Soft edges are generally in diffused light and often appear in the middleground of a composition. Lost edges frequently dissolve into darkness, allowing objects to melt into the surrounding areas, and are often in the background.

While at first glance shadows may appear to be simply dark, they frequently have a fair amount of color. This color is determined both by the color of the object's surface and by the color of the light. The color of the shadow will be less intense compared to the lighted area of the surface. The temperature of your shadow's color will be opposite to the temperature of the light. In other words, warm light produces cool shadows and cool light produces warm shadows.

Cast shadows, because of their dark values, can significantly emphasize your idea as well as destroy it if they are not carefully considered. Be aware of this quality. Treat cast shadows as a part of your composition, and adjust their strength in your rendering, if necessary.

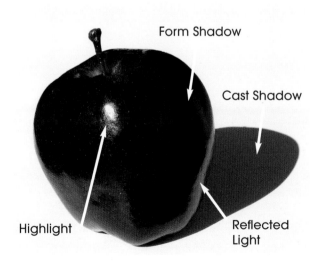

Under a strong light source, the structure of the form shadow on this apple is very clear. Notice, too, that the cast shadow has a well-defined edge.

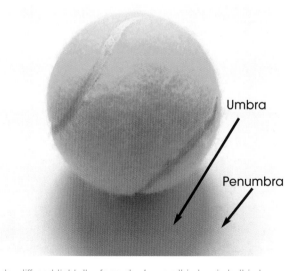

Under diffused light, the form shadow on this tennis ball is less clearly defined. The edges of the cast shadow are soft; nonetheless the umbra and penumbra are visible.

Rendering Light with Colored Pencils

Light itself has the highest value in a composition and often serves as the focal point. Since the white of the paper is the brightest value available in my materials, I preserve it for rendering the brightest highlights. For the remainder of the lighted areas, I use colored pencils, working from light to dark. I render each area by carefully adding new layers of the pencil. It is important to use light pressure at this stage in the development of a composition, because each layer of pencil medium adds a significant change in values.

Yellow color associates with warmth, fire, and light. On the color wheel, the temperature of the colors warms significantly as they move toward yellow. Yellow seems to move forward in the painting, and it attracts immediate attention. So it is natural that when we are depicting the lightest value of the composition—light—we will incorporate the yellow hue.

TIP: When making a painting, try to be in the same lighting conditions each time you sit down to work. I prefer to work in daylight, but if I have to work at night I use a white light lamp. White light better simulates daylight and allows you to see colors closer to their true appearance under the natural daylight.

The wonderful thing about colored pencils is that their distinct translucent quality allows us to work in layers similar to glazing in oil painting but without the waiting period. I have found that "underpainting" lighted areas with different shades of yellow makes the yellow glow through the layers of pencil and imitates the presence of light.

When you layer colored pencil, it lands on the paper unevenly. Even if you are diligent and skilled in how you apply your strokes, this will occur. This is because of a number of factors: The paper surface has hills and valleys, your hand motion will be slightly irregular no matter how adept you are, and the ingredients (i.e., pigment, wax, and so forth) in the pencil core are imprecisely mixed. However, this is really one of the joys of the medium, and it can create wonderful visual effects. For example, let's say that you apply a layer of canary yellow pencil. You will notice that it does not perfectly cover the surface. Then if you layer poppy red on top of it, your second layer will not be perfect either. Layering these two pencil colors will produce an optical mixture of pigments and a new secondary hue—orange.

Compare the handmade orange with the premixed orange to the right. Notice how the handmade mixture glows when compared to the manufactured color. This happens because the manufactured orange is mixed well, very evenly, and consists of two primary colors, yellow and red. The handmade mix is not perfect; it allows some particles of yellow and red to be very close to each other but not physically mixed with each other. The result is that they intensify each other and create a glowing effect.

TIP: I save my pencil selections separately for my current project so that I don't have to guess in different lighting conditions about a new color. Likewise, it is best to display your painting in the same light in which it was created, as this will lessen the chance of distorted colors and values caused by inappropriate lighting.

Even if you apply an OMS wash with a tapping motion on top of this handmade mix, it will not combine all particles of both layers perfectly and evenly. Instead, it will pull particles closer together and cover the speckles of the paper between them, but it will still preserve the glowing effect. This is why handmade hues appear to be brighter

Here two manufactured colors (canary yellow on left and poppy red on right) are mixed to create orange. Notice how lively this handmade color is when compared with its manufactured counterpart below.

The orange color from a manufactured orange pencil, shown here, is flat compared to its handmade counterpart above.

than the same premixed color straight from the pencil. Particles of two colors that lie very close to each other, but are not perfectly mixed, intensify the brilliance of each other. That is why underpainting with yellow creates an imitation of light when followed by the layering process.

TIP: Unless you purposely intend to do so, avoid using several highlights with the same shapes and strengths in your composition. Artists who work with photographs created with a flash often struggle with this issue. Analyze your reference materials and fix any distortions by deciding on the shape and brightness of the highlights before you start to render them.

It is helpful to plan your entire composition in advance to see how the values and colors of the background will affect your foreground. For instance, if you finish your main subject and then attempt to merge it with a dark background, it could cause your main subject to look pale. The best approach is to work on the entire composition at the same time and not put it together as a puzzle, finished section by finished section. In other words, don't complete any one part of your composition until the very end of the entire process. This will allow you to adjust all of the values and colors as you go along. Always remember that a contrast in values emphasizes the illusion of light. This means that a dark surrounding makes light appear brighter. Think about how bright a fire looks in the middle of the night, and keep this in mind when you create your composition.

Objects that are closer to the viewer will have better defined edges. When an object is in the distance, its contours are often not clear, and they consequently appear to be out of focus. Beginning artists often have a tendency to outline objects and render well-defined edges even where they do not exist. For example, an apple doesn't have a well-defined edge, but rather a disappearing curve. So when you outline an apple, it loses its realistic appearance and looks more like a colored, flat shape. When you plan your composition, be sure not to draw a hard line between two values if you can't see one there. Instead, create values that change smoothly and morph into each other. This will bring dramatic realism to your rendering.

TIP: Because hard (well-defined) edges attract attention, a viewer is likely to spend more time looking at something that he or she can see clearly. To emphasize this effect, try to place hard edges near the focal point of your composition. Conversely, slightly blur edges in secondary areas of your composition.

Rendering Shadows with Colored Pencils

Shadows generally have the darkest values in a composition. They often serve as either quiet areas, where the eye can rest, or as backdrops or counterpoints to the focal point. Very often in reference photographs the values of shadows are distorted and either overdarkened by the camera (typical for cast shadows) or washed out by the direct lighting (typical for form shadows). One of the first tasks of the artist is to identify these distortions prior to the rendering and later adjust the shadow's appearance according to the compositional idea while preserving its realistic representation.

TIP: Don't be afraid to "push" the values in your work. Many beginning artist rely too heavily on middle values. In so doing, highlights are not light enough and shadows are not dark enough. This approach kills realism and makes forms look flat.

As I work from light to dark, I identify my shadow areas early in the process but bring them to a completion during the final stages of creating my painting. Cast shadows and form shadows are fundamentally different in their essence. Therefore, I approach the creation of each kind of shadow with slightly different methods.

While rendering a cast shadow, keep in mind that it is not solid but transparent and has its own colors and values. This fact is especially obvious in cast shadows that are produced under a weak source of light and thus have soft edges.

When creating a transparent shadow and working on white paper or a very light background, you need to produce dark values, and you don't have the luxury of many layers of pencil. Multiple layers of colored pencil would generate a solid color that is much too heavy. One approach is to use the powder-brushing technique and define the main shape and value gradation of the shadow starting with a gray pencil. (This technique is described in greater detail on page 58.) Gray will lower the value of the white of the paper instantly and allow you to apply a few layers of complementary colors and at the same time preserve the feel of shadow transparency. Whether the gray is cool or warm will depend on the temperature of the particular shadow, which in turn depends on the quality of the light in the image.

The following layer will be created using powder of various mixes of low-intensity complementary or close to complementary colors, gradually increasing the darkness of the shadow the closer it comes to the object. And finally, create powder from the pencil (or pencils) closest to the main color of the object and apply that powder to the cast shadow. The overall effect of the combined colors in the cast shadow should not be too bright.

Note that you can skip the gray pencil and start with a complementary mix if a cast shadow is portrayed against darker values than the white of the paper. In this case the mix of complementary colors will produce a dark enough range of values to represent the values of cast shadow.

TIP: Shadows will diminish the prominence of textures and details or, depending on how deeply these aspects of the object fall into the shadow, the shadows will cause them to be lost from view completely. So don't overwork the details in shadowed areas.

If you need a complete control over the medium when rendering a cast shadow area, you may find that the powder-brushing technique is not suitable. As an alternative, you could use a harder brand of pencil (such as Verithin) and work in light layers. This will prevent the surface of the paper

from becoming overloaded with large amounts of pencil medium that creates the effect of a solid, heavy color. Use the same approach in layering as was described above.

If you prefer to use only softer brands of pencil, work with a very light touch and then gradually add more layers to darken the values according to your composition. Using a colorless blender and OMS in between layers could help you to even out your strokes and achieve the transparent quality of the shadow.

TIP: Don't confuse your viewer by using too many light sources in your composition. The best situation allows one primary source of light and one set of shadows, all of which point in the same direction. Treat shadows as a part of your design, and don't let them overpower your composition. When a shadow has the wrong direction, value, or color you jeopardize the realism of the entire piece.

As mentioned earlier, in colored pencil painting if you want to preserve layering, it is easier to darken values than to lighten them. So to develop a form I usually start with lighted areas first (as they are the lightest) and gradually darken the local color by introducing first hues of the opposite temperature followed by complementary or close to complementary colors, as I get toward the shaded areas of the form and its darkest values. Adding complements to the main color makes it recede and reduces the intensity of the color. That is exactly the effect we want when representing a form shadow. Strong hues in shaded areas would compete with lighted areas and create confusion in the composition. (To see how complementary colors can be used to create form shadows, see the apple and pepper exercises, on pages 119 and 129 respectively.)

When the gradation in values of an object is almost invisible (i.e., when the edges between the values are very soft), I start with the lightest values of the object and continue to work all the way to the darkest. However, when there is a significant difference in the values (i.e., when there are distinct hard edges, patterns, or small details) and I want to avoid losing them during rendering, I begin developing the middle values first and create what I call a "value or color mapping."

With the value or color mapping approach, I identify the main color, middle value, of the object and mark the location of well-defined edges. Then, once I see what should be lightened or darkened, I adjust the values. I literally push them apart, gradually lightening and darkening them according to my composition. I lighten areas by pulling off value with mounting putty and other erasers and working with lighter colors. I darken areas by gradually adding colors with opposite temperature and complementary colors. Working in this manner, I am not in danger of overdarkening my values or dulling the color, as could occur by underpainting with complementary colors. Working from light to dark gives you total control when shaping your objects and preserves the brilliance of the color.

TIP: If you are portraying an object that should be in the background in your composition, add some blue to it. This will help to emphasize the illusion of depth in your work. Conversely, if an object is meant to appear in the foreground, add some yellow to it.

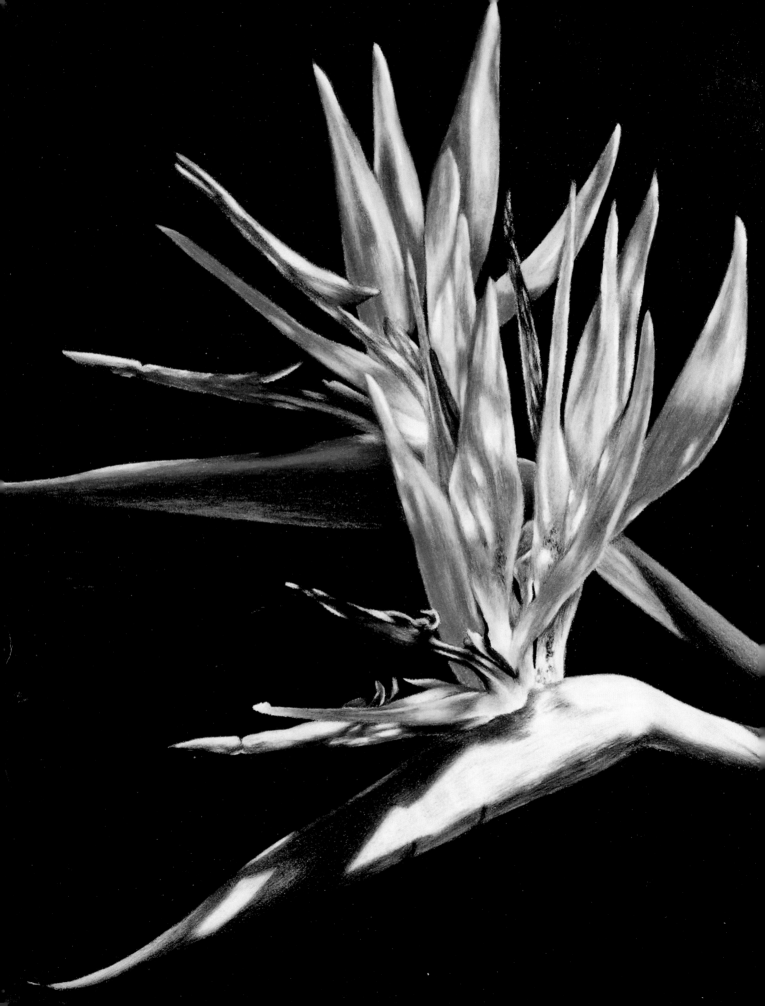

chapter

3

Mastering Essential Techniques

Many contemporary artists are so deeply engaged in the concept of self-expression that they have lost sight of the second vital part of being an artist—their craftsman skills. It is common these days to "express your-self" artistically by smearing some paint on paper or canvas and calling it an abstract image. Self-expression is an artistic privilege, and before moving into that realm you must teach yourself the hand-eye coordination to re-create with your hands that which your eyes can see or your brain can imagine. Only once you gain complete charge of your medium are you free to smear paint in the manner you had planned, not just in the way it happens to land upon the painted surface.

Colored pencil is an extremely versatile medium. It can mimic the effects of oil paint, emulate the look of pastel, create subtle washes like watercolor, and even breathe color like airbrushed acrylic. In addition to impersonating other artistic mediums, colored pencil is an excellent tool for rendering a plethora of artistic styles. To benefit from all of the potential features of colored pencil, you must have absolute control of the medium. This means that you need to understand the qualities of colored pencils and know the best ways to apply them. This chapter will provide a comprehensive survey of essential colored pencil techniques, techniques I developed after many long hours experimenting with the medium. I hope it will assist you in your own quest for perfection.

Alyona Nickelsen,
Firebird, 2004,
Prismacolor colored
pencils on 250 gsm white
Stonehenge paper,
8 x 11 inches
(20.3 x 27.9 cm)

The Basic Strokes

Colored pencil mediums require that you know the point of your pencil intimately. Should it be sharp, dull, or flat? Should it be hard or soft? This versatility is a prime advantage of colored pencils; it can give you absolute control over the medium, allowing you to render just about anything you can imagine.

A sharp point is very useful for covering the surface of your paper with an equal layer of pencil. This is a good technique to re-create smooth surfaces (such as a person's face), shiny surfaces, or delicate transitions between values. It is also quite handy when employing the blending technique, as discussed on pages 50–51. Remember that "blending" in this case doesn't mean literally smudging color, as one would with graphite or pastel. Instead, it means having two or more colors overlap each other. This creates the illusion of colors blending into each other, and a sharp point is instrumental in this process.

A dull point is useful for rendering textures that have prominent bumps or protrusions, as discussed with the roughening technique on page 54. Dull points are also great when working around areas with impressed lines and patterns, as described on page 55 with the scoring patterns technique. And finally, a dull point is good for creating textures that are not in focus, such as foliage in backgrounds (as can be seen in the small florets in the image on page 82).

The flat point of a pencil and the broad point of an Artstix are excellent for covering larger areas and for creating patterned textures. The effect would be similar to the way a wider flat brush would be used in oil painting. It covers areas quickly; plus, when strokes overlap they create a certain textural effect. These kinds of textures are appropriate for out-of-focus backgrounds and for abstract patterns and shapes. The flat point was used for rendering the background with the abstract pattern that appears on page 75.

In addition to the various pencil points, colored pencils come in two different kinds of density: hard (such as Prismacolor Verithin) and soft (such as Prismacolor Premier). Their use would be similar to that of graphite pencils with varying hardness (H, F, and B). The harder pencils provide a moderate deposit of pigment and a limited deposit of pencil binding medium (e.g., wax in wax-based pencils). This allows you to render hard lines, intricate details, delicate shadows, and the slightest transitions of value. Soft pencils are used for all other purposes in colored painting. You can see the difference in the layering with a hard point and a soft point in the illustration below.

Once you've established what kind of point is best suited for the purpose at hand, you'll need to determine what kind of pencil strokes you will use, as the direction of the pencil application will be visible. Approaches include vertical, horizontal, diagonal, and circular—or a mix of some or all of these. If you use a combination of strokes, you will be left with no visible direction and a more even coverage of the surface of your paper.

Layering with a hard pencil (left) provides a moderate deposit of pigment and a limited deposit of binding medium, while layering with a soft pencil (right) deposits significantly more of both.

Colored pencil painting shares some terminology with drawing. The basic strokes for artists who work with colored pencils are as follows:

Hatching Applying pencil strokes close to each other and in the same direction to cover the paper evenly with the color.

Crosshatching Applying pencil strokes first in one direction and then in the opposite direction to create a dense coverage and to preserve the direction of pencil strokes.

Striking strokes Applying pencil strokes with a heavy landing and a smooth takeoff from the paper. This is useful in creating various textures.

Circulism Applying colored pencil strokes in a circular motion to create an even coverage or a special effect.

The way you hold your pencil has a significant impact on how you control it. The closer you position your hand to the business end of the pencil, the more control you have. So, if you want to create fine details, hold the pencil close to the tip. Positioning your hand a little farther away from the tip of the pencil, however, creates more leverage and gives you the added freedom needed for looser strokes. And finally, positioning your hand toward the end of the pencil gives you wide amplitude of motion. It provides less control over the strokes and allows you to work almost in parallel with the surface of the paper. In addition, holding the pencil almost parallel to the surface of the paper allows you to create irregular coverage, as this allows the pencil to skip along the subtle hills of the paper and not dip into the valleys. This is valuable for some textural effects. Having a dull pencil point is especially effective for this purpose.

Hatching (left) and crosshatching (right) creates a visible pattern of strokes, which is a valuable component in the process of rendering textures such as fabric.

Striking strokes incorporates a heavy landing of the pencil point on the paper surface and a smooth take off. This kind of stroke is helpful for creating textural effects such as animal fur, grass, and so forth.

TIP: Attach your paper with artist tape to a portable surface so that you can move and turn the paper. This will make it a bit easier to apply strokes in various directions, which will help you to avoid the halo that may otherwise unintentionally occur around a subject.

Turning your work while rendering is helpful to avoid the halo effect (shown on the left) that is naturally produced by the motion of your hand when working around shapes such as the circle shown here.

Layering Colors

The layering technique is achieved by overlapping the manufactured pencils' premixed pigments, thereby creating the illusion of a different hue. A sharp pencil with a needlelike tip is commonly used for the layering technique. The paper surface is entirely covered with pigment in two ways: first, by applying pencil strokes very close to each other, and second by applying successive layers of different colors. Because of the translucent nature of colored pencil, each successive layer alters the appearance of the last one.

TIP: When removing artist tape from your artwork, always pull at an angle. Do not jerk the tape, and do not pull straight up. You could very easily tear the paper and ruin an otherwise perfect piece. Also, make sure that you don't leave artist tape on a painting for an extended period of time—especially if the tape is not acid free.

Controlling the pressure of the pencil is vital for colored pencil application. I have found that I generally use three levels of pressure:

Light touch This application, which occurs when you apply light pressure to the paper, deposits a minimum amount of pencil medium to the paper surface. I commonly use a light touch when I'm applying the first color of a layering sequence, rendering light values, or creating delicate shadings that require a smooth transition between values.

Normal touch This application deposits a good amount of pencil medium to the surface. I work with a normal touch when I'm rendering the middle values of a composition, working on

backgrounds, defining and rendering details, and so forth.

Heavy touch This application deposits a heavy coat of pencil medium to the paper. Usually I work with a heavy touch when I'm vigorously burnishing an area, working on the darkest values in a composition, or applying the last stages of a layering application.

Notice how differently pigment and wax are deposited when a light touch (left), normal touch (middle), and heavy touch (right) are used.

TIP: It is easier to erase a dark color applied with light touch than a light color applied with a heavy touch.

The swatches on the left and right show low- and high-density layers, respectively. Notice that the paper is visible when the strokes are not close enough together.

Using the layering technique with colored pencils is similar to using the glazing technique with oil paints, but without the need for drying time between layers. The translucent quality of

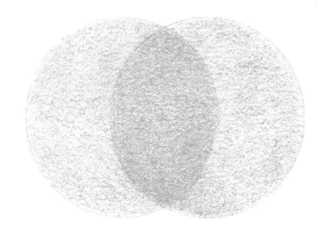

As a result of the optical blending of two manufactured colors, we not only have a new color, but also a darker value and denser coverage.

colored pencils allows initial layers of pencil to change the appearance of subsequent layers. In addition, each layer can have a different density of coverage, giving the artist even more artistic control. (Of course, while I use the terms "light, normal, and heavy touch," measuring the pressure behind your pencil application is not an exact science, and in practice you can press slightly heavier or lighter as necessary.)

Layering white or other light pencils (such as cream, cloud blue, pale sage, and so forth) makes the surface of the paper more even, which can allow subsequent layers to appear smoother. This, however, will change the value and color of those subsequent layers, so it is advisable to try this technique on a piece of scrap paper first, using the colors that you think you want to use for your final rendering. You might want to save these swatches for future reference, so make notes about the colors that you've used (and in which order).

TIP: Wax-based and oil-based colored pencils work together perfectly with the layering technique. You can substitute colors, mix colors, and layer colors on top of each other.

Working with Wax-based Pencils

If you're working with wax-based pencils, there are three things to keep in mind:

First, wax-based colored pencils, of course, by their very nature, contain wax. After heavy working, wax has a tendency to create a milk-like film, called a "wax bloom." This usually occurs as a result of heavily burnishing an area or applying multiple layers, but it is nothing to worry about. You can fix wax bloom easily by gently wiping the surface with a tissue and then spraying it with a workable fixative.

Second, if the temperature is high in your work area, your wax-based colored pencils will tend to become soft and will deposit more pigment and wax on your paper, even if you apply a light touch. Conversely, if the temperature is cool, the colored pencil cores harden and deposit less wax. This occurs simply because wax softens with heat and hardens with cold. (See page 9 for information about a product that enhances this characteristic.)

Third, by polishing layers of wax-based pencil with a regular tissue, you can give a glossy look—either to a select area (such as the background) or to the whole composition—at the final stage of rendering. However, be careful not to polish the early stages of a layering process. If you do, the surface of the paper will become slick, making it difficult to apply additional layers. This could also create an uneven gloss effect that is very difficult to fix. So leave any polishing to the very end.

Fusing Colors

While the layering technique involves a visual blending of colors, the fusion technique encourages the colored pencil pigments to be physically blended. Colors can be fused in a number of different ways, using solvents (such as odorless mineral spirits, OMS), a colorless blender, or a combination thereof. Of the various solvents (discussed on pages 6–7), I personally prefer using OMS.

TIP: Solvents occasionally cause a slight change in some colors. So it is always best to test colors and solvents on a scrap of paper to see if the colors shift.

OMS dissolves visible pencil strokes and enhances the colors. However, before using OMS, make sure that your pencil strokes have been applied in a manner that is conducive to the success of the color fusion method. A rule of thumb: The farther away the pencil strokes are from one another, the more difficult it will be for them to melt together. You will not need a great amount of OMS. When I refer in my demonstrations to an OMS wash, I don't literally mean to wash the paper with the solvent. I mean to sparingly and evenly apply OMS to the area being worked. OMS can be applied with the following tools:

Cotton pad This is recommended for larger areas, such as backgrounds, skies, and landscapes, or if you just have a considerable area of solid colors to apply.

Q-tip This is recommended for smaller areas and for curves or corners.

Waterbrush This is recommended for tiny areas or for when you need to be very measured in your application of OMS.

Regardless of the tool you choose, it is best to use a gentle tapping motion to dissolve the pencil strokes. In this manner, you can apply OMS over multiple layers of pencil without destroying the layering effect. When applying OMS, avoid uneven pencil coverage of the surface, as this creates blotches of color that will be difficult to even out later. And remember that solvent can dissolve your pencil layering if it is applied too liberally or if the area is rubbed too vigorously. I apply the

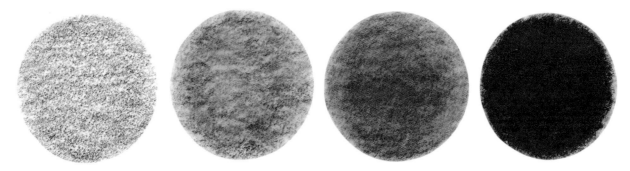

These swatches demonstrate the effects of different applications of OMS. The first circle is unmodified pencil. OMS was applied with a tapping motion to the second circle and with a rubbing motion to the third circle. OMS and then a second layer of the same color were applied to the fourth circle.

This sequence demonstrate the effects achieved by applying OMS in conjunction with a colorless blender. First, colored pencil is applied to the swatch in one dense layer.

Then, a second layer of color is added. Notice that the first layer of pencil is visible through the second layer.

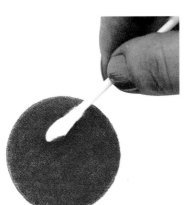

Next, an OMS wash is applied with a Q-tip. Notice that the pencil dissolved immediately and the paper under the layer was covered instantly and completely, as it would be if paint were used.

Finally, a colorless blender is used to fuse the two colors together. The result was a unified, but not solid, color. However, notice that the layering effect was destroyed.

wash fairly often when I am working on lighter values, when I need to show a smooth transition between colors, or when I mix different hues.

TIP: If too much pressure is applied with the colorless blender, it could destroy the tooth of the paper by essentially flattening it.

OMS dries with no trace in about twenty minutes and, if properly used, doesn't destroy the tooth or texture of the paper. However, if you apply colored pencil to paper that has been recently washed with OMS and that is not yet completely dry, you could end up with the surprising result of a melted pencil effect. This could cause you to apply an overly heavy layer of wax even though you may not be adding extra pressure.

The second option with the color fusion technique is to use a colorless blender. This is a great tool for physically mixing colors, smudging edges to create a blur effect, or smoothing layered pencil strokes. The colorless blender works best when you have quite a few layers of pencil on your paper or when you want to engage in heavy burnishing.

And the third option is to pair OMS with a colorless blender. (OMS softens the binding of the colored pencil core and a colorless blender works as a mixing tool.) Used together, these two tools perfectly complement one another to physically blend layered colors, producing a single, solid color. Success is most readily achieved in this manner when a number of layers of pencil have been applied.

TIP: Typically, a colorless blender works well only when you have quite a few layers of pencil. However, after solvent has been applied a colorless blender performs perfectly even with only one or two layers of pencil.

Working with White

White pencil is a vital tool in colored pencil painting. It is widely used for burnishing colors, lightening values, smoothing out pencil strokes, and creating highlights. The paradox is that white pencil is used least for rendering the color white.

Burnishing Colors

Burnishing is the process of applying a heavy layer of colored pencil to create a saturated color and a smooth surface. (Depending on your needs, you can use white or any other color pencil for burnishing.) After burnishing an area, it is difficult to apply more layers of pencil—as the paper tooth will be completely buried under the pencil medium, and the point of the pencil will slick away from the paper. Spraying the surface with workable fixative will allow you to add one or two more layers of pencil. Burnishing is very handy to show a smooth surface in your composition.

Burnishing with white pencil (right) produces smooth and even coverage of the paper. It also lightens the value of the original layer of orange (left).

Lightening Values

White pencil can be used to lighten the values in your rendering. However, sometimes white pencil can create surprising (and not always pleasant) results, depending on how it reacts with the previously applied colors. For example, when white is applied to the color red, it will create pink instead a lighter value of the same red. So please

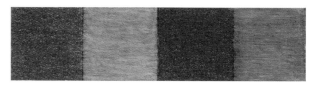

When using white pencil to lighten values, make sure that there are no unexpected shifts in color. Remember to try it first on a scrap of paper. (Notice in this example how the reddish orange lightened well with white, but the red turned a surprisingly light shade of pink.)

remember to experiment first on a piece of scrap paper to determine how the white will affect the targeted color.

Smoothing Out Pencil Strokes

When applied lightly, white pencil can be used to smooth out and unify your pencil strokes. Pencil strokes may appear to be uneven because uneven pressure was applied during the layering process, and therefore the resulting deposit of pencil medium are uneven as well. You can smooth out this unevenness either by adding another layer of colored pencil in the same (original) hue to bring the entire area to a darker level or by using white pencil to lighten the darker strokes and make the entire area lighter. When using a white pencil, make sure not to press too hard, as this could shift the value of this segment too much. If you

When using a white pencil to smooth unevenly applied strokes, keep in mind that the overall value of your rendering will be lightened.

just briefly touch the pencil strokes that are darker with the white pencil, you will achieve smooth coverage of the area.

Creating Highlights

White pencil can be used to create highlights on an object. This effect can be very useful in some cases, such as creating a shiny glare on a glass or the fogginess seen on some fruits. You should note, however, that using white pencil can sometimes lead to dulling the color and conferring a milky look to the surface. If you are not happy with the result of your efforts and would like to restore the brilliance of the original color, just reapply the previously used color, and it will shine again, just as it did before.

White is as translucent as any other colored pencil. Therefore, it will not completely cover previously used colors. So white will not work, as it would in opaque oils, to create a bright highlight on top of an object with a dark value. Usually, this highlight will be darker by a few values than it should to be. To create the brightest highlights, you must either preserve the white of the paper, which is the best option, or use an opaque medium, such as white color from Caran d'Ache's Neocolor II (which is a water-soluble pencil). This white still will not be as bright as the white of the paper, but it is brighter than the translucent white of colored pencil.

Highlights can be rendered in a variety of ways: by preserving the white of the paper (left), by applying white pencil on top of a dark layer of color (middle), and by applying white Neocolor II on top of a dark layer of color (right).

Rendering White Objects with Colored Pencil

In the real world, pure white is created by an equal mixture of all visible wavelengths of the light spectrum. However, in art white is a very tricky color to render realistically. You can make a white subject by showing its shape and volume using a range of gray pencils, but this yields a monochromatic picture where variations of values, but not colors, are exhibited. So how do we imitate white using color? The answer is simple, though a little confusing. You need to mix equal amounts of the three primaries—red, blue, and yellow.

When rendering a white color it is better to start with low-key colored pencils and work from light to dark, slowly building the values and the intensity of the color. In this manner, if any of the three colors is overpowering others, you can easily adjust it without worrying about overdarkening the subject. For the lightest values, you need to use harder pencils (such as Verithin). This will help to reduce the amount of pigment that gets deposited on the paper and will provide a smooth transition to heavier loads of pigment for darker values.

Lighted areas of a white object would normally be rendered in warmer colors, while the cooler colors would be used in the shadows. The intensity of the colors will depend on the lighting situation. The more contrast there is in the lighting, the more intense the colors should be to render the object. I have included a few examples of handling white subjects later in the book; see white petals, pearls, lace, paper, and eggs on pages 84–85, 98–99, 106–107, 150–152, and 153 respectively.

Roughening the Paper

Colored pencil artists, like other artists, commonly struggle to depict textured surfaces such as orange peels, avocado skins, and the like. It takes a great deal of time to draw around each and every bump. After a few battles of my own with oranges, I determined that there must be a better way to solve this problem. I experimented extensively and came up with the roughening technique. This approach helps create a believable rendering of complex textured surfaces in a comparatively short period of time.

The main principle is to give more texture to certain areas. Begin by placing a surface with a random (or otherwise desirable) pattern underneath your paper. Then, rub the top of your paper with a smooth object. This will leave impressions on your paper. You may think it would be easier just to use a paper with a rough surface, such as those papers that are commonly used for pastel drawings. This might be true if your composition consisted entirely of a specific texture, but what would you do if your composition combined a smooth surface and a rough surface? Of course, the answer is to rough up the paper.

The process is simple. Use a pumice stone or other relatively flat object with a rough surface. Place the object under your paper. With a tool, such as the convex side of a spoon or a wooden sculpting tool, press against the top of the paper. This will create impressions that follow the texture of the surface of your object. Use only clean tools to prevent soiling your paper, and be careful when pressing not to puncture or move the paper. If you want to increase the texture, apply moderate pressure.

You are already halfway there. Your paper now has more "tooth" where the roughening took place. When you render the rough part of your composition, make sure that you hold the pencil almost parallel to the surface of the paper. The point of the pencil should be dull. This will help you skip over the bumps of the paper and create the rough look of the textured area. After applying a few layers of color you can wash it gently with odorless mineral spirits using a tapping motion. This helps to get rid of the white of the paper and smooth out the color transitions. Let the paper dry, and then continue to apply more layers in the same manner.

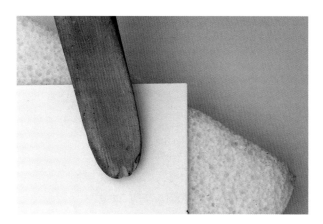

The roughening technique can help create complex textures. First, create indentations on your paper by placing it on a textured surface and rubbing the paper with a smooth tool.

Second, using the side of a blunt pencil, rub back and forth on the roughened paper. This can be modified wih odorless mineral spirits and additional layers of pencil.

Scoring Patterns

Using line and pattern impressions are other useful techniques. They can help you with such challenging tasks as leaving a fine line of light color on a dark background. This can be used to create highlights on hair or animal fur, veins on leaves, the tiny pattern of strawberry seeds—or even emphasize your signature. The approach is simple and, in essence, is like a reversed version of the roughening technique. First, you impress the line, shape, or pattern onto your paper. Then, when you apply your colored pencil, the scoring will become visible. The brightness and color of the impressed lines or patterns can be regulated during the latter stages of colored pencil painting.

Here is how this technique works: The pattern scoring technique requires tracing paper or some other semitransparent paper and either a stylus pen or a ballpoint pen. First, place the tracing or semitransparent paper over the area of your paper that you are planning to impress. Then, apply moderate pressure to the paper layers with the ballpoint or stylus pen to make the desired line or pattern. Once you have created the impressions, you can apply colored pencil in the usual manner, but when coloring the areas of impressed lines or

patterns, hold your pencil almost parallel to the paper surface. This will allow the pencil to skip the impressed lines and leave the area free of color. Later in the process you can apply color or adjust the value of the impressed lines or patterns using the very sharp point of a pencil.

TIP: To fix incorrectly made lines or accidental scratches produced during the pattern scoring technique, apply the color that surrounds the line until it matches completely.

If you wish to create a pattern in a color other than the white of the paper, simply apply the color on your paper first and then create the impressions, but remember that this color will be the first layer of the background of your impressed pattern and will alter the colors of subsequent layers. So plan accordingly.

Next, holding your pencil parallel to the paper, rub around the area that you have scored. This will reveal the impression.

The pattern scoring technique can be used to render highlights or fine lines. First, place a piece of tracing paper over your paper, and then draw the desired pattern.

If you want to remove a highlighted area, simply go back over the impression with a pencil identical in color to the surrounding background.

Negative Painting

The negative painting technique is helpful when you must render small details against a dark background, as it allows you to create the background first and then subtract (erase) the details, rather than work around them. Of course, you have to keep in mind that colored pencil layers will never erase entirely. There will be a slight coloration (about 10 to 15 percent of the original layering), especially if multiple layers have been applied and burnished or fused with a colorless blender and OMS. If you require large, white areas against a dark background, it is better to preserve those areas with masking fluid or masking paper rather than attempt the negative painting technique. For the thin lines and tiny highlights, the sgraffito technique (discussed on page 59) is the best option.

Before I discovered colored pencils, I used to draw a lot with graphite pencils, and I often used a negative drawing or erasing technique to lighten values and create various shapes and lines. This was pretty easy to do with graphite, since regular erasers work well, but with colored pencil painting, this technique seems to be somewhat challenging. In the first place, colored pencil does not erase well. (A regular eraser simply smears the colored pencil and can ruin your painting in very short order.) However, it is definitely possible to use this technique with colored pencil. You just need to use tools that are appropriate to the medium.

My favorite tool for erasing colored pencil is Magic Tape. With this tool I can erase colored pencil almost completely, exposing the white of the paper. When working with this technique, it is helpful to keep your roll of Magic Tape on a dispenser, as this will help you cut pieces of tape with minimum effort.

The procedure is easy: Cut a small piece of Magic Tape, hold one of its ends with the fingers of your left hand (if you are right-handed like me), and apply its free end to the spot on the artwork that you wish to erase. Then, holding a graphite pencil or a ballpoint pen in your drawing hand, rub over the Magic Tape back and forth until you have covered the entire erasing area. Lift the tape with

Working with regular graphite pencil (or a ballpoint pen) over a piece of Magic Tape allows you to see what will be erased.

Using the right erasing tools (such as Magic Tape), you can erase up to 90 percent of colored pencil application.

a slight angle. (To prevent damage to the paper, don't jerk the tape.) You will notice that the pigment has stuck to the adhesive of the tape and that the erased area is much lighter.

You can repeat this process as many times as needed. If only light erasing is required, you can reuse the same piece of Magic Tape. For more aggressive erasing of an area, however, you should use a fresh piece of tape.

Alternative erasing tools that work well for using the negative painting technique with colored pencils include kneaded erasers and an extremely useful substance called mounting putty. Kneaded erasers are less tacky than mounting putty and are only appropriate for erasing the first few light layers of pencil or for lightening areas of your work. Make sure that you do not drag the kneaded eraser across your painting or rub the paper, as you would when erasing a mark made with graphite. Colored pencil requires a slightly more restrained, but equally simple, technique. You just dab the kneaded eraser onto the surface of the paper and pull up the pencil deposit.

Mounting putty has more tack than a kneaded eraser, but it can be used the same way. Mounting putty has the added advantage, however, of being able to be used in later stages of your painting, when you are dealing with more layers of pencil medium. When you apply mounting putty to the surface of your paper and pull it straight up, it will make a popping sound. Don't forget to knead the eraser before the next application.

Mounting putty is also an excellent tool for lightening values. When using mounting putty for this purpose, simply roll a small piece of putty into a cylinder or sphere shape and glide the putty across the area you want to lighten. Be sure to knead the putty between rolls to avoid reapplying the pencil residue you just removed. Glide the putty over the surface as many times as needed to enhance the lightening effect.

Using Kneaded Erasers and Mounting Putty

While kneaded erasers and mounting putty are effective tools when working with the negative painting technique, they also serve two additional purposes for the colored pencil artist: First, both tools are useful for cleaning up an area of your drawing when a drafting brush is not appropriate. Second, you can use mounting putty to create random spots. For this you have to separate small balls of mounting putty in desirable sizes. Create the background color you need. Dab one of the putty balls onto the surface of your drawing. Lift it up and you will have a lighter area with a slightly irregular shape. By aimlessly applying the various sizes of putty you will begin to see a random configuration emerge. Then, by alternating the shapes and sizes of the mounting putty, you can overlap the lightened and colored areas to achieve amazing effects. I have included a demonstration of this technique on pages 74–75, using mounting putty to create an out-of-focus background.

Some artists I know use an electric eraser to remove layers of colored pencil. I personally do not use an electric eraser for this purpose. From my experience, electric erasers do more to damage your paper and destroy its surface than to clean it. So far, this tool has been useful only to smudge colors together and create patterns.

Powder Brushing

When your composition has a large area that requires delicate transitions of values, I recommend using the powder-brushing technique. This technique utilizes powder created by filing either a traditionally shaped colored pencil or an Artstix pencil. This powder, when applied in multiple, exceptionally thin coats, creates an almost airbrush-like effect.

The tools required for this technique include a metal tea strainer, cotton pads or Q-tips, odorless mineral spirits, and a few small plastic or glass containers (preferably with covers) to preserve the leftover powder. Some artists use a knife when they want to collect pigment samples from their colored pencils. The problem with this approach is that a knife creates unevenly sized shavings. (By contrast, a metal tea strainer creates a powder, which has evenly sized particles.) When large and small particles are applied to a surface at the same time, the larger particles tend to create hard lines rather than the diffused line or shape intended. This is why I always use a metal tea strainer for the powder-brushing technique; furthermore, I have found that a metal tea strainer works much better than a flat file, rat-tail file, sandpaper, or any of the other tools I have tried. Because of the way the metal mesh on the tea strainer is placed, the powder slips through the spaces into the collecting container, and, when applied to paper, the powder doesn't leave buildup on its surface. It is also easy to clean with a stiff toothbrush or small metal brush.

After you collect enough shavings of the particular color that you need, use a dry cotton pad or a Q-tip to apply the pencil powder. Using a circular motion, gently rub the powder into the surface of the paper. To achieve delicate transition of color, make sure to use very light coats of the powder. If necessary, you can use odorless mineral spirits with a clean cotton pad to dissolve any unwanted lines or blotchy spots of color. Let the surface dry, and continue to apply additional coats of the same color, or new colors, as desired. This will give your color depth and will allow you to change the value.

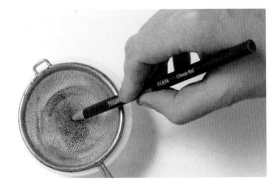

A household tea strainer is the perfect tool to create powder—either from colored pencils or an Artstix pencil.

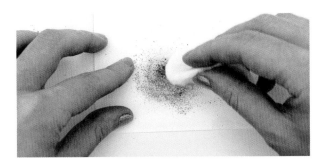

Use a cotton pad or a Q-tip to apply the colored pencil powder. For delicate value transitions, apply powder using a circular motion and don't press too hard into the paper.

To darken the values, reapply more powder. Powder brushing also allows you to create diffused and soft edges.

Sgraffito Rendering

Shiny materials—such as crystal, glass, chrome, gold, and silver—have numerous highlights. As these bright spots attract the attention of viewers, such materials are often included in still-life compositions. However, the complex patterns created by the light and its reflections are difficult to render. Values can morph into one another or be in contact with one another. Dull and vivid colors are neighbors within the tiniest areas, and myriads of bright highlights shower the surface.

The best approach to this task is to visualize the highlights of the object as an abstract pattern. Because colored pencils can be sharpened to create a hard, sharp point, the intermediary values featured within the object are not difficult to render. You just have to be patient and carefully follow the pattern of the glass, crystal, metal, and so forth. The highlights, however, can pose challenges for the colored pencil artist. For larger highlights, it is easy to preserve the white of the paper by masking the area with masking fluid, but creating smaller highlights can be a tedious task—especially when they appear in clusters, as these might require the artist to draw around each of them.

TIP: When using an X-Acto knife, be careful not to cut too deeply into the paper, as you could end up with a hole in your painting. To avoid this, keep your knife at an angle that is close to the surface of the paper.

To simplify this difficult task, you can create small highlights using the sgraffito technique. This involves scraping away layers of colored pencil with an X-Acto knife and letting the white of the paper show through. Various highlights that can be rendered with the sgraffito technique include thin bright lines against dark backgrounds, cracks, and highlights on hair or fur. Of course, to prevent the deposit of colored pencil residue over the highlighted area, this technique should be employed as the final touch at the end of the drawing process. Notice the smallest highlights on the glass of water in the image on page 91 as well as the tiny hairs on the tomato stem in the image on page vi.

TIP: The more layers of pencil that have been applied to the paper (and the darker their values), the more prominent the highlights scraped off by an X-Acto knife will appear.

With the sgraffito technique you can create various shapes and sizes of highlights.

Using Photographs for Maximum Impact

I personally champion a realistic rendering style, so this book is all about realism. However, when you look at my original artwork you can see evidence of the human hand. My work is not photorealistic or painting over a photograph. (I don't have anything against photorealism as a type of art or coloring over photographs and calling it so; it is just not my personal venue.) However, I do use photographs as reference for my artwork.

The practice of using photographic references during the painting process generates endless debates among artists. Some go as far as to label this practice "cheating" and call the results "not true art." I personally think that artists commonly confuse judgments about someone's personal artistic skills with assessments of the quality of the final artwork that that person creates.

Drawing from life and making sketches help us sharpen our personal artistic skills, enabling us to transfer an image of a three-dimensional subject onto a two-dimensional surface. Similarly, drawing from photographs helps us to develop the skill of transferring a two-dimensional subject onto a two-dimensional surface and, hopefully, simultaneously making it look three-dimensional, which is not an easy task.

Using certain tools and techniques cannot diminish the value of your work. To use photographic references successfully, you need to have an excellent knowledge of your subject; otherwise you wouldn't be able to correct all of the distortions created by the camera. Drawing from life will help you possess this knowledge. If you don't have this knowledge and you choose to draw from photographs, you will be forced to guess, and this will lead to mistakes. The number of mistakes you make during the creation process will be a measure of your skills as an artist. How you gather this knowledge and develop your skills is up to you.

Skeptics might say, "Where is your creativity as an artist when all you are doing is copying a photograph? Doesn't this practice make you just a copier?" My answer is simple: We are all copiers, and creativity is in the creating.

Yes, we are all copiers to a certain degree. Some copy what they see. Some copy what they interpret. Some copy what they feel or hear, showing it through the visual collaborations of abstract colors and shapes. We all copy on paper or canvas what we can sense, visually or otherwise, but all of our artwork is a copy of what we have in our minds.

Consider the following aspects of the creative process of copying photographs: We artists take photographs in order to create our composition. We create our vision and copy our thoughts by way of the camera. Transforming the image—from the photograph to the blank piece of paper—is a test of our mastery of the craft. The better we can execute this transformation, the clearer the message will be for the observer.

While I am comfortable using photographic references during my creative process, I always take my own photographs. There is nothing wrong with being inspired by someone else's art or idea, but this is very different than copying someone else's artwork outright and then presenting the final work as your own. The latter practice is strongly discouraged, on legal and moral grounds.

Transferring Images to the Paper

As mentioned, I do use photographs at the beginning of my creative process. However, I use them as reference only. I call the hands-on aspect of my creative process "colored pencil painting." This is entirely different from coloring over printed reference material, retouching a photograph, or other similar processes where a photograph is used as a part of the artwork.

When I am struck by a subject that is begging to be painted or when an idea pops into my head about a potential composition, I grab my camera or sketchpad and save those ideas, either in digital form or on paper.

If I begin a composition with a sketch, the next step will be a physical restoration of the thought. This includes gathering objects, choosing a light source, and setting it up. Then I proceed with a photography session, which typically progresses in three or four segments with viewing, sorting, and analyzing files in between.

Sometimes capturing my original inspiration takes long hours and hundreds of photos. After the general assembly is done, I begin adjusting details such as the position of the objects and the direction of the lighting. The cumulative result of this plethora of small decisions is the final photograph, which I call my "reference image." Notice the adjustments that I made to the image in the sequence on pages 62–63. The final image contained a good range of values. However, in my rendering I decided to adjust the brightness of the background. A step-by-step sequence of rendering the final painting, *Orange Thoughts,* appears on pages 124–128.

Expressing an image in a realistic style requires close attention to detail and precision with the rendering of all elements. It is challenging to capture the true appearance of an object— its perspective and proportions, colors and values, edges and shadows, imperfections and results of weathering and age. You can't successfully fake your way through such an intricate process; you must have a true understanding of the nature of all parts of your composition, including highlights, foreshortenings, and textures. You have to be able to logically look at every area of the composition and understand the physical relationship between the subjects, their relative positioning, the way light hits each surface, and so forth.

Use of bad photographic references, combined with a lack of understanding of a subject, could lead to a failure in your ability to render a composition realistically. Therefore, it is advisable to hedge your bets. Starting with good reference images and making life-study drawings of your composition will minimize the number of guesses you will need to make during the process—and will ultimately result in a stronger image.

I've often heard that a good artist can create a true masterpiece from any reference. While this may be true when speaking of subjects other than realism, realism needs to refer to reality. If a bad reference is the only connection you have to reality and you don't have specific knowledge about what makes the image bad (and therefore what you can do to fix it), the resulting painting is likely to be, well, bad realism.

TIP: If your photograph shows a weird angle of the subject and is likely to confuse the prospective viewer of your artwork, pick a better position or an angle that is less confusing.

I rarely use the digital image in its original form for my work. Alterations are almost always necessary. These may include adjusting the cropping, enhancing the brightness, contrasting the color, uncluttering the composition, combining subjects from multiple images, fixing camera distortions, and so forth. Keep in mind that there is a significant difference between images that your eye and brain interpret and images that are coming from the camera, computer, or printer process. To match exactly what we see in life with what comes from the printer we need knowledge and experience in photography, computer-image manipulation, and the printing process. It is advisable to read as much as you can about photography and computers and take classes taught by experts in these subjects. A lack of knowledge about these processes will create imperfections in your references that could reflect in your artwork.

Basic knowledge of a graphics program such as Adobe Photoshop will be very helpful when you are manipulating your references and improving your composition. If you need to crop the picture, simplify the background, or combine two pictures together, it is often much easier to perform these tasks in Photoshop than to manipulate objects in your set. Also you can easily adjust brightness/contrast, hue/saturation, color balance, shadow/highlight, and so forth in your photograph. If the overall picture is too dark or too light and the details in the shadows or highlights do not show, you can adjust the picture or just print the same reference in lighter and darker versions so that the details are clearly presented.

TIP: When using more than one photograph, always keep the light source and shadow direction in mind. Even the most realistically rendered selection of objects will be unconvincing if the shadows are not consistent.

Once you've adjusted the basic compositional elements and lighting of the image, the next step is to analyze the photograph: to see where the

I was not happy with this initial photograph because the image was overexposed. I also didn't like the position of the orange, and the peel was too crunched together.

I repositioned the setup for this image, but I was still not satisfied. There was not enough contrast between the shapes and curves, and the peel was too dark inside.

camera may have distorted or flattened the image, created hot spots, focused on the wrong area of the composition, and so forth. Here are some of the most common distortions produced by a camera:

Misrepresentation of perspective When perspective is incorrectly captured with a digital image, your task in Photoshop is most often to straighten lines. For instance, a horizon should be horizontal and repeated lines that are perpendicular in real life should appear at a logical and consistent angle in your photograph.

Misrepresentation of proportions Look for exaggerated sizes and foreshortening of objects and their parts in your image. For instance, a head or hand that was closer to the lens may appear to be excessively large in your digital image compared to a body that was farther away.

Incorrect depth of field Sometimes objects seem to be too close to each other in digital images than we originally indented to show them. Normally, objects that are close to the viewer

My third attempt provided an almost perfect reference for my idea of depicting a "thinking orange." The similar shapes created a pleasant arrangement without being monotonous.

should be in focus, and therefore their edges should appear crisp. Conversely, objects that appear at a distance should be out of focus, with blurred edges.

Altered values Look for overdarkened or overlightened values on subjects in your digital images and adjust these accordingly. Often photographs created with a flash contain overdarkened shadows and hot spots on highlights.

Modified colors Look at the colors in the image to see how the shades compare to the original objects and adjust accordingly. Pay particularly attention to the look of white in a picture to ensure that it doesn't have too much blue, yellow, or red in it.

When it is impossible to fix a photograph by manipulating it in Photoshop, I make notes to myself about the problems and fix them during the painting process. After I am satisfied with the picture I see on my computer monitor, I print the image large enough to see the details and to determine whether I am satisfied with the colors. This is a very important step. The photograph will become the mold from which I will create my artwork.

Some artists attempt to minimize their use of photography, pointing out that they use only part of the photograph as reference material. All the rest is their interpretation. Still other artists liberally use the term "artistic license" when they really mean that they attempted to render an image and it didn't end up as they had planned. Style should be a matter of intent and not the result of an accident. And the term "artistic license" should not be used to excuse a lack of skills; "artistic license" is properly used when a particular effect is intentional, such as a rendering of an object that deliberately deviates from realism. Many artists—particularly those whose work is classified under impressionism, cubism, and many other "isms"—

have interpreted reality or their internal worlds in unique and intentional manners. These approaches provide stark contrast to realism, which aims to represent items in a manner based on reality.

It is now time to create an outline for the future colored pencil painting. Some artists are afraid that the word *tracing* will sound unprofessional and lower their credibility. I think about tracing my own photographs as nothing more than another step toward positioning my composition on the paper. A good analogy might be to compare tracing an image with using a compass. Every time you use a compass you perform an act—the end result of which is that you have a perfect circle in the shortest possible time. Now, try to create a circle freehand. If you don't have the necessary skills, you will spend quite a bit of time making the circle, and even so it might not be perfect. With practice, it will take you less time and effort to get a perfect result. If you use a compass, you will have that circle in no time, but it will not help you develop your freehand drawing skills.

The same is true with tracing. Tracing in and of itself will not diminish the value of your artwork; however, it also does not help you develop your drawing skills. It is just one of many preliminary steps in the creative process. By contrast, sketching from life trains your hand-eye coordination, and the act of sketching must be part of your growth as an artist. Does this mean that you need to sketch every object every time? I don't think so. In my opinion, it doesn't matter what methods, tools, or shortcuts an artist uses to create his or her artwork as long as the desired outcome is achieved.

Here are few methods to help you create an outline on your paper.

The Grid Method

Cut a piece of clear acetate to the size of your photograph. Mark the acetate at regular intervals (e.g., 1 inch or 1½ inch), both horizontally and vertically, so that the acetate is ultimately divided into squares. Use a graphite pencil and a light touch to draw the same number of squares on your paper. If your photograph is the same size as your painting, make the squares on the paper the same size as the squares on the acetate. If your paper is larger than the photograph, you will need to increase the size of the squares accordingly; if the paper is smaller, the squares should be smaller. Moving from square to square, copy all of the shapes and lines in each square on the photograph to your drawing paper.

Pros: This method is traditionally considered not as shameful as tracing over a light box or using a tool like Photoshop. It teaches hand-eye coordination skills as well as how to render an image from one two-dimensional surface to another. It works well for enlarging images, as you would do when transferring a small sketch to a large canvas in preparation for making an oil painting.

Cons: This method takes longer than tracing, and if you don't have strong drawing skills, it can be less accurate. In addition, you have to erase the grid from your final drawing; if you have drawn the lines too heavily, you may have accidentally impressed lines on the paper, which can cause problems when additional layers of colored pencil are applied. It also does not teach any freehand drawing skills.

The Light Box Method

Place your photographic reference on a light box, and position your paper on top of the photograph. You might want to use artist tape to secure each layer. Turn on the light box. This lets light shine through the photograph, allowing the basic outline of the image to be visible through the paper.

Using a graphite pencil, trace the image. If you don't have a light box, then an alternative transparent surface (such as a window, glass, door, or spare piece of glass with the edges taped) set up in front of an alternative light source can be used instead.

Pros: This is much faster than the aforementioned grid method, and it does teach some hand-eye coordination.

Cons: This method doesn't teach drawing skills from life, and it also doesn't work if you are using one of the thicker papers.

The Photoshop Method

Using Photoshop you can simplify the entire tracing process by completing the following steps:

1. Open your picture in Photoshop.
2. Click the Filter menu then choose Stylize and Find Edges from the menu.
3. Save the new image in the same folder as the original image.
4. Print the image on regular paper, and use it as a working sketch. (Note: Do not print the outline directly on your final paper, for two reasons. First, the final image will not be a pure painting; it will be considered mixed media, collage, or something similar, which may disqualify it from certain juried shows. Second, remember that colored pencil is translucent and the ink from the printer will shine through the lightest values of your painting, even if you print it very lightly; it is not possible to erase or correct printed lines later in the process.)
5. Transfer this outline onto your drawing paper, using the grid method, the light box method, or a sheet of graphite transfer paper. The last approach is my favorite, and the one I demonstrate throughout the book. To do this, simply place a sheet of graphite transfer paper between the outline and the paper that you will use for your final painting. Using a regular ballpoint pen, trace the outline.

Pros: This method speeds up the transfer process tremendously. You can reuse an outline over and over. It is the most accurate of the three methods described, and it works with any paper.

Cons: This method does not teach any freehand drawing skills, and the hand-eye coordination skills taught by this method are minimal.

When using the Photoshop method, first, print the outline of your image on a regular sheet of printer paper.

Then, using a sheet of graphite transfer paper and a ballpoint pen, trace the outline onto your drawing paper.

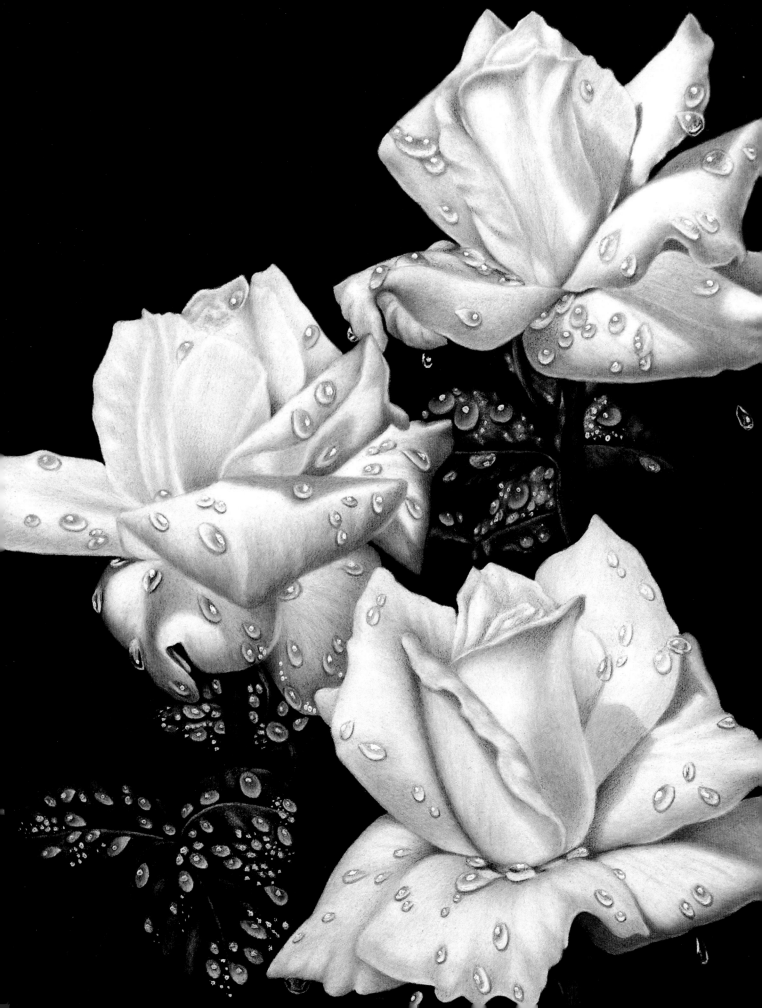

chapter

4

Creating Textures and Surfaces

Textures play a critical role in realistic rendering. There is more to an orange than just the orange color and round shape. A correctly rendered bumpy and irregular texture will provide a more convincing representation of this fruit than would even the most articulately rendered smooth and even texture.

Myriads of textures and surfaces surround us in everyday life—and there are even more possible lighting situations. The human eye relies on reflected light to determine the texture of an object's surface. Naturalistic rendering requires not only a keen eye for analyzing and a steady hand for rendering textures but it also requires a thorough understanding of the various aspects of light and how it reflects off each kind of surface. Because of its abilities to create intricate detail and capture a wide range of colors, colored pencil is an excellent medium for depicting a variety of textures. These factors—combined with the tremendous new methods and techniques that have been recently developed—yield an unmatched opportunity for the colored pencil artist.

It is simply impossible to describe all of the variations in texture that you may encounter. In this chapter I provide general approaches to the problems that arise together with methods you can use to solve them. Later, in your own compositions, you will better understand the situations and will know how to achieve a particular effect or surface texture. By modifying the colors you select or the order in which you execute the techniques, you can utilize the methods presented here to create literally thousands of textures.

Alyona Nickelsen,
Rose of Equinox, 2004,
Prismacolor colored
pencils on 250 gsm white
Stonehenge paper,
11 x 8 inches
(27.9 x 20.3 cm)

Choosing Colors

One of the most striking elements of your composition will be your use of color. Color often defines the tone of a painting. It can be used to heat up the conversation you are having with the viewer—give it more spice—or it can be used to tone it down a little, if other aspects of the composition become too intense.

Before you begin to render an object and its texture you must decide which colors you will need. Begin by gathering your reference photos, scraps of drawing paper, and pencils. At this point, you need to analyze all of the shadowed and lighted areas on your reference images and then create color swatches for each of these areas. (The concept of color swatches was first introduced on page 11.) Remember to leave room on each color swatch for written notes, as you may want to jot down observations or impressions as you're working.

Creating color swatches is an important aspect of working with colored pencils. In short, the process involves layering colored pencils in various orders, burnishing them with either white or another color, and applying OMS washes to the layered colors and observing any color shifts when the swatches are both wet and dry. Make sure to save all of your color swatches. Even if they are not applicable for your current project, you will almost certainly find a use for the particular color combinations in future projects.

I chose this photograph of a flower with a beautiful purple-blue color scheme to demonstrate how to make color combination decisions. Look at this reference and you will immediately recognize the purples and blues. I thought my lavender pencil would be a good match for the overall color of the petals. However, to double-check my color choice, I decided to take advantage of one of the aids available to the modern artist: Adobe Photoshop. Since I took this photograph with a digital camera, this process was easy. First, I opened the image in Photoshop. Then I chose Filter, Pixelate, and Mosaic from the menu. A dialog box appeared with a preview of my image in pixels. By adjusting the scroll bar, I was able to change the size of the pixels. (The larger the pixels were, the closer I was to the overall color of the image and the fewer details I could see.) I selected a comfortable level of pixels so that I

The delicacy of the values and colors of this flower create a challenge when trying to identifying them.

Photoshop is a helpful tool for matching the colors in a reference photo to the actual colored pencils available from manufacturers.

I needed to experiment to determine the colors that would help me render the flower. The first row shows pure lavender and then lavender mixed with blue slate, Imperial violet, violet blue, and Tuscan red, respectively. The second and third rows are identical in their color combinations. However, in the second row each swatch was burnished with white and in the third each received an OMS wash.

To complete my palette for this flower project, I needed to sample some additional colors. Again, I used lavender as the base color. I then layered the laven with blue lake, Mediterranean blue, Copenhagen blue, and peacock blue, respectively. Again, I burnished the swatches in the second row with white and applied an OMS wash to the swatches in the third row.

could clearly see the colors that were engaged in my image—and confirmed that my lavender pencil was a good place to start.

Now I was ready to create some color combinations, using lavender as my base. The first row of swatches shows straight lavender and then lavender mixed with blue slate, Imperial violet, violet blue, and Tuscan red, respectively. The second and third rows are identical to the first in terms of their color combinations, except I burnished each swatch in the second row with white and applied an OMS wash to each swatch in the third row. (Notice how the colors in the third row darkened a little. I jotted down a note to myself, as I knew I needed to keep this in mind as the piece matured.)

From these swatches, I established that white added to the lavender would work for the lightest values of the petals. Blue slate worked well on top of lavender and could participate in the painting also. Imperial violet created a vibrant hue that would be appropriate for some of the shadow areas. The violet blue provided a little too much blue to the mix, so I decided not to use it. Tuscan

red balanced the other swatches nicely and would work well in the dark shadows, but it was too dark for the medium shadows. So I needed to introduce a lighter color with more red in it. Dahlia purple seemed just right for that task.

I wanted to confirm my color selections, so I sampled some additional colors. Again, I started with lavender as my base color. After that I layered blue lake, Mediterranean blue, Copenhagen blue, and peacock blue, respectively. As with my other color swatches, I burnished the swatches in the second row with white and applied an OMS wash to the swatches in the third row.

I appreciated the effect that blue lake had on the lavender. However, it was extremely similar to the lavender/blue slate mix, so I decided not to select this color. Mediterranean blue darkened the value of the mix and shifted the color away from red and closer to the blues, so I made a note for myself that this color could be used for rendering mid-value blue. Copenhagen blue pushed the lavender even further toward blue, and peacock blue added a greenish shade.

Choosing just the right colors is even important for compara-
tively straightforward subjects, such as the cloudy sky shown
here. To render this image I used powder blue, blue slate, light
cerulean blue, Mediterranean blue, peacock blue, and slate
grey for the sky and powder blue, peach beige, greyed laven-
der, lavender, and white for clouds, which I applied using the
powder-brushing technique.

Neither combination helped me match any of my
reference requirements, so I decided to skip
those colors. However, I didn't see any color in
this swatch that would serve as a representation
of dark-value blue. So I made a note for myself
that I must consider indigo blue as one compo-
nent of my selection to solve this issue. I kept my
notes together with the reference photo in a spe-
cial folder so that I could revisit these combina-
tions at a later time.

My final selection of pencils was lavender,
blue slate, Mediterranean blue, dahlia purple,
Imperial violet, indigo blue, and Tuscan red. Of
course, you could choose different colors,
depending on what brand of pencils you are
using, the colors that are available to you, your
personal interpretation of the color, and so forth.

Once you have determined how you will
achieve your entire color scheme, you are ready
to concentrate on the texture. Rendering differ-
ent textures is just a technique or set of tech-
niques that will give you the necessary effects on
paper. Regardless of what you may have heard,
no magic is involved in the process.

TIP: Don't be afraid to incorporate gentle touches of
color and a wide range of values when rendering
"white" clouds. High-key yellows, pinks, purples,
and greens will bring life and excitement to your
rendering.

Getting Yourself Started

Before you begin to render your textures, you need to ask yourself a series of questions:

First, does the paper surface require alterations of any kind to achieve the desired effect?

The alteration required will depend on the kind of textures in your composition. If the surfaces you are about to render are smooth or just slightly bumpy, your paper most likely will not require any alteration. However, if rough textures feature prominently in your composition, you should consider using the roughening technique. Likewise, if it includes distinct marks or patterns of lighter value against a darker background, consider using the pattern scoring technique.

Second, should you preserve the white of the paper for rendering the lightest values of your composition?

If this is necessary, you need to use masking fluid or masking paper to preserve these areas prior to applying any color pigments. An alternative approach is to render highlights using the sgraffito technique later in the process.

Third, does the subject on hand require you to work from light to dark or from dark to light?

If you plan to render a subject with a smooth value transition, it is better to gradually darken values (i.e., to work from light to dark). Particularly if your subject features distinct edges between values, patterns, or small details it is better to use the color/value mapping approach. (First, mark the edges and details; then darken or lighten the values during rendering.) However, if your overall composition is dark, you can work from dark to light and use the negative painting technique in combination with applying layers of lighter colors to develop a range of lighter values.

Fourth, what kind of pencil is required to do the job on hand?

As we discussed on page 46, dull pencils are effective both for rendering textured surfaces and for creating patterns. Sharp pencils, on the other hand, are best for creating smooth surfaces and for layering. And pencils with a flat point are handy for covering larger areas as well as for developing textural effects. Sometimes the pencil itself isn't required, but rather its shavings—the powder-brushing technique comes into play when you need a delicate value or color transition. Pencils with a hard point are great for the same purpose, and they provide you with more control than powder brushing.

TIP: When the object you are about to render consists of complicated pattern or numerous details, don't be overwhelmed by its complexity. Divide it mentally into smaller pieces and render them area by area, keeping the overall shape of the object in mind.

(Left) Rendering patterned fabrics can be a daunting task. However, if you have a game plan before you get started, your chances of success improve tremendously.

Rendering Backgrounds

Most representational art features a focal point (which is generally the main subject) and a background (which is often the farthest plane from the viewer). The primary subject must attract the viewer's first glance and the majority of his or her attention. It is usually better lit and has more detail than the rest of the painting. The background is usually less defined than the main subject.

TIP: The value and color of the background should never be an afterthought. Rather, it should be considered at the very beginning of the creative process. If you wait until the end of the painting to render the background, its colors and values will affect the appearance of the focal point.

Backgrounds can take any number of forms. They can be a solid color, an abstract gradation of colors and/or values, a combination of colors presented in some kind of pattern or depicting a texture or surface, or a representation of an identifiable scene such as a landscape, seascape, or foliage. Regardless of the form the background takes, it is generally depicted without too much detail. Therefore, when you are working on texture and surface rendering, you must understand how well defined it should to be. You should also determine whether you need to show a truthful representation or just give the viewer a hint of the nature of the context.

Black

Although you may have heard differently, a solid black background can be achieved quickly and effectively with colored pencils and without the need for colored paper. To create a black background on white paper, simply use a normal touch and apply a layer of black pencil, an OMS wash, followed by one layer each of indigo blue, dark green, and Tuscan red. Apply a final layer of black and then blend the mixture with the colorless blender. This formula will create a very dense and solid black color. Slightly less intense variations of black can be achieved by eliminating one of the three colors and/or the final black layer.

This method leaves the paper in such a condition that it can still take a few additional layers of pencil. So you can apply layers over the black to simulate rendering on black paper. If you find that you have used a heavy touch to create your black background, and in so doing have compromised the tooth of the paper, apply a coat of workable fixative. This will bring the paper back to a working condition, allowing it to accept a few additional layers of pencil.

Black can be created in various ways. The first square shows pure black pencil. The remaining squares received an OMS wash. The third square received a second layer of black. Indigo blue was added to the fourth, fifth, and sixth. Tuscan red was added to the fifth and sixth squares. Dark green was added to the last square, giving it a dense black tone.

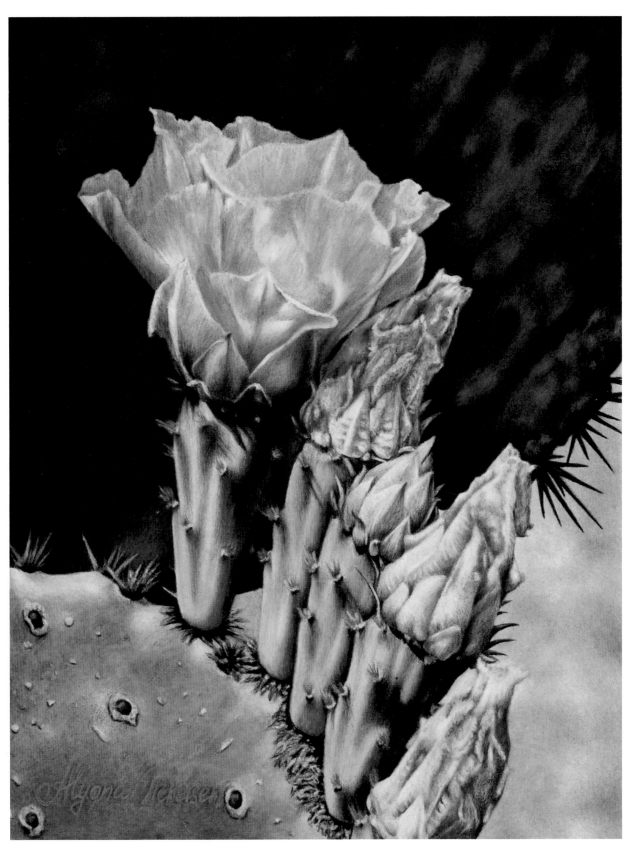

Alyona Nickelsen, *Desert Rose,* 2006, Prismacolor colored pencils on 250 gsm white Stonehenge paper,
10½ x 8 inches (26.7 x 20.3 cm)

Gradated Tones

Often a composition will require a simple background—one with color but one that doesn't feature any recognizable items. In these instances, the powder-brushing technique comes in very handy. As discussed on page 58, powder brushing is the colored pencil equivalent of airbrushing. I created this technique to help me depict the various subtle and gradated shades I saw in the sky and other surfaces.

When creating *Desert Rose,* on the previous page, I knew that I wanted to create a blurred background for the lower right area of the composition. I wanted to give the impression of the greenery typical of a desert environment but didn't want to add overwhelming detail, as I knew this would draw the viewer's attention away from the focal point of the image: the yellow flower. I decided that the powder-brushing technique was the best way to go, so I layered powders of limepeel, marine green, pink rose, blush pink, and blue violet lake, overlapping some portions of the spots to create a color mixture. I then dissolved the background colors and edges using OMS and burnished the area with white to better merge all colors. The end result was that the background picked up many of the colors in the main composition but provided a quiet area that wouldn't distract the eye from the main message.

Abstract Patterns

If you analyze such common backgrounds as a large body of water, distant greenery, or a rock formation, you can often conclude that it could be simplified as a collection of abstract shapes. These shapes can usually be grouped into three to four major masses of values. They sometimes have hard and well-defined edges and other times have blurry and barely detected edges. They might have a certain logic in their appearance or may have a more random placement.

The following demonstration addresses the situation in which a background has a wide range of values but its shapes do not have distinct edges. The process of rendering this kind of abstract pattern involves layering and fusing colors, using a colorless blender, and lightening values with mounting putty.

TIP: Adobe Photoshop has a tool to create simplified value separations. Open your picture in Photoshop. Then go to Filter, Artistic, and Cutout.

▲ This reference photo is an excellent example of a blurry background that features spots and other shapes consisting of very dark and very light areas. If I intended to create a finished painting based on this theme, I would have to adjust the value range of the background compared to the value range of the main subject, since the background currently competes with the focal point and attracts more attention than necessary. However, in this form, the background provides an excellent reference for how to create abstract patterns.

▲ First, I transferred the outline of the flower to my working paper and protected it with masking paper. Then, using the flat point of a black raspberry pencil I applied the first layer of color in a circular motion. Using a light touch, flat point, and circular motion, I added indigo blue to the darker areas and goldenrod to the lighter areas. This helped create the impression that the bright spots were made by light, and the dark areas were cool shadows cast by the flower.

▲ Next, I took a small piece of mounting putty and formed a ball. I pressed the ball against an area where I wanted to lift the color, flattening the putty, and then pulled it straight up. Then I reshaped the putty into another ball and repeated the same motion until I had covered the entire background. This created a random configuration of rounded shapes and provided lighter values against the dark background. As I was working, I tried not to create any logical pattern.

▶ Using a cotton pad slightly dampened with OMS and a light tapping motion, I dissolved the pencil strokes. To prevent smearing the pencils and destroying the value patterns, I used two pads— one for darker areas and one for lighter areas. While the surface of the paper was still slightly damp, I worked with a colorless blender, white, black, and all the previously used pencils to adjust the values of the background, smooth the edges of the spots, and merge the pencil strokes together. A circular motion and a flat point helped me create this painterly effect.

Rendering Greenery

Trees, branches, and leaves often appear in the background of a composition. However, they can also be a part of the focal point. The basic techniques for rendering these items apply either way. However, minor adjustments need to be made to maximize their impact and create the desired overall effect. When greenery is part of a background, make sure to blur the edges, downplay the details, and add blue tones, as this will appear to push the objects away from the viewer, create a feeling of depth, and lessen the visual emphasis of the area. When greenery is part of the focal point of a composition, create sharp edges, add fine details, and incorporate yellow tones to bring the leaves forward visually and capture the viewer's eye.

This section covers some ideas for the technical execution of greenery. Of course, each situation is unique, but the same basic approaches can be used for many other scenarios.

▲ Analyzing my reference photo, I could tell that the background for the grass was dark soil and that the grass itself had just a few values, including only a few highlighted blades. This confirmed my decision to work from dark to light.

Grass

When the subject of my composition is placed on grass or if the subject simply includes patches of thick grass, I generally don't want to attract too much attention to the grass itself. In these instances, I utilize the negative painting technique, working from the darkest values to the lightest to create a dark background. Occasionally I also employ the sgraffito technique to create the brightest highlights on the blades of grass.

A similar approach can be used to create any needle-looking shapes in large masses. These could be fir tree or pine tree branches, a stack of hay or straw, animal fur, short hair, and so forth. To render these textures, simply select the appropriate color scheme for the subject and particular lighting situation and follow the same procedure.

▲ With a sharp point and a light touch, I first applied a layer of black. Next, I applied a layer of indigo blue, which provided the necessary temperature to complement the warm tones of the sunlit grass. And finally, I applied a layer of dark umber, which provided a hue that is natural for soil.

▲ With Magic Tape and a sharp pencil, I "erased" the blades of grass, beginning with the point farthest from the viewer and moving forward. I tried to ensure that my blades were not too symmetrical or straight, as slight variations in directions and sizes help create some character for the grass. The result of this erasing process was the negative-like effect shown here.

▲ With a sharp point and a light touch, I applied apple green over the grass, starting with the back and moving forward and using striking strokes. I mimicked the direction of the blades, trying not to be too precise. Then, in a similar manner, I applied chartreuse. I could have stopped at this point and finished this piece by making a few bright highlights.

▲ To create the impression of a thick carpet of grass, and widen the range of the middle values, I repeated the erasing process again.

TIP: If the grass that you are rendering is in the sun, begin the process with dark green, olive green, and so forth instead of black. This will create a lighter background for the blades. As a result, the entire appearance of the grass will be in lighter values.

▲ Finally, I erased a few additional highlights and then filled them in with white, followed by touches of canary yellow. I then added some dark green to unify the pattern and enhance the color. If I had required more detailed rendering of the grass, I could have added more highlights with an X-Acto knife, using the sgraffito technique. I articulated the edges of the grass blades with a sharp dark green pencil and added touches of yellow.

Ferns

Ferns grow in low-light conditions, but they look absolutely ravishing when they are revealed in the bright sun. With their intricate patterns, ferns can easily seduce artists into rendering more details than are necessary. Remember that the darker the shadow and the farther away the greenery is from the viewer, the less detail is needed. Rendering ferns requires knowledge of layering and fusing colors and, depending on the lighting conditions, sometimes also using mounting putty or white pencil.

TIP: When rendering ferns, don't go overboard in capturing details, especially in the shadow areas. You will just waist time and confuse the viewer.

▲ For this demonstration, I chose a reference photo that included both bright- and low-light conditions so that I could compare the differences in colors and values. As you can see, some ferns appear to be close, and some are hiding in the darkness of the shadow. The following two steps focus on the section that features bright-light areas.

▲ I began by outlining the brightest leaves. Using black pencil, I modeled the dark values and then followed this with indigo blue, dark green, Tuscan red, and Kelly green. Next, I layered canary yellow on the illuminated parts of the leaves, and then I modeled values and established the local color with limepeel and Kelly green.

▲ Next, I applied an OMS wash. After this dried, I used a colorless blender to pull together the colors in the shadowed area. Then, I applied touches of green ochre and indigo blue to the lighted leaves. For the lightest parts, I added chartreuse and white. With the sharp point of a black pencil, I outlined the hard edges as needed.

Geranium Leaves

As with ferns, the greenery of geraniums features complex patterns of lights and shadows. The leaves themselves provide a unique set of shapes and rich colors that play subtle tricks with garden light. The surface of this leaf has a velvety finish, so there are no bright highlights. The shape of the leaves is rounded and has a distinct curvy edge. Rendering geranium leaves requires familiarity with layering and fusing colors, the use of white, and working with mounting putty for lightening values.

TIP: To portray natural-looking green hues, incorporate your own handmade greens and don't exaggerate the brilliance of the colors.

▲ This reference photo shows a cluster of geranium leaves with various lighting conditions. To overcome the innate complexity of the subject, I looked at this image as an abstract collection of shapes and values.

▲ First, I applied black, Tuscan red, and indigo blue to form the dark values. Using mounting putty, I lifted some of the light shapes. Then, with a light touch and following the curves of the leaf, I applied chartreuse to the lighter and dark green to the shadow areas, lifting color with mounting putty as I worked.

▲ Next, I applied an OMS wash. Once dry, I applied Tuscan red, indigo blue, dark green, canary yellow, chartreuse, and limepeel in the background and on the leaf. Then, with a colorless blender, I pushed the colors together. White helped me add highlights, while black gave more depth.

Leaf Veins

Many drawings of leaves made by young children feature prominent veins. While these images represent the nature of the leaf, they are far from realistic renderings. How, then, do we use colored pencils to create leaves with visually accurate veins? The answer lies in the pattern scoring technique.

Using this technique, you lightly impress the patterns of the veins onto the paper before applying any pencil. Then, when you are ready to add color, use a pencil with a dull tip and hold it almost parallel to the surface. This will allow the pencil to skip the impressed pattern. The resulting pattern will show through many layers of pencil and will contain no pigment coloration. Later in the rendering process you can adjust the thickness and value of the impressed line, blending some of the color around it with a colorless blender. For naturalistic rendering, ensure that the veins fade away as they disappear from focus. White pencil is always handy when you need to smooth your strokes or lighten the value.

▲ After transferring the outlines of the leaves onto my drawing paper, I discarded the transfer paper and worked through the reference print-out using a fine ballpoint pen. This allowed me to impress the veins of the leaves onto the drawing paper. Then I concentrated on coloring the image. As usual, I began with the area surrounding the leaves. In this case, I chose a solid black background, which I created by layering black, Tuscan red, dark green, and black again. Next, I applied canary yellow on the leaves, using a pencil with a relatively dull tip and holding it almost parallel to the surface of the paper. Because of the translucent nature of colored pencil, I knew that the yellow would shine through subsequent layers of color and help create the illusion of light, so I was liberal in my application. Nevertheless, the pencil skipped the impressed veins of the leaves, generating an intricate pattern.

▲ This reference image shows leaves with a prominent vein pattern. The veins are thicker closer to the center of the leaf and much thinner next to its edges.

TIP: Shadow and light create colorful patterns that can be confusing to render. Try breaking down patterns into smaller pieces and work as usual, from the outside to the inside, treating the farthest part that you are currently rendering as a background for the part closest to you.

▲ Next, I began to separate the darks and lights, using chartreuse, apple green, and grass green on the lighted areas and olive green and dark green on the shadowed areas. I used pencils with relatively dull points, again to skip the impressed vein design and generate an intricate pattern.

▲ Using a cotton pad and a gentle tapping motion, I applied an OMS wash. I was careful not to rub the paper, as this likely would have smudged color into the impressed lines. The OMS wash helped merge colors together, but it didn't destroy the layering or overly mix the pigments.

▶ To complete the image, I added touches of Tuscan red to the darkest shadows, emphasized the highlighted areas with canary yellow and white, and finished merging colors and values together with a colorless blender. As Tuscan red represented the complementary to the green mix, it helped dull the other colors, allowing them to gradually recede into the shadows.

TIP: When pencil strokes follow the curve of a leaf, they better define its shape.

Rendering Flowers

Nature has designated flowers to be one of its most beautiful gifts to the world. They attract immediate attention with their amazing shapes, marvelous colors, and unique scents. Flowers have bloomed through the entire frame of human history in our poems and songs; they are an inspiration for our compliments and symbols of love and affection; they are glorified in almost every kind of artistic expression known and have starred in every imaginable artistic or advertising design.

Although flowers are a common subject in visual art and still life arrangements in particular, it is not so easy to portray the true beauty of this everyday miracle. One common mistake to which many beginning artists fall prey when rendering flowers is creating hard outlined shapes, edges, and value transitions. This may work well for decorative rendering, but it is far from the delicacy required for realistic rendering. If you analyze floral reference images (indeed, if you study flowers themselves), you will notice that sometimes the transitions between values and edges are virtually undetectable. Some petal boundaries aren't even articulated with a line. Nevertheless, your mind adds the line definitions, which is precisely why so many beginning artists transfer their understanding of the petals to the paper in that manner. To avoid this, you need to re-create the lines, values, and edges exactly as you see them. If you don't see a line, don't draw it!

There are literally thousands of different variations of flowers. Of course, it would be impossible to show how to render them all in one book—even if that book were solely dedicated to this purpose. The following discussions provide solid general advice. If you keep the main ideas in mind and trust your eye when you render your own floral displays, you will be on a clear path to excellent results.

Small Florets

Many floral compositions feature tiny flowers and plants that surround the central theme of the bouquet. Rendering each and every floret could be a tedious and time-consuming task. However, this is actually not necessary, particularly if you know how to create the appropriate texture. Layering and fusing colors, using white for burnishing or lightening values, and working with mounting putty are key to the success of this challenge.

▲ This reference image features both tiny yellow florets and large white irises. Two step-by-step sequences follow, analyzing each flower in turn.

▲ When transferring the outline of the flowers onto my drawing paper, I indicated the placement of the florets. I applied black, Tuscan red, and dark green to create the background, being careful not to color the main masses of the florets. Then, using loose and choppy strokes, I added canary yellow to the florets to create the effect of a shining light and bestow the main color to the plant.

▲ Using choppy strokes and a normal touch, I introduced marine green to the florets to break the main masses into smaller sections. Then I applied an OMS wash with the goal of smearing some green color into the bright yellow and blurring my strokes just slightly. This step created the necessary variety of values on the small flowers, darkening their overall value compared to the irises.

▶ During the final stage of rendering the florets, I added touches of Spanish orange, chartreuse, and Tuscan red. With mounting putty, I pulled out the different-sized round shapes. Then, using white, black, and colorless blender, I added the necessary details and edges to create the impression of the floret foliage and hint at the directions of the branches. I was careful not to go overboard with details and hard edges, as I didn't want the florets to compete with the focal point.

White Petals

White petals provide a unique challenge. Rendering them successfully requires a keen eye, as form depends on extremely subtle changes of value and comparatively little color. The curves of this flower's petals morph into each other, with such slight value shifts that sometimes no borders are visible. Notice how thin, smooth, and delicate the petals are. Rendering the white color and the translucency of the petals will require a mix of hues rather than various grays. Delicate layering, fusing, and burnishing colors (as well as using white pencil to smooth pencil strokes and lighten values) is critical to the success of a subject such as this.

▲ To begin, I transferred the outline of the image to my paper and marked the main shadow areas. As usual, I developed the background first.

▲ Using a light touch and a sharp point, I applied jade green, nectar, and sand to create a "road map" for the values of this image. I was careful not to press hard for darker values. Instead, I created density of color by working over certain areas for a longer time. Notice that the colors I selected create a low-intensity mix of green, red, and yellow.

▲ Using a waterbrush, I then applied an OMS wash on the flower, being extremely careful at the edges. Next, I lightly burnished it with white. To complete the image I added Verithin indigo blue to the shadowed areas as well as additional applications of jade green, nectar, and sand to the remaining areas. Using a colorless blender and more white, I merged the final strokes together.

Setting Up a Floral Composition

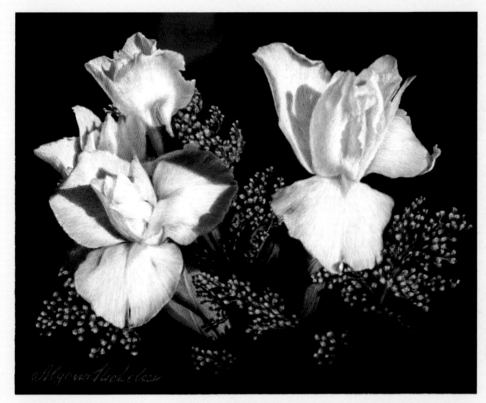

Alyona Nickelsen,
Between Shadow and Light,
2008, Prismacolor Premier colored
pencils on 250 gsm white
Stonehenge paper, 8 x 11 inches
(20.3 x 27.9 cm)

values, or shapes. Places your accents and manipulate values with great care to orchestrate the appearance of your floral arrangement.

The background must allow the flowers to stand out and attract the viewer's attention. Black or dark green backgrounds often provide excellent support for the bright colors of floral petals.

The successful rendering of flowers greatly depends on a number of factors. Of course, you need to be thoroughly versed in your materials and techniques. However, before you even think about rendering, you need to make sure that you have excellent reference material from which to work. Some people like to paint from live flowers. Personally, this doesn't work for me, as live flowers change too rapidly, and it is difficult to keep the lighting consistent over a long period of time.

Photographs help solve these problems for me. However, it is critical that you work from an impeccable image. Here are some things to keep in mind:

All elements of the composition must be taken into consideration, even if you have just a single flower. Resist compressing flowers into a tight bunch. Do not allow the harmony and balance of your composition to succumb to the diversity of hues,

The lighting needs to be carefully considered. Backlighting the petals can create a dramatic effect. The great number of values in the petals helps relay the delicate and almost translucent nature of their structure.

All of this being said, one of the great things about painting from photographs is that you can take liberties during the painting process, changing things to enhance the overall image. Before I started working on this painting, I noticed that the yellow of the florets could attract too much attention. Since I wanted this part of the composition to be secondary and not compete with the irises, I adjusted the value while I was working, darkening them slightly. I also intentionally blurred the edges of the florets, again to allow the irises to be on center stage.

Lilies

Rendering lilies is similar to rendering irises. They simply have more curves and more colors. To successfully overcome the challenges that these features pose, it is important to choose the right colors, treat each petal as an abstract shape, watch the values carefully, and avoid creating extra edges or lines if they are not visible. Being able to layer and fuse colors are critical skills to have when rendering lilies. Plus, white is an indispensable burnishing tool for re-creating the smooth surface of the petals.

TIP: Shadowed areas and lighted areas often don't have distinct borders on curved flowers. Rather, they flow into each other.

▲ For this demonstration I selected an area of the lily that features the curves of the petals with central bright colors and patterns surrounded by delicate whites.

▲ First, I transferred the outline of the flower and marked the placement of the dotted pattern on my paper. Then, with a sharp point and a light touch, I applied olive green to the leaves. Next, I focused on the petals. Using the same sharp point and a light touch, I worked on the white areas with blue slate, jasmine, and jade green. Then, with pink rose, process red, and touches of pumpkin orange, I began developing the lighted red areas. For the shaded areas I added blue slate.

▲ For the lighter areas I used hot pink, poppy red, and orange. For the shadow areas I added magenta and crimson red. To the deep shadows I added dahlia purple and indigo blue. Then I worked in the middle of the petals with chartreuse and pink rose. I used magenta on the lighter areas, crimson red and Tuscan red on the midtone areas, and dahlia purple and indigo blue on the shaded areas. I used a colorless blender and then lightly burnished the petals with white.

Sunflowers

Sunflowers—with their glowing crown of yellow petals and their ability to turn toward the sun-have inspired artists of every age and experience. Beginning artists tend to make them look almost decorative. However, if you closely analyze the shapes, positions, and sizes of the petals of a sunflower, you will see that each has its own individual characteristics and personality. Rendering sunflowers successfully requires mastery of layering and fusing colors, using white to smooth out strokes and value transitions, and facility with a range of pencil strokes.

TIP: The colors of the petals vary from glowing light yellows to deep, rich browns.

▲ As this reference image shows, sunflowers feature a wide range of values. The borders between the petals are sometimes striking and prominent and occasionally completely undetectable.

▲ I began with the deep black background, by applying a layer of black pencil and an OMS wash, followed by indigo blue, Tuscan red, and dark green. Next, with a sharp point and a light touch, I used pumpkin orange to create a preliminary value map of the petals. Using olive green, I then created the value map of the leaves.

▲ For the flowers I used canary yellow, sunburst yellow, yellowed orange, yellow ochre, white, pale vermillion, poppy red, dahlia purple, Tuscan red, kelp green, and indigo blue. For the leaves, I used canary yellow, sunburst yellow, kelp green, indigo blue, Tuscan red, and black. Finally, I applied a colorless blender to the entire composition.

Rendering Water

Realistically portraying water has always been attractive and, at the same time, challenging to artists. Truly, how do you capture on a canvas or on paper something that has no shape or color and is always literally on the move? Motion is the very nature of water. Nevertheless, over time artists have developed a few ways to represent water in the static environment of visual art.

Because they are temporarily motionless but retain some shape, dewdrops provide one way to present water. They can lend an authentic feel of freshness to fruits or flowers in an arrangement. Rendering the distortions caused by fluid water is yet another alternative for creative artists. Ice can also be an opportunity for portraying such an inconsistent substance as solid water. No matter which challenge the artist accepts, water never fails to bring a visual feast to the eye of the viewer.

Dewdrops

Dewdrops occur in a variety of sizes and shapes. Dew is formed primarily from water's unique property, known as surface tension, which allows it to hold a rounded shape. If not for surface tension, the dewdrop would be pulled and flattened by other physical forces, such as gravity. If a water drop were moving prior to coming to rest (such as a rain drop), its shape would also be affected by its velocity. The faster a water drop is moving when it hits its resting surface, the longer and thinner will be its final resting shape. The surface on which the drop rests also affects its shape. Hydrophilic surfaces, such as fabric or paper, have the propensity to absorb or mix with water, giving the drop a concave shape that is flat near the base. Hydrophobic surfaces, such as glass or wax, have an electromagnetic property that causes water to be repelled

from the surface, giving the drop a convex shape that is more rounded near the bottom.

Concave and convex shapes are the exact properties that allow eyeglasses to magnify and reduce images. Similarly, a dewdrop will magnify or reduce the image behind or under it, depending on the shape of the drop. As dewdrops are transparent and usually have a bright highlight right next to an area with the darkest value, rendering them accurately requires some knowledge of physics, a keen eye, a steady hand, facility with using masking fluid, and, in the example shown here, mastery of the scoring pattern technique. In addition, white pencil provides the critical role of burnishing colors, smoothing out pencil strokes, and creating reflections on the dewdrops.

TIP: To create the illusion of depth, the veins should be more prominent at the central areas and less visible at the top of the leaf.

▲ The dewdrops in this image have various shapes and work as miniature magnifying lenses. This allows them to amplify the texture, which is clearly visible in this leaf from my rose bush.

▲ First, I protected the brightest highlights with masking fluid. Then, I applied black, followed by mix of Tuscan red, dark green, and indigo blue to create a dark background. Then, I made a few random spots using mounting putty and applied apple green and touch of yellow. Afterward I applied a layer of canary yellow to both the leaf and the drops.

▲ Next, using tracing paper and a ballpoint pen, I created impressions of the leaf's vein pattern. Then, using a relatively dull point, I applied dark green, true green, apple green, and Kelly green on the leaf and the drop areas. I held my pencil almost parallel to the surface of the paper and varied my pressure, using less on the water drop areas and more on the shadowed areas of the leaf.

▶ I burnished both the leaf and the drops with white pencil. Then, I removed the masking fluid from the highlights. The darkest values were closest to the brightest highlights, so I outlined the darkest areas of the dewdrops with indigo blue and slight touches of Tuscan red. Next, I applied touches of chartreuse on the drops, creating the illusion of light. I darkened the central portions of the leaf with marine green and dark green. Then, using white and a colorless blender, I unified the colors and smoothed the transitions. Finally, I applied white next to each of the drops to create a reflection effect.

TIP: When impressing leaf vein patterns, ensure that the patterns on the drops are slightly larger than the patterns on the rest of the leaf. This will create the illusion of magnification.

Fluid Water

Water and glass both distort images. The more curved the surface of the glass is or the faster the currents of the water are, the greater the distortions will be. Sometimes the deformation is so great that the objects are practically unrecognizable. However, even if the abstraction is intense, the distortions will repeat the shape of the glass and the direction of the water currents.

To realistically render these distortions, we have to identify the manner in which they are created. In practice, rendering these distortions is not as complicated as it seems. Here is my, hopefully elegant, solution to this challenge. When rendering *Summertime,* on the right, I layered and fused colors, burnished with white, blended with a colorless blender, used negative painting, and employed the sgraffito technique.

As usual, I began by working on the background, applying black at the top of the piece and gradually lightening the value toward the intersection of the shadowed and lighted areas. Then I applied an OMS wash to help darken the value of the background. Next, I added indigo blue, dark green, and Tuscan red (in this order) to provide the greatest contrast possible and to create darker and duller versions of the reds and greens that gradually come out of the shadow and appear in the wood grain of the table surface. I blended the background with a colorless blender to eliminate the pencil strokes.

Using a Verithin indigo blue pencil with a sharp point, I applied a pattern to the straw above and below the water level. Using a light touch of cloud blue and Verithin lemon yellow, I applied color to the underwater portion of the straw. The colors needed to be very light, almost undetectable, to create the illusion of the slight value differences between when the straw is exposed to the air and when it is visible through the transparent glass and water. I added touches of true blue to the stripes in the lighted areas and ultramarine to the stripes where the straw is bent or has a curve or shadow. With a sharp point and a light touch, I used celadon green and jasmine to create the illusion of the roundness of the straw and to articulate some ridges where it is bent. And finally, with a white pencil I smoothed all of my strokes and the transitions of colors on the straw.

TIP: If a straw is distorted inside a glass of water, the distortion will indicate the level of the water, the transparency of the water and the glass, the shape of the glass, and the quality of the light diffused through the water and the glass.

I applied the colors of the background to the darkest areas of the clear glass. Working on each shape, value, and color individually, I re-created the rest of the reflections and distortions visible through the glass. First, I applied colors that appear unmixed and brilliant (such as magenta, true blue, chartreuse, orange, and lemon yellow). Then, I worked with the same colors and in combination with canary yellow and indigo blue, layering, mixing, and merging them inside the shapes of distortions and reflections. I then applied OMS to the entire image of the glass with a tapping motion so it did not destroy any layering and did not smear any of the darker colors. I used a colorless blender to smooth my strokes, and some of the edges, values, and color transitions. I adjusted the lighter values by lifting pigment with Magic Tape or mounting putty and applying white pencil. Using a sharp-pointed black pencil, I brought more contrast to the sharp edges of some of the shapes. Scraping the pigment with an X-Acto knife, I then created the brightest and the smallest highlights according to my reference image.

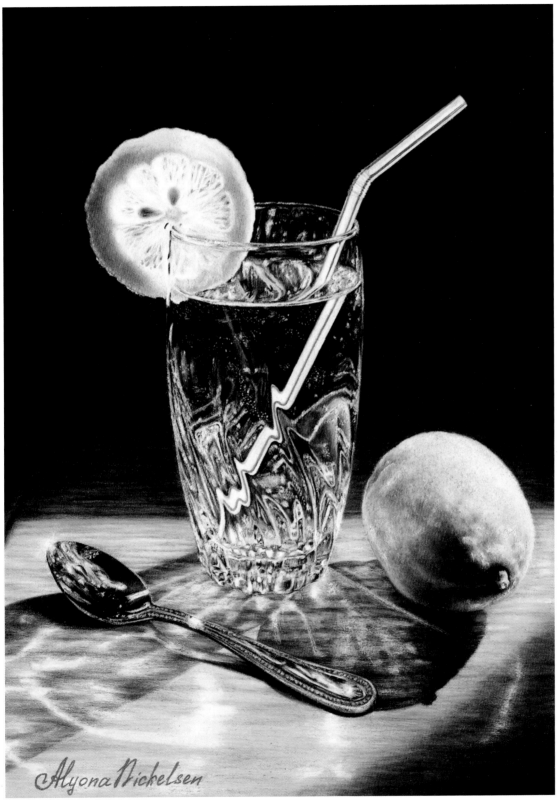

Alyona Nickelsen, *Summertime*, 2006, Prismacolor Premier colored pencils on 250 gsm white Stonehenge paper, 9 x 13 inches (22.9 x 33 cm)

Ice

Probably the two most challenging subjects for artists to capture are glass and water. Ice—with all of its depth, mystery, and glory—is a texture that falls between the two. The surface of ice is often smooth and transparent. You can frequently see bubbles of air captured inside. Ice reflects the colors of its surroundings. Rendering ice involves mastery of layering and fusing colors, using mounting putty, and employing the sgraffito technique. In addition, white is essential for providing the final touches, burnishing the colors, and smoothing out pencil strokes.

▲ This reference photograph captures the mysteriousness of ice.

▲ With consistent intensity, stroke direction, and pressure, I applied peacock blue and white to the background areas. This created the illusion of an opaque, smooth surface—perfect for this piece of ice. Then, I applied the same color to the areas of ice with varied pressure and multidirectional strokes. To create texture, I held the pencil almost parallel to the paper, allowing it to skip some of the hills of the paper. Then, I added indigo blue to the shadows and darker areas.

▲ Using a cotton pad and a tapping motion, I applied an OMS wash. Then, I put on touches of ultramarine and true blue. I burnished with white the areas of the ice that had smooth value transitions. I also added touches of yellowed chartreuse to the ice and then I darkened the shadow with black and additional indigo blue. I reapplied all previously used colors, lightened some values with mounting putty and Magic Tape, and scraped the smallest highlights with an X-Acto knife.

Rendering Fire

Flames are a powerful image. They can symbolize warmth and passion, or they can provoke feelings of danger and fear. Sometimes fire can be just a simple source of light, or it can act on its own as an untamed beast, destroying everything in sight. However, regardless of its role, fire will always attract the attention of the viewer.

The values of flames are often very light. Consequently, the transitions between them are often smooth and sometimes undetectable. Rendering fire involves deft handling of the layering and fusing techniques and using white to burnish colors

.

▲ The dark background this reference photograph creates a great contrast for the bright flames.

▲ I worked on the background in the usual manner, applying black, an OMS wash, Tuscan red, and indigo blue. Then, I began developing the darkest values of the flames themselves, using mineral orange followed by poppy red. I developed the lighter values with canary yellow, using a light touch. I worked in patches, making sure that I didn't add any color to the lightest values of the flames.

▲ Next, I applied an OMS wash, being careful not to drag the colors into the lighter values. To complete the image, I burnished the flames with white. This eliminated my strokes and blended the transitions between the lightest values. Then, I reinforced the colors by reapplying previously used pencils. I added touches of raspberry to the very edges of the flames to intensify the red color of the fire.

Rendering Surfaces

Myriads of fascinating textures surround us every day—from the swirling wood-grain patterns on a coffee table to the delicate opalescent shimmer in a string of pearls to the high-intensity reflective surface in a silver plate. Life is filled with visual marvels. It would be impossible to describe all of surfaces that could provide artistic inspiration, but on the following pages I provide a few examples of how I render a few of the most common textures. Once you get comfortable with these, you can start to experiment with other surfaces that inspire you. With patience and practice you will establish your own unique repertoire.

Wood

What is distinct about timber that makes us believe that we are seeing wood and not something else? The answer, of course, is the wood grain. To realistically render wood grain, clearly define one side of the grain, but keep the other side blurred.

Various kinds of wood have different colors, ranging from a deep mahogany to a light ash, and different grain patterns, from swirling to curved, but the approach to rendering wood is the same: First, define the pattern of the wood grain with a darker color, and then work on the remaining wood areas. Depicting wood involves layering colors and burnishing with white.

▲ My reference photo shows a blond wood with a pattern typical of many wood grains. Notice how the prolonged shapes sometimes morph in ridged lines that are located almost parallel to one another. The overall color of this wood is a dull yellow, but the wood grain itself is a visibly darker value than the rest of the wood.

TIP: To enhance the texture and look of the wood be careful to make all of your strokes follow the direction of the grain.

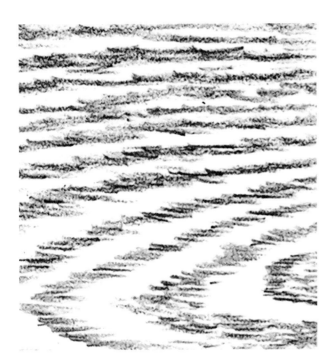

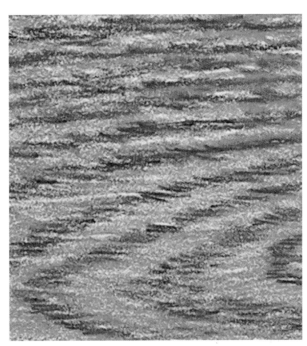

▲ First, I began rendering the image with choppy strokes, applying burnt ochre and following the wood pattern. This established the darkest value of my composition and created a base for developing the natural look of a wood pattern.

▲ Next, I used choppy horizontal strokes to apply yellow ochre. If I had needed to blend my strokes a little, I could have used an OMS wash now with a gentle tapping motion, being careful to avoid destroying the look of the wood grain.

▶ Using a normal touch and horizontal, choppy strokes, I applied a coat of sunburst yellow over the entire surface. This created an overall color for my composition and unified the strokes of my previous layers. Then, I burnished the entire surface with white. However, since the white dulled my delicate colors and caused them to appear pale, I reapplied burnt ochre, yellow ochre, and sunburst yellow to reinforce the colors of the wood. Then, I merged the strokes together with a colorless blender. And finally, I added touches of light umber in the darkest areas.

Silver

Metal surfaces are infinitely fascinating. They come in a range of lusters and colors. They can be impressed with designs or slick and smooth. The surfaces of metal objects can be curved or flat. The one thing that most metallic surfaces have in common is that they reflect images that surround them—and each of the various qualities of the metal changes the characteristics of those reflections.

The more shaped the metal surface is, the more distorted its reflection will be. The more color the metal has, the more altered the colors of its reflections will be. For example, silver practically doesn't change the appearance of reflected colors; however, brass brings a distinct yellow scheme to all colors reflected. Rendering reflective metals requires facility with layering and fusing colors, burnishing with white, negative painting, and sgraffito rendering.

TIP: When rendering shiny and reflective surfaces make sure the edges between values are as crisp or as blurry as those portrayed in your reference photo.

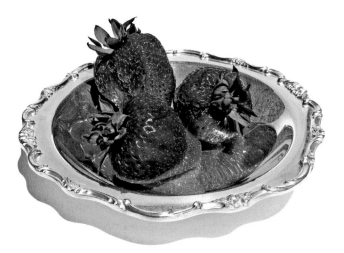

▲ This reference photo shows a silver plate filled with strawberries. The reflections of the strawberries are bright and clear, indicating the highly lustrous surface of the metal.

▲ I began by making a color map with the sharp point of the following pencils: French grey 70% (for the pattern on the rim of the silver plate), dark brown and yellow ochre (for the reflection of the rock wall), poppy red and Tuscan red (for the reflection of the strawberry), peach beige, greyed lavender, and pale sage (for the silver plate), and beige and blue slate (for the cast shadow).

▲ Next, I used a waterbrush to apply an OMS wash to the entire composition. Using a sharp point and a light touch, I applied indigo blue to the rim and surface of the plate. Using a sharp point and varied pressures, I applied Tuscan red and canary yellow to the rim of the plate, scarlet lake to the reflection of the strawberry, jasmine and burnt sienna to the reflections of the rock wall, and jasmine to the plate itself.

▲ Then, I used a sharp-pointed white to burnish the entire work and smooth the edges of the brightest highlights. As white tends to dull colors, I added all previously applied colors to reinforce their appearance. I adjusted the values, using white for the lightest areas and black for the darkest areas. And finally, I smoothed all visible strokes with a colorless blender to finish the work.

Pearls

Despite the apparent simplicity of their spherical shape, pearls in a painting always attract the attention of the viewer if the artistic rendering reveals their true nature—an ultrasmooth but uncommon surface. The sparkling reflections and delicate coloring of a string of pearls lend a touch of class to almost any composition. Tackling this task may at first seem formidable. However, with a mastery of layering and fusing techniques, manipulating masking fluid, and working with white (to blend colors as well as smooth the edges of the highlights), you will be on your way.

▲ This reference photo captures the essence of pearls—their perfectly round shape, subtle pale color scheme, and highly reflective surface. The black background (which is actually a mirror) creates a tremendous contrast for this delicate subject.

▲ I transferred the outline onto my drawing surface and masked all of the bright highlights with masking fluid. I was careful to check the roundness of each pearl. Working on the background in the usual manner, I then layered black, an OMS wash, Tuscan red, dark green, and indigo blue, followed by an extra layer of black. Using a light touch and a sharp point, I applied jade green, pink rose, and jasmine for the pearls in approximately equal amounts, working in patches. This created an approximate value map. When I wanted to lighten values, I used mounting putty. Then, I added patches of greyed lavender and seashell pink.

▲ Again using a light touch and a sharp point, I applied black cherry, peacock green, and indigo blue to develop the darker values of the pearls and to cool the form shadows. Again, I used mounting putty to lift some of the colors, lightening values as needed.

TIP: Add light touches of color rather than work in solid, sequential layers.

▲ With a pair of sharp tweezers, I lifted the masking fluid from the highlights. Then, I lightly burnished each pearl with a sharp white pencil. With the help of a colorless blender I fused the colors together and then reapplied indigo blue, black cherry, and peacock green to intensify the appearance of color in the darkest values. After that I added touches of salmon pink and lavender to reveal more pinks and to warm up and balance the color mix. Finally, I readjusted the values around the highlights by lightening the edges with white and darkening with black the areas where the pearls touch the mirror.

Cut Crystal

Rendering cut crystal can seem very complicated. Indeed, it can be a lot of work. However, if you divide the pattern into simple shapes and watch the contrast and values, you will be able to render even intricate pieces. The end result is a winner in any right-thinking judge's eye.

In previous demonstrations in this chapter, I have tended to work on general shapes first and then render details afterward. I have also tended to focus on lighter values first and then gradually develop the middle and darker values. However, from my experience rendering a wide variety of glass subjects, I knew that it would be difficult to work on this project in a similar manner. Cut crystal is different because it consists of complicated patterns of shapes, edges, and values. It features colors that morph and mix into each other side by side with more pure, bright colors that are achieved straight from the pencil. If I neglected these details from the beginning, it would be difficult to re-create them later. Unfortunately, with this subject it also would be easy to get lost in the details of the reflections and incorrectly portray the main shape of the glass.

The best method I have found for this task is to first create an approximate road map of all shapes, edges, and values and work in the light, medium, and dark areas all at the same time. In other words, I needed to render the details first and then work on the general masses later, because rendering cut crystal involves a delicate balance of layering, fusing, and burnishing some colors and allowing other colors to exist in their original form, straight from the pencil.

TIP: To capture the precise facets and brilliant colors of cut crystal be very careful with all the edges, angles, proportions, and distortions.

▲ For this demonstration, I decided to work on this fraction of a crystal candle holder because it represents the widest range of values.

▲ To begin, I transferred a detailed outline to the drawing paper, making sure to indicate all major shapes, values, and highlights. Then I created a value map with indigo blue and black grape, being careful to use a sharp point and a light touch so that I could make adjustments later, if needed.

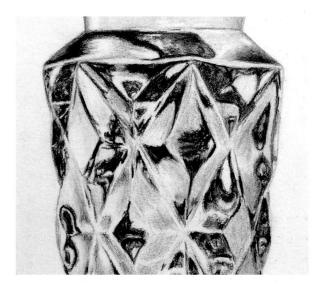

▲ Next, I applied an OMS wash with a waterbrush. Then, I began adding color and developing values. In the darker areas I used Tuscan red and indigo blue. In the lighter areas I added greyed lavender and powder blue. With a sharp point and a light touch, I added canary yellow, pumpkin orange, true blue, and ultramarine to a few areas where the colors gleam under the light.

▲ Once I completed the value/color map, it was a good time to step back from my work, squint, and inspect the general shape of the candlestick without being distracted by the details. This allowed me to easily judge the adjustments that would be needed to create the volume for the entire candlestick, without worrying about losing the detail.

TIP: Be careful not to mix the hues. Instead, place them very close to each other. They will represent a prism effect and the sparkles of color where light shines through the crystal.

▶ I burnished the entire drawing with white and then reapplied all of the previously used colors. I used black to darken the darkest values and increase the contrast. Then, with a colorless blender, I smoothed the transition of the values and color changes, making sure that the edges in the rendering were as smooth and crisp as they were in my reference. Finally, using Magic Tape, I lifted the areas needed to attain the brightest of the highlights.

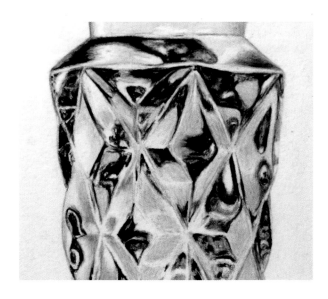

Rendering Fabric

Fabric appears in many forms in art—as a freshly pressed shirt in a formal portrait, as a rumpled picnic cloth in a landscape scene, or as a gently cascading swath in a luxurious still life. Therefore, having a good grasp on how to render fabric realistically can be a valuable addition to your artist's tool chest. Properly crafted, fabric can provide one of the most interesting spots in your composition.

Before rendering fabric you must evaluate its essential characteristics—in particular, its color, its texture (rayon can be very smooth, while canvas can have a visible weave), its stiffness (regular cotton is softer than denim, for instance), its luster (linen tends to have a matte quality, while silk can be very shiny), and its position (whether it is hanging from or wrapping an object or whether it is laying flat). In addition, you must carefully consider the lighting, as each of the characteristics of the fabric can be altered significantly by the amount of contrast between the lit and shadowed areas. This may sound like a complicated process, but, as usual, my advice is simply to analyze what you see and master the essential techniques so that you can re-create the fabric in your painting. Once you get a sense for the process, you will be able to render even the most complicated of materials.

Rumpled Fabric

Fabric can create complicated folds and wrinkles. Rumpled fabric, with all the curves and twists, is seemingly unpredictable. However, understanding how gravity and kinetic forces work will give you an idea regarding the appearance of rumples—whether they are lying on a flat and immobile surface or wrapped around a figure in motion. Analyzing the structure of rumples and mentally simplifying them into a connected set of basic

shapes, such as cylinders or cones, will help you produce a more realistic representation.

If rumpled fabric has a shiny surface and is placed under a strong light, it presents an even more challenging situation. However, the laws of physics that apply to every other kind of drapery apply to rumpled fabric as well. Consequently, the appearance of apparently random wrinkles or folds can make perfect sense, if you take the time to study them.

As with any intricate task, it is important not to be overwhelmed by its complexity. One way I have found to overcome this problem is to first observe the general shape of the fabric and then mentally divide it into smaller sections. Then you can analyze and work on each area separately. Creating rumpled fabric involves mastery of layering and fusing colors, using a kneaded eraser, and adding white highlights.

▲ For this demonstration, I picked a crimplene blouse that had the appearance of silk. I then rumpled it and placed it under a strong light to create plenty of contrast.

▲ First, I transferred the outline of the rumpled fabric to my drawing surface. I applied ultramarine to develop the major value masses, using a light touch in the lightest areas and slightly increasing my pressure for the darkest shadows. As I was working I used a kneaded eraser to lift color, as necessary.

▶ To complete the image, I darkened the middle values by adding Tuscan red, Copenhagen blue, and dahlia purple. I developed the darkest shaded areas with indigo blue, dark purple, and black. I also added light touches of dahlia purple to the light values to unify the overall color of the fabric. Then I smoothed my strokes with a colorless blender and added white pencil to the reflected light on the folds.

▲ Next, I smoothed the strokes with an OMS wash. However, if this fabric had been more complex or had a featured a more textured surface, I could have used a Q-tip or a waterbrush. Because of the lack of small details in this particular image, I was able to use a cotton pad. I let the surface dry completely before proceeding further.

TIP: The appearance of any texture depends on the lighting. Direct light makes textures less visible. Light that falls at an angle makes textures appear more prominent.

Denim

The surface of denim fabric is unique, with its many scratch-like lines and irregularities. Naturally, the spontaneous strokes that come effortlessly to the colored pencil artist work beautifully for rendering denim, and the result can be quite impressive. This is one of those cases where the rendered fabric can actually look better than a photograph of the same thing.

Different kinds of denim vary in color, so you will want to adjust your color recipe accordingly. However, a basic rule of thumb is that ultramarine, peacock blue, and Copenhagen blue can be used to provide reddish, greenish, and bluish hues, respectively. In addition, incorporating a number of markings and highlights will create the illusion of wear and tear on the fabric. The key to depicting denim successfully involves mastering the pattern scoring technique, layering and fusing colors, and using a kneaded eraser.

▲ First, I transferred the outline of the folds to my drawing surface. Before applying any color to the image, I used the pattern scoring technique to mark the stitching—first by placing tracing paper over my outline and then, using a stencil and a ballpoint pen, creating a pattern consisting of two rows of short lines parallel to each other.

Next, I applied denim blue to the entire image, using a pencil with a dull point. I held the pencil almost parallel to the surface, applied varied pressure, and followed the directions of the folds, using hatching and crosshatching strokes to create the distinct pattern of denim fabric and define the shapes of the folds. In this manner, my pencil skipped the indentations of the stitches, leaving them colorless.

With a pale vermillion pencil with a sharp point I added color to the stitch patterns. Then I lifted color here and there with a kneaded eraser to define the worn areas.

▲ I was careful to select a good reference photo, one that included a wide range of values. Notice how the surface of the fabric was neither smooth nor reflective; rather, it had a random configuration of lines and markings and an overall matte quality.

TIP: When part of the fabric is not in focus, do not re-create the entire pattern, with all of its associated details. Simply provide the viewer with a hint of the fabric's texture and pattern.

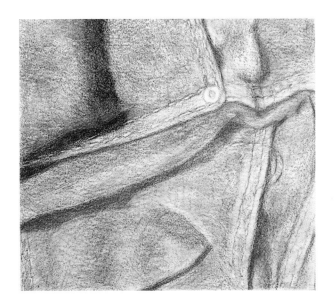

▲ Using a cotton pad, I applied an OMS wash mostly with a tapping motion to keep from destroying the textured quality of the fabric. (I could have achieved the same effect with a Q-tip as well.) I let the surface dry completely before proceeding further.

▶ Using sharp-pointed pencils, I added ultramarine, peacock blue, Copenhagen blue, and true blue to the folds and shadows. Then I darkened the deepest shadows with black. To complete the image, I added more pale vermillion to the threads, lifted some highlights with mounting putty, and smoothed some areas with colorless blender, being careful not to destroy the natural coarseness of the denim.

▲ I added some Tuscan red, followed by indigo blue, to develop the shadowed areas. I continued to work with hatching and crosshatching strokes. Also, with a relatively sharp point, I added some markings in indigo blue to darken the folds and better define their shapes.

Lace

What can be homier and add more comfort to a composition than a lace doily? What can enhance the charm and innocence of a scene more than lace on the trim of a little girl's dress? The task of rendering a lace surface might seem complex; however, the key to accomplishing this goal with ease is being true to your reference image and mastering basic layering, fusing, and burnishing techniques.

TIP: White is the most common pencil for burnishing because it has the smallest amount of pigmentation in the core. You can burnish with any color, including black. However, remember that black pigment is the darkest color available and will overpower any pigments layered previously.

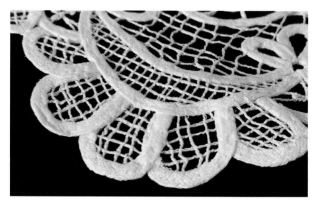

I picked this reference photograph of a doily lying flat against a dark background to show the main idea of rendering lace. To create folded lace, simply apply your knowledge from the previous demonstrations of handling rumped fabric.

▲ I transferred the outline of the lace, being careful to capture all of the details shown in my reference image. Then I created the background between the threads of the doily. Using sharp pencils to create nice, crisp lines, I applied black, Tuscan red, and indigo blue. Then I applied an OMS wash, using a waterbrush to render more intricate details.

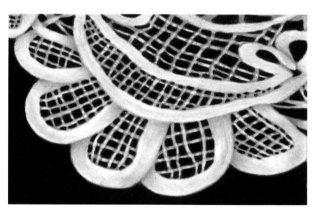

▲ I completed outlining the doily patterns, working in the same manner. Then, to create some volume in the rather flat doily, I added touches of greyed lavender, blue slate, jade green, and sand, using a sharp point and a light touch. Then, I burnished the image with white to finish and smooth my strokes.

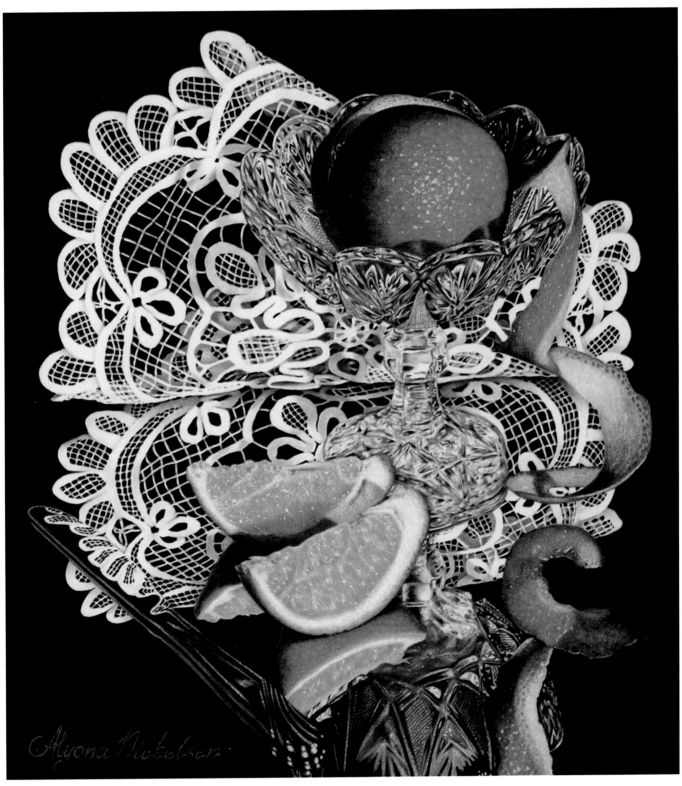

Alyona Nickelsen, *Curve Appeal*, 2005, Prismacolor colored pencils on 250 gsm white Stonehenge paper,
12 x 13 inches (30.5 x 33 cm)

Rendering Fruits and Vegetables

A plethora of shapes, colors, and textures can be seen in the appearance of fruits and vegetables. Thus, they have achieved prominence in still life compositions, quite literally for millennia. The considerable assortment of fruits and vegetables to which we have access these days presents such a wide variety of artistic challenges that it would be impossible to cover them all. Instead, I have selected a few of the most common textures—rough orange skins, gleaming pulp, foggy grapes, and shiny peppers. Once you have mastered these subjects you can scout out new and fascinating textures. The possibilities are virtually endless.

Citrus Fruit

The idea for *Curve Appeal*, which appears on the previous page, came to me after the happy end of a long chain of experiments that I conducted in an attempt to truthfully re-create the surface of an orange. It was at this point that the roughening technique took a permanent place in my colored pencil painting toolbox. To emphasize the surface of the orange peel, I placed it against strongly contrasting colors (white and black) and emphasized strongly contrasting surfaces (including the orange peel, crystal, doily, and silver).

The combination of challenging surfaces and a wide range of values attracts attention and has generated a flurry of questions. One viewer asked, "If you did it on white paper, how did you make the background so dark? If you did it on the black paper, what did you use for your whites?" Another viewer wondered, "Where is the object,

and where is its reflection?" This is exactly what I expected from such a controversial image.

Curve Appeal engages a large portion of my arsenal of colored pencil painting techniques, including layering and fusing colors, burnishing, negative painting, roughening, and sgraffito rendering. It is an excellent example of what can be done with colored pencil on a plain piece of white paper (when you know your way around).

Both *Curve Appeal* and *Summertime*, which appears on page 91, feature freshly cut citrus fruit. This poses a unique challenge. Orange wedges and lemon slices don't have a solid consistency. Instead, both of these fruits contain clusters of small, translucent gel-like cells. In the process of cutting the fruit, some of the pulp is invariably punctured and juice is spilled. As a result, wedges and slices of citrus fruit tend to appear to be very moist. The sidebar on the facing page details how I tackled this visual challenge.

Rendering the complex textures of citrus fruit can be a challenge for artists. My roughening technique can facilitate this process.

Taking a Slice

This is a detail of *Curve Appeal.* The full image appears on page 107.

This is a detail of *Summertime.* The full image appears on page 91.

Here is my method for capturing the juiciness and freshness of just-cut orange slice: Using a lemon yellow pencil with a sharp point, I established the basic hue of the fruit. Beginning from the pith and working toward the center of the slices, I used striking strokes. Then, I applied an OMS wash, using a cotton pad and applying the liquid with a tapping motion to prevent smearing of the newly created texture.

I allowed the surface to dry completely and then followed with striking strokes of canary yellow, Spanish orange, and chartreuse. This provided a spontaneous layering of strokes that flowed in the same direction but didn't create a solid layer. For my darker values, I added pale vermillion, orange, and touches of limepeel. Then, I lightly burnished the wedge with white and smoothed some of the strokes with a colorless blender, being careful not to go overboard, as this would have destroyed the texture. To finish the wedge, I added some bright highlights with the help of an X-Acto knife.

Rendering a lemon slice is somewhat different than rendering an orange wedge—not only because of the diversity of the color schemes of the two fruits but also because of the variety of the thicknesses of the different cuts. Since lemon slices are generally quite thin, a considerable amount of light shines through them. The success of the appearance of the lemon slice shown here is based mainly on the great contrast created between the rich dark background and the lightest values of the pulp and rind. Also, notice how the smooth transitions between a wide range of values create the illusion of light.

To make the peel, I layered the following colors: lemon yellow, canary yellow, greyed lavender, marine green, and pale vermillion. These layers were not solid, but rather I applied touches or color in small amounts. This helped me achieve a smooth mix of colors and darken the values incrementally.

I created the inside segments of the lemon slice by applying sand, yellow chartreuse, cloud blue, greyed lavender, salmon pink, and canary yellow. Again, I used light, striking strokes and worked from the peel toward the inside of the slice. I darkened the values of some of the smaller areas to create the illusion of translucency.

I depicted the inside seeds with touches of lemon yellow, burnt ochre, pale vermillion, and marine green. Then I burnished the image with a white pencil, which not only helped me get rid of some of my pencil strokes but also lightened some of the colors. This created the illusion of washed-out colors under a strong light source.

Notice the touches of bright color on the very edge of the peel's darkest part. I created this effect by using an X-Acto knife and then coloring over the area with sharp lemon yellow and orange pencils. This detail further enhanced the feeling of bright sunlight shining through the translucent slice of lemon.

Grapes

You may have noticed a foggy quality on the surface of certain fruits and vegetables. This frequently occurs when the items are moved from the cold of a refrigerator to a warmer environment, as condensation collects on the skin and causes it to fog up. This phenomenon is especially pronounced when it appears on various types of grapes. Rendering this quality is simple, provided you are skilled with layering and fusing colors and working with white.

TIP: When rendering grapes, remember that the stems are not flat. Instead, they have their own shape and volume.

▲ After the surface was completely dry, I added yellow chartreuse and apple green. I used touches of grass green to create form shadows. Then, I added touches of pumpkin orange to the base of the stems and to the darkest cast shadows.

▲ Underpainting with various yellows usually creates the illusion of light. In this case, however, it relays the almost translucent structure of the grapes. With a sharp point and a light touch, I applied goldenrod to develop the major shapes and values of the green grapes. I lightened the values with mounting putty. Then, I used a Q-tip to apply an OMS wash with a tapping motion.

▲ With a colorless blender and a white pencil, I smoothed all my strokes. I preserved the milky look in a few places, but in the remaining areas I reapplied the previously used pencils to reinforce the brightness of the colors.

Peppers

Irregular shapes, bright colors, shiny surfaces, and various sizes—what a perfect object for a still-life composition! Of course, I am talking about bell peppers. This is one of the most popular vegetables our fellow artists use for rendering. So naturally you will meet this glorious character in this book as well.

The word *shining* describes almost any bell pepper—whether it is green, red, yellow, or orange. So how can we achieve this sheen and the bright rich colors in our rendering? The three key elements that contribute to the distinct appearance of a bell pepper are underpainting the image with yellow, saturating the colors of the surface, and providing heavy contrast between deep, rich shadows and bright highlights (the former being created by mixing complementary colors and the later being created by preserving the white of the paper). In addition, mastering the color fusion techniques will eliminate any pencil

strokes and produce the necessary smooth surface. And finally, just a few strokes of a white pencil, held almost parallel to the paper surface, will create the waxy look of a bell pepper's skin.

We will work on bell peppers in the next chapter; however, let's take a minute to examine the two peppers below. By now, you should have fully digested the idea that no single volume of step-by-step demonstrations can possibly spell out all of the ways of rendering the infinite variety of fascinating surfaces and textures that you will discover in the real world. To succeed as a realistic artist, you need, first and foremost, to develop an eye so that you can really see the qualities that make each subject unique and, second, to master the materials and basic techniques of the medium, as these will allow you to re-create everything you see with veracity and purpose. The process is an adventure—perhaps frustrating at some moments and inspiring at others. Stick with it and see where this adventure that we call art can take you.

Handmade greens feature a wide variety of hues, many of which are not available as individual colored pencils made by commercial manufacturers.

The best approach to creating glowing yellow colors and three-dimensionality is to work from light to dark and carefully model form shadows.

chapter

Practicing with Simple Still Lifes

Some art instructors believe that beginning artists should practice their skills by copying large-scale works by other artists. In my opinion, this method is misguided. Such a pursuit requires large expenditures of time and effort and is likely to create frustration and confusion. If you were learning a new language, you certainly would not be able to write a poem in that language right away. First, you need to know how to correctly put sentences together. Only after you have mastered the basic elements of grammar and have been exposed to elements of literary style can you begin to delve into the more complex techniques used to create novels and poems.

The quest is similar with new art techniques. You have to train yourself with simple examples. With smaller pieces you will not spend a great deal of time on each project. You will gain direct understanding of the main issues involved in rendering various subjects, textures, and colors. And hopefully you will find great joy in the image itself.

The demonstrations provided in this chapter have been selected for those who have just started experimenting with colored pencil techniques. However, anyone who is interested in the new and powerful techniques of colored pencil painting will learn from these examples. It is thus that I have intentionally selected bright and catchy images to make your first experiences with colored pencil exciting and possibly a little less complicated. I hope you enjoy this new journey.

Alyona Nickelsen,
Blazing Bells, 2006,
Prismacolor colored
pencils on 250 gsm white
Stonehenge paper,
12 x 13 inches
(30.5 x 33 cm)

Keeping the Basics in Mind

In the exercises that follow I attempt to explain the thought process I have gone through when choosing the colors, strokes, pressures, and techniques required to execute each step. Because words can be imprecise (especially when describing a visual process) and because every artist is different, there is a chance that I might say "light touch" in a step that you might need to execute in another manner to achieve desirable results. So, to take maximum advantage of the exercises in this book, use common sense and trust your own instincts. Keep in mind that you can make corrections between steps, reuse the same pencil in a step later than described, or repeat a step two or more times.

That said, the following tips would be helpful to keep in mind:

The idea is first, and the execution is second. Your project must begin in your mind before your pencils ever touch the paper. You need to be very clear about the color schemes you will use, the preparations you will execute, the techniques you will employ (and in what order), and so forth before you apply any color. Good planning will reap excellent results.

Clean up after yourself. While the process starts with transforming your sketch to the final paper, it is extremely important to sketch clean or lighten the graphite lines as much as possible prior to applying colored pencil. You can even progress through the graphite sketch inch by inch, replacing it with color to prevent any graphite from showing in the final work. Try not to rub the graphite; instead, use mounting putty or a kneaded eraser to lift it from the paper without damaging the surface.

Attach your paper to a drawing board, and turn the board as you work. This provides a more natural way of applying pencil strokes than working at a drafting table. After a few hours of working in this manner you will appreciate the benefits of this approach.

Use a large, thick rubber band to attach your reference photo to your drawing board. This way you can alternate quickly between your reference and your rendering to achieve a more accurate match of colors and values.

When you need very light values, consider using a hard brand of pencil for your first layer. In situations such as this, I like using Prismacolor Verithin pencils, and then I follow with layers of regular (softer) colored pencils. This prevents crumbs of soft media from depositing an overly heavy layer on the paper.

Work from the outside to the inside. This method allows you to approach your composition with a winning perspective. In other words, establish the background first, because the values and colors of the objects and surfaces on the outside of the composition affect the values and colors of the objects and surfaces on the inside.

Take it easy when darkening. In colored pencil, it is easier to darken an image than to lighten it. Thus, it is more appropriate to apply several layers with a light touch than one layer with a heavy touch.

Pay close attention to subtle color and value changes. Check your reference image often and make adjustments as necessary as you work. Here is an excellent way to compare your values with

the reference photo while you are working on your project: First, make sure that you print your outline and your reference photograph in the same size. This will help you to place your composition perfectly on the paper. Print your reference in grayscale one more time on a sheet of clear acetate, making sure that it is the same size as the painting. This will allow you to overlay the acetate

on your work during the rendering process. In this manner you can see through the reference image and correct values as required.

TIP: Outlines for each of the projects in the exercises that follow are available for download at www.brushandpencil.com/bookdownloads.aspx

Alyona Nickelsen, *Celestial Incursion*, 2008, Prismacolor Premier colored pencils on 250 gsm white Stonehenge paper, 8 x 11 inches (20.3 x 27.9 cm)

A Single Bartlett Pear

In this project we will achieve an entire range of values in a light-colored subject without muting the resulting colors.

▲ First, let's examine this reference image and identify any notable characteristics. Notice that the brightest highlight has an irregular shape in the middle of the broadest part of the pear and that it continues up to the top of the fruit, gradually fading away. In addition, the entire surface of the pear is covered with a random configuration of not-too-defined tiny spots or speckles.

Next, let's determine what changes we would like to make. As this image is a bit flat, it would be a good idea to enhance the curves and contrast of the pear, giving it a stronger three-dimensional presence. In addition, the shadow is a bit harsh in this photograph, so let's provide just a hint of shadow beneath the pear for our rendering.

▲ Transfer the outline of the pear to your drawing surface. The overall colors of this subject are light. Because of this it is important to erase the graphite lines before applying colored pencil, otherwise, the graphite will be in the final project. You can use the masking fluid to protect the brightest highlight or just avoid any coloring in that area.

TIP: When working with such light values as those that feature in a pear, take your time, keep your touch light, and avoid muscling the pencil into the paper.

▲ Begin by applying a layer of canary yellow. Use a light touch and a sharp point. Follow the curves of the pear, decreasing your pressure toward the middle of the pear and around the highlight. For the highlight itself, preserve the white of the paper. This process establishes the lightest values of the subject. In addition, the yellow will shine through subsequent layers of pencil and create a glowing effect.

Ground your pear with cool grey 30%. Ensure that your shadow is darker where the pear touches the surface and fades away.

Apply an OMS wash to the pear and its cast shadow. This will smooth your strokes and cover the white speckles of the paper.

▲ Define the middle range of the values and the main color for the pear. Apply chartreuse followed by apple green—both with a sharp point and a light touch—following the curves of the pear. Work from the outer edges toward the center.

Add touches of yellowed orange, pale vermillion, and pumpkin orange. Try working in small patches, with relatively dull pencil points, almost parallel to the surface of the paper, and with a very light touch. This will create an uneven, spontaneous application of color. Use mounting putty when you need to lighten the values of the pear, and add dark green to the darkest areas of the pear.

▲ Use white pencil to lightly burnish the entire pear. Then, reapply the chartreuse, apple green, and yellowed orange. Blend and smooth your strokes with a colorless blender.

Apply Tuscan red and indigo blue lightly and in patches to the darkest areas of the pear to bring up the contrast and to better define the shape and curves of the pear. Use a colorless blender to gradually change lighter values to darker ones, but don't overmix the colors.

Create a random configuration of dots on the pear by using dull points of pumpkin orange, Tuscan red, and dark green pencils that have been dipped into OMS. Then work on the shape of the stem with kelp green, pale vermillion, and dark brown. Remember that the stem is not flat but that it too has a curve and a very weak highlight.

If you used masking fluid to protect the brightest highlight, remove it now. With white pencil smooth the edges around the bright highlights in the middle of the pear. Also touch the sides of the pear with white to create an indication of reflected light. With the help of the same white pencil, cause the cast shadow to "fade away" behind the pear. Then darken it with dark green and dark brown in the area where the pear touches the surface.

One Red Delicious Apple

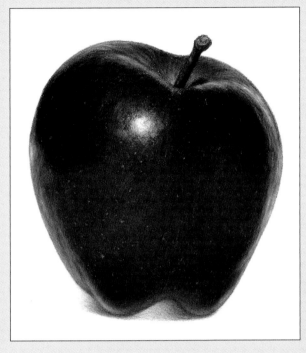

TIP: When rendering the stem of any fruit, don't forget that it is rounded, not flat, and that it needs to be sculpted accordingly with highlighted and shadowed areas.

STEP #1: Use **canary yellow** to provide a base for the apple.

STEP #2: Define the shape of the cast shadow with **cool grey 30%.**

STEP #3: Apply an **OMS wash** to the apple and its cast shadow with a Q-tip or waterbrush.

STEP #4: Articulate the surface of the apple with **poppy red.**

STEP #5: Use **indigo blue** and **Tuscan red** to give the cast shadow depth.

STEP #6: Apply an **OMS wash** to the entire surface of the apple, except the bright highlight, and the cast shadow.

STEP #7: Use **magenta** to imbue a cool red color for the shaded areas of the apple.

STEP #8: Darken the values of the apple with **kelp green,** as it serves as a complementary color.

STEP #9: Burnish the previously applied layers with **white.**

STEP #10: Reapply **poppy red** and **magenta,** concentrating on the lighted areas and shaded areas, respectively.

STEP #11: Add touches of **yellowed orange** and **scarlet lake** next to the stem cavity and around the brightest highlight.

STEP #12: Add **indigo blue, Tuscan red,** and **dark green** to the darkest areas of the apple.

STEP #13: Use your **colorless blender** to smooth the transition of the values.

STEP #14: Dip **yellowed orange** and **magenta** pencils (with dull points) into OMS and hit the surface of the apple to create a random configuration of dots.

STEP #15: Use **white** to create the illusion of reflected light and highlights.

EXERCISE #2:

Twin Cherries

In this project we will depict twin cherries—the perfect subject for showing how to handle high-gloss and reflective surfaces with the layering technique.

▲ Let's examine this image. The main color of the cherries leans toward a dark, but not a pure-hue, purple. The surface of these cherries is extremely smooth and highly reflective. This effect is created by the high contrast of very dark and very light values, which are located close to each other. Notice that the shadow is darkest immediately under the cherries and that it lightens gradually as it progresses away from them. Also, these cherries are so shiny that they even leave lustrous reflections on the shadows. In our rendering our colors will not appear as muted and subtle as they are in the reference.

▲ Transfer the outline of the cherries to your drawing surface. I recommend protecting the brightest highlights with masking fluid before applying colored pencil because we will need to have the brightest possible values in our rendering to create the shiny effects.

TIP: Under intense light, cherries can sometimes look almost black. This is one case where you must make adjustments to bring the color into play.

▲ Begin by defining the shadow with Verithin indigo blue. The Verithin brand is a hard pencil that deposits a smaller amount of wax than a regular pencil. This is very helpful when creating a smooth gradation of values and for rendering the transparency of the shadow.

Apply canary yellow with a sharp point and a light touch to the body of the cherries. Decrease your pressure when working on the lighter areas. Then, with a sharp point, apply jasmine followed by artichoke in the darker areas on the cherry stems. With a sharp point of dark umber, work on the area where the stems are connected. Vary your pressure from light to normal to create a bumpy surface texture. Then add touches of pale vermillion.

▲ Apply Verithin Tuscan red to the shadow, gradually changing its value as you progress away from the cherry. Don't forget to keep the reflective spots on the shadow in a lighter value. Using a sharp point, add apple green to the stems. Because the stems have a round shape and the light is coming from the left, the left side of the stems is slightly lighter than the right side. Then, with a sharp point and a light touch, work on the cherries with mulberry and dark purple. The yellow will shine through the layers of purple. However, with this project we are going to rely on layering (not an OMS wash) to create the varied color effects.

▲ To create the darkest values of the stems, add indigo blue followed by dark umber. Touches of pale vermillion here and there will be a nice addition to the color scheme of the stems. Develop the shape and full range of the values of the cherries by working with process red and dahlia purple on the lighter areas and black raspberry and moss green on the darker areas. Add touches of jasmine next to the highlights and Verithin indigo blue to the darkest shadows on the cherries. Add black raspberry and moss green to the shadows under the cherries.

▲ Work on the shadows with white pencil to unify all of the colors and strokes. Keep the reflective spots lighter. Then work lightly with white on the cherries themselves, carefully merging colors together. Check the reference often to see where you need to keep the edges between the values well defined and where you need to make a smooth transition; this is the secret to the realism we are trying to achieve. White pencil will bring gloss to the surface but will also lighten values of cherries, so you have to readjust the colors in the next step.

◄ To complete the image, you need to bring back the colors and values. Reapply colors as necessary, and use a colorless blender to smooth the transition between the colors. Make sure that your darks are dark enough. Darken the shadows under the cherries with black and add some white to the lighter areas of the shadow. You can also add just a little black to the darkest values on the cherries to create a higher contrast and a glossy effect.

Remove the masking fluid from the highlights and smooth the edges with white and colorless blender. You can also add a few small bright highlights to the cherries with an X-Acto knife and add reflective light with a few touches of white pencil.

A Whole Orange with a Curled Peel

In this project we will use the roughening technique to simply and effectively create the bumpy surface of an orange.

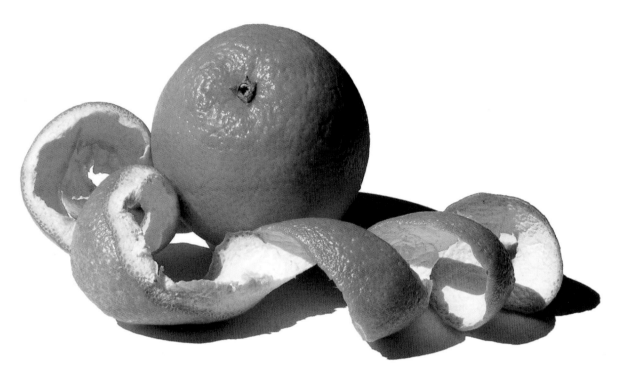

▲ Let's take a minute to examine this image. The colors of this composition vary from the lightest yellows on the inside of the peel to deep blues in the cast shadow. The surface of the orange skin is bumpy, with many undefined highlights around the stem and on the curves of the peel. One bright spot (a hot spot) is located in the center of the peel—where the light hits the peel almost directly. (This should be adjusted in our rendering.) The darkest shadows are behind the peel and just beneath it, where the peel touches the grounding surface. The shadow contains a large quantity of orange and red colors, which are reflected from the orange peel and the orange itself.

TIP: When rendering the bumpy areas of the orange peel, make sure to hold your pencil almost parallel to the paper. This will support the texture you created with the roughening technique and make sure that it is not flattened under layers of wax.

◀ Transfer the outline of the orange to your drawing surface. Before applying any color, use the roughening technique to enhance the texture of the paper in all of the areas where the orange peel will appear. Using the rounded part of a regular tablespoon, press the designated areas of your drawing against a pumice stone that has been placed behind the paper.

▼ Next, using a relatively dull point and holding the pencil almost parallel to the surface of the paper, apply lemon yellow to the areas where the exterior of the orange will appear. In this manner

the pencil will skip the bumps you created and will help develop the texture of the orange peel. In the same way apply sky blue light on the shadowed areas of the pith.

Work on the lighter areas of the cast shadows with a light touch of lemon yellow and kelp green, followed by touches of indigo blue. Increase your pressure in the darker areas of the shadow.

◄ Using a waterbrush, apply an OMS wash (the first of three) to give the surface a buttery feel and blend the colors together. Be careful not to drag the darker colors into the light values of the white pith. While the image is still moist, notice that it has a haze. Let the surface dry completely before applying more pencil layers.

◄ Develop the colors further with light applications of canary yellow, yellowed orange, pale vermillion, and carmine red on the orange and orange peel. For the shading on the pith, add greyed lavender, pale sage, cream, and peach. Touch the darkest areas of the pith with salmon pink to provide the illusion of depth. Work on the shadow with cream, goldenrod, and touches of burnt ochre.

◀ Apply the second OMS wash with a tapping motion (rather than rubbing). Before proceeding further, let the surface dry completely. This step helps to unify the colors and initiates the painterly effect.

▼ To create a three-dimensional orange and convincing curls for the orange peel we must engage the entire range of values. So far we have created the textured surface of our subject and established its light and medium values. Apply poppy red, Spanish orange, burnt ochre, sienna brown, raspberry, artichoke, and kelp green to the orange and the orange peel to establish a smooth transition from

lighter values to darker for the orange. Add just a hint of indigo blue to the darkest shades of the orange. Remember to use a light touch and hold your pencils parallel to the paper.

In the same manner, work on the pith, using jasmine, mineral orange, and artichoke, being careful not to overdarken it. Add lemon yellow, pumpkin orange, and Tuscan red to give life to the shadow.

▲ Using a light tapping motion, apply a third OMS wash to blend the colors together and smooth the transition between values. Let the surface dry thoroughly before resuming. Then, carefully touch the lightest areas of the composition with white, taking care not to destroy the texture effect. Check all edges of the composition and either blur them with white and a colorless blender or refine them further with a sharp point of the appropriate colored pencil. Using an X-Acto knife, add tiny sharp highlights on the orange around the stem and on the curls of the pith.

To increase the contrast of the composition, add touches of black pencil to darken the shadow behind the orange peel and immediately beneath it. Use a colorless blender to smooth your strokes. Be extremely careful with this last step, as overblending can flatten the texture effect.

One Red Bell Pepper and a Half

TIP: Make sure to fully erase the graphite lines, since they will show through the layers of light-colored pencil, especially around the seedpods.

STEP #1: Use **canary yellow** to render the skin, seedpod, and walls inside the half pepper.

STEP #2: Apply an **OMS wash** to the skin area.

STEP #3: Use **cool grey 30%** for the cast shadow.

STEP #4: Apply **poppy red** and **apple green** to the peppers and stems, respectively.

STEP #5: Indicate the outside curves and the deep areas inside with **kelp green.**

STEP #6: Shape the curves of the stems with **Tuscan red.**

STEP #7: Apply an **OMS wash**.

STEP #8: Add touches of **sunburst yellow** and **carmine red** to the lighted areas.

STEP #9: Cool down the shadows with **magenta** and touches of **raspberry.**

STEP #10: Darken the shadows with touches of **dark green** and **indigo blue.**

STEP #11: Reapply **apple green** to the stems.

STEP #12: Add touches of **pumpkin orange** to the stems, where the lighter areas transform into shades.

STEP #13: Curve the stems with **dark green** and **indigo blue** in the darkest shadows.

STEP #14: Add touches of **jasmine** and **salmon pink** to the ends of the stems.

STEP #15: Work on the flat cut of the stems with **dark brown.**

STEP #16: Smooth the strokes with a **colorless blender.**

STEP #17: Add touches of **apple green** on the seedpod next to the stem and **limepeel** and **salmon pink** to the middle.

STEP #18: Use **mounting putty** to lift random spots for the cut seedpod.

STEP #19: Outline and shade some of the seeds on the edge of the seedpod with **dark brown.**

STEP #20: Smooth strokes and lines with **white** and a **colorless blender.**

STEP #21: Add **Tuscan red** and touches of **black** on the cast shadows, where the peppers touch the surface.

STEP #22: Utilize **white** to fade the shadows and create highlights and reflected lights.

STEP #23: Use a **colorless blender** to smooth the final strokes.

One Peach and a Juicy Half

In this project we will use the tooth of the paper to render the distinct, fuzzy quality of the surface of the peach.

▲ Let's look carefully at this reference photo. The colors vary from light yellows to deep dark reds. Notice that, in addition to the fuzzy surface characteristic of all peaches, these particular fruits have certain irregularities that add to their personality. Let's keep some of these, but fix others, in our rendering.

The prominent marks next to the stem were created by the branch of the tree. Since these add to the uniqueness of this particular peach, let's include them. However, while cutting the half peach, I damaged the skin slightly. Let's fix this. We should also adjust, to some degree, the values of the shadows so that they do not overpower the peaches.

▲ Transfer the outline of the peaches to your drawing surface. Indicate the direction of the shadows. Straighten the line on the side of the peach half to fix the squashed look as it appears on the reference. Indicate the mark from the branch on the peach, because we will keep it in our rendering.

TIP: To create the fuzzy texture of the peach, keep your pencils almost parallel to the paper surface and follow the shape of the curves as you work. Applying color in this way will expose some of the tooth of the paper.

▲ Using a light touch and a sharp point, work on the shadows with French grey 30%. Then apply canary yellow with a relatively dull point to the peaches, keeping the pencil parallel to the surface of the paper. Try not to cover all of the paper in this layer. Instead, expose the white of the paper by allowing the pencil to skip some of the valleys of the tooth of the paper. Remember to follow the curves of the peach and sculpt it with your strokes. Add touches of peach-colored pencil to the darkest areas of the peach—the indents and around the seed.

▲ Develop the shadow by adding some lavender. Darken it with Verithin dark brown. On the peaches, add pale vermillion, poppy red, crimson red, and chartreuse, working in patches of color rather than in layers. Leave the area of the branch mark slightly lighter. Then lightly work on the seed with pale vermillion and chartreuse. Darken a few of its areas with Verithin dark brown. Add touches of dark umber to the stems.

▲ With a cotton pad and a tapping motion, apply an OMS wash to the entire composition. To keep from destroying the texture effect, be sure not to rub the surface of the paper. The wash will mix some colors together, but after it completely dries some paper speckles will remain exposed. These speckles will have just a slight coloration.

▲ Add touches of pale vermillion and indigo blue to the shadow. Define the lighter areas with yellowed orange, poppy red, scarlet lake, and Tuscan red. The branch mark has to be lighter in value than the rest of the peach surface, so lift the color as necessary with mounting putty. Gradually move into the shadowed areas of the peaches, using mulberry, dahlia purple, and kelp green. Darken the stem of the peach with more dark umber and touches of Tuscan red. Add more chartreuse to the slice of the peach and a little poppy red to the seed.

Smooth your strokes in the shadows with white pencil. On the peaches themselves, work with white very carefully in a circular motion and use a very light touch.

▲ To restore the value range of the peaches, reapply all of the previously used colors. Add touches of white to areas where the peach fuzz has whitish spots and where the peaches have highlights. Darken the shadows beneath the peaches with touches of black. Darken the seed and the stem of the peach with dark umber. Don't forget that no seed, or stem, is ever flat; rather, they have shapes and a range of values.

Add sharp and tiny highlights on the peach half with an X-Acto knife to create the effect of peach juice. Working with a colorless blender, smooth your strokes carefully. Leave some of the white speckles of the paper visible to support the texture of the peach skin.

EXERCISE #5:

A Single Strawberry

In this project we will use the pattern-scoring technique to create the distinct seed pockets on a delicious strawberry.

▲ Let's examine this image. It is immediately apparent that the surface of the strawberry is covered with small pockets, each of which contains a tiny seed. The pockets are larger at the middle of the strawberry and smaller at its tip. The pattern of the pockets depends on their locations.

The overall color of the strawberry is red, leaning toward yellow, on the lighted areas and red, leaning toward blue, in the shaded areas. By contrast, the seeds are mostly light yellow. The pockets are a little bit darker in value than the area surrounding them. The very middle of the strawberry has a few bright highlights and a few lesser-strength highlights. The shadow has reds in it that are reflected from the strawberry and greens that are reflected from the strawberry leaves.

▲ Transfer the outline of the entire strawberry to your drawing surface. Mark the brightest highlight on the strawberry and indicate the shadow beneath it. After you are done, cover the outline with tracing paper. Take a regular ballpoint pen (one that is not too generous with its ink) and press moderately to draw the pattern of pockets. Make sure to create dents that vary in size and have the same direction as the reference photo. Remove the tracing paper.

▲ You can mask the brightest highlights at this point, or you can just avoid coloring them during the rendering. Then, with a sharp point and a light touch of cool grey 70%, work on the shadow beneath the strawberry and the leaves. Then apply canary yellow to the strawberry itself, using a relatively dull point and holding the pencil almost parallel to the surface of the paper. Allow the pencil to skip the dents that you created in our previous step. Vary your pressure and follow the curves of the strawberry—lighter where its shape is bulging and more intense where it curves. This will establish a base for the texture and the lightest values of the strawberries. Be careful not to color the brightest highlight, but you can add light touches of yellow to the shadow.

▲ With a dull point and a normal touch, layer magenta over the entire strawberry. Hold your pencil parallel to the surface and allow it to skip the dents. Vary your pressure following the curves of the strawberry—lighter toward the middle and harder on the shaded areas where the strawberry is curved. This approach will help you to avoid depositing too much bluish red (magenta) on the lighted areas of the strawberry and more on the shaded areas. In the shaded area on the strawberry leaves, work with apple green, followed by kelp green.

▲ To develop the lighted area of the strawberry, lightly apply sunburst yellow in patches, holding the pencil parallel to the surface of the paper. Go over the sunlit areas and lightly color the seeds inside the dents. Add touches of Tuscan red to the shadow beneath the strawberry and dark green to the shadow under its leaves. Add touches of sunburst yellow to the lighted areas of the leaves and dark green to the darkest shadows on the leaves.

▲ Go over the entire strawberry with crimson red, holding the pencil almost parallel to the paper. Add touches of crimson lake to the shaded areas of the strawberry, again holding the pencil in the same manner. This step will help to unify the colors and achieve a smooth transition between the values.

TIP: When you apply color to the strawberry, the pencils will deposit stronger color around each dent because of the sharp edges created during the pattern scoring technique. Don't worry about this; it is exactly what we intend to do.

▲ Using a white pencil, go very lightly over the entire surface of the strawberry—including the leaves and the shadows—to smooth out your strokes. However, take care not to press too hard, as this could destroy the texture of the strawberry. Restore brilliance as necessary by reapplying previously used colors. Darken the shadowed areas lightly, by touching the straw-berry and leaves with Tuscan red. Smooth the edges of the brightest highlight of the strawberry with white and colorless blender. Add reflective light and a few less prominent highlights with white. Darken the shadow beneath the strawberry with touches of black, and fade the edges of the shadow under the leaves with white.

EXERCISE #6:

An Ear of Indian Corn with Husk

In this project we will depict an entire corncob by individually coloring each and every one of its various kernels.

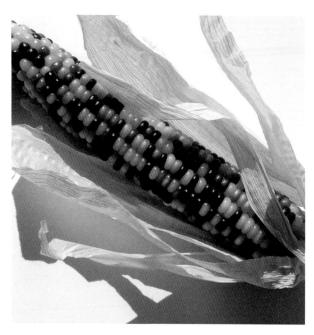

▲ Let's carefully examine this photo. Each kernel of the Indian corn has its own color. In addition, each kernel appears to be very smooth—with one bright highlight, a rounded shape, and well-defined curves. The husks look silky and very light, even semitransparent. The texture of the husks is not smooth but instead is impressed with a pattern along the length of the husks. Also, there is good contrast between the rough texture of the corncob and the silky texture of the corn husks.

Now let's determine what changes we might want to make for our rendering. Notice how the shadows of the corn are dark and the corn is hiding inside. In other words, the shadow is over-powering the focal point, which is the corn. Our intent is to bring the corn up to the viewer but not to lose the attractive pattern of shadows that makes this subject so unique.

▲ Transfer the outline of the corn and husk to your drawing surface. Don't forget to indicate the bright highlight of each kernel and the directions of the lines on the husks.

TIP: To achieve a realistic appearance of a highly detailed subject such as Indian corn, you must meticulously render each detail. For every corn kernel pay close attention to the highlight, form shadow, cast shadow, and so forth.

▲ Color mapping establishes the color trends for the work. To perform this task, use the sharp point of your pencils and apply color with a light touch. Begin by creating cast shadows with celadon green and beige for the lighter areas and contrasting them with slate grey and marine green for the darker areas.

Render the husks by using a combination of beige, cloud blue, and jade green. Use a sharp point and a light touch, and make your strokes visible, following the direction of the natural pattern of the husks. The kernels are a bit more complicated. Begin with lemon yellow or canary yellow (depending on the intensity) on the lighted yellow areas, and follow this with yellow ochre on the shadowed yellows. Use Verithin indigo blue for the blue kernels and Verithin Tuscan red for the red. Render white kernels with a combination of light peach, cloud blue, and jade green.

▲ Using a waterbrush, apply an OMS wash to unify the colors and blend the pencil strokes.

▲ Continue developing the values and colors, working area by area. In the shadows, use pink rose and cloud blue to accent the lighter areas and green ochre, indigo blue, and Tuscan red for the darker ones. The leaves are a blend of peach, beige, blue grey, cloud blue, jasmine, green ochre, and yellow ochre. Continue the application as we did in the previous step. Make your strokes visible, and follow the direction of the leave patterns.

Use greyed lavender and cloud blue on the lit yellow kernels. Establish the shadowed yellows with mineral orange. Then work on the blue kernels with indigo blue and Tuscan red. Develop the red kernels with Tuscan red, kelp green, and indigo blue. Fill the remainder of the set with white kernels, using light peach, greyed lavender, cream, and pale sage.

▲ Apply a second OMS wash to unify the colors, and remove the pencil strokes. However, make sure to preserve the pattern created earlier on the leaves. Then lightly burnish the leaves, the shiny portions of the kernels, and the shadowed area with white. Adjust the values and colors and develop the shapes by repeating all of the colors used in the previous steps.

▲ To complete the image, make all final adjustments to the shapes, values, and colors. Now evaluate your image: The shadow just beneath the corn is appropriately dark, but it lightens as it fades away. This provides a good contrast to the focal point of the image (the corn kernels). The husks nicely wrap around the corncob and don't distract the attention of the viewer. Instead, they provide a textured contrast and create a good pattern for the negative spaces. The kernels have some repetition but do not appear monotonous. In addition, they nicely contrast with the shadows and husks. In short, the overall contrasts work well—ranging from the vibrant colors of the corn to the transparent texture of the dry husks.

EXERCISE #7:

A Dandelion Against a Blue Sky

In this project we will use the powder-brushing and negative-painting techniques to render a puffy and extremely light dandelion.

▲ Let's first take a close look at this photo. Because of its consistency, the puffy dandelion head allows us to see some color of sky through it and also the more solid seeds that are inside of the head and closer to its center. Notice that the values of the sky behind the dandelion are slightly darker on the top and that they change gradually into lighter values on the bottom. This provides beautiful contrast for the dandelion head, so we will certainly want to maintain this effect for the rendering. However, I would like to change the color of the sky a little more toward the blue rather than the reddish blue shown in the reference, as this will yield the feeling of a sunny day rather than an overcast one. Also, because this image appears pretty flat, we should provide more contrast for the stem of the dandelion.

▲ Transfer this outline of the stem and head of the dandelion to your drawing surface.

TIP: To avoid unnaturally solid edges on the dandelion, apply the background first and then lift the marks to indicate the forms of the puffy flower.

▲ Begin defining the background by applying true blue. Use a heavier touch at the top than at the bottom. This will provide strong contrast for the dandelion head. Make sure that the direction of your strokes is the same throughout and that you do not create a halo effect around the dandelion. Turn your work often for a more natural and convenient motion of your hand while you are working.

Next, start to develop the illusion of the inside of the head of the dandelion. With a sharp point and a normal touch, apply striking strokes of moss green, progressing from the center of dandelion toward the outside. Keep your strokes different sizes and directions. With the same sharp point but a light touch, add moss green to the stem, leaving a highlighted area on the left side, a darker value in the center, and a lighter value on the right to mimic the roundness of the stem.

▲ Using a Q-tip or a cotton pad, apply an OMS wash to the blue background. This will unify your strokes. Let it dry completely before proceeding further.

▲ Using the powder-brushing technique, create a fine powder from a true blue pencil and apply it to the head of the dandelion with a cotton pad. Don't be afraid to overdarken this area a little.

▲ Then, using Magic Tape and a ballpoint pen, erase a pattern on the dandelion head with a crosshatch motion. This will create the lighter values on the head and the illusion of the puffiness in the flower. The true blue powder that is left over will create the illusion of the translucent nature of the head of the dandelion.

▲ Use a colorless blender to smooth the background and create a contrast with the texture of the head of the dandelion. Using pointed pencils, apply touches of dark brown on the seedpod and just a slight amount of crimson lake on the stem. Add touches of white to the stem to create a weak highlight along the side. This will impart the necessary roundness to the stem. To complete the image, burnish the dandelion with white, working in strokes from the inside to the outside of the head of the dandelion to create the puffy, uneven shape. With a colorless blender, smooth the colors on the stem. This will further enhance its three-dimensionality.

EXERCISE #8:

A Wooden Mortar and Pestle

In this project we will develop wood grain on a curved surface to render a wooden mortar and pestle set.

▲ Let's examine this photograph. It becomes immediately apparent that there are some qualities that we will want to keep but others that we will want to change for our rendering. The mortar and pestle have well-defined and very smooth edges. To accurately capture this image, we will need to faithfully re-create these features. However, in the photo the wood has a pale blond color. To enhance the feel of the wood grain, let's emphasize the red color of the wood. In addition, let's lighten the shadow a bit and fix the dark stain on the front lip of the mortar.

Notice that there are no bright highlights in the image. In addition, the deep shadow inside the mortar conveys important information. It indicates the mortar's depth, curves around the pestle, and gives the viewer an idea of the direction and strength of the light source. To obtain veracity in our rendering, we must be certain to correctly render the edges and values of this shadow.

▲ Transfer the outline of the mortar and pestle to your drawing surface, including the direction of the shadow and the pattern of the wood grain on both items.

TIP: A subtle use of complementary colors helps gives life to this image—with pumpkin orange featuring in the lighted area and indigo blue featuring in the shaded areas.

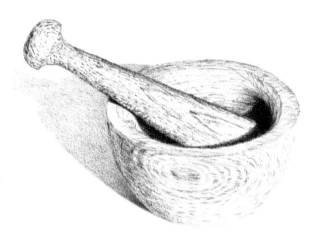

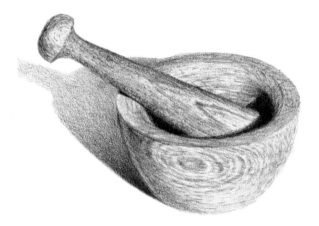

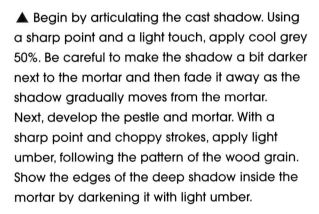

▲ Begin by articulating the cast shadow. Using a sharp point and a light touch, apply cool grey 50%. Be careful to make the shadow a bit darker next to the mortar and then fade it away as the shadow gradually moves from the mortar.

Next, develop the pestle and mortar. With a sharp point and choppy strokes, apply light umber, following the pattern of the wood grain. Show the edges of the deep shadow inside the mortar by darkening it with light umber.

▲ Work on the cast shadow with slate grey, followed by a moss green. Begin your strokes from the darkest area of the shadow, next to the mortar. Decrease your pressure as you move away from the mortar and fade it at the farthest reaches.

Next, continue with the pestle and mortar. Examine the photograph to determine which edges are crisp and which are smooth, and proceed accordingly. Using a sharp pencil, add choppy strokes of burnt ochre to the pestle and mortar. Then cover both wooden objects with jasmine, again using choppy strokes but this time following the curves of the objects. Add touches of moss green to the shaded areas and to the shadow inside the mortar.

▲ Using a waterbrush, apply an OMS wash, being careful not to pull the darker values into the lighter ones. Work carefully, lightly touching the surface with the brush.

After the surface dries, darken the shadow in the darkest area with dark umber, indigo blue, and black. Then, with a colorless blender, smooth all of your strokes on the shadow and merge all of the value transitions. Add touches of pumpkin orange, dark umber, and indigo blue to the wooden surfaces, following the pattern of the grain.

To finish the image, apply white pencil to the shadow as it fades away. With a sharp point and striking strokes, follow the pattern of the grain and add touches of canary yellow, yellow ochre, and burnt ochre to the set of objects. This will bring light and life to the colors.

Adjust the values on the wood by lifting areas with mounting putty and darkening when necessary with touches of indigo blue, dark umber, and light umber. Using striking strokes, apply white to smooth the transition between values and indicate reflective light.

A Brass Pitcher

TIP: Be sure to utilize the white of the paper for the brightest highlights—either by preserving it with masking fluid or by exposing it with the negative-painting technique

STEP #1: Apply **black grape** to establish the road map of the main values and colors.

STEP #2: Add **canary yellow** to provide the main color of the metal, where the pitcher appears yellow.

STEP #3: Develop the mid and dark values of the reflections with **indigo blue, Tuscan red,** and **marine green.**

STEP #4: Work on the light values of the reflections with **cloud blue, greyed lavender,** and **sand.**

STEP #5: Model the shaded areas of the yellow part of the pitcher with **orange, pumpkin orange, marine green,** and **Tuscan red.**

STEP #6: Create a glare effect with touches of **greyed lavender.**

STEP #7: Add texture to the handle with **Tuscan red** and **marine green.**

STEP #8: Use a **colorless blender** to smooth strokes and value transitions.

STEP #9: Add touches of **black** in the darkest areas of the reflections.

STEP #10: Burnish the surface of the pitcher and blur the edges of the highlights with **white.**

STEP #11: Create powder from **black** and **black grape** pencils and apply it lightly to the area of the cast shadow.

Crumpled Paper

In this project we will concentrate on shadows and edges to create the multifaceted surface of a crumpled piece of paper.

▲ Let's examine the key features of this photograph. Crumpled paper has a wide range of values. In this image the lightest values of the paper (which almost blend into the white background) are on the right side, while the darkest values appear in the deep wrinkles (which are almost as dark as the cast shadow on the left side). The borders between the values are crisp and well defined at times but are almost invisible at other times. Keeping this in mind, we must use colors to re-create the illusion of the white paper. Also, to make this exercise even more exciting and complex, we must convincingly render what was originally a continuous, blue-squared pattern but that now shifts and breaks, depending on the wrinkles and folds of the paper.

▲ Transform the outline of the crumpled paper, including the blue-square pattern and the cast shadow, to your drawing surface.

TIP: Although they may seem distorted, copy all of the lines for each square just as they appear in the reference photo. Sometimes you can clearly see them, and sometimes they disappear into the light or shadow.

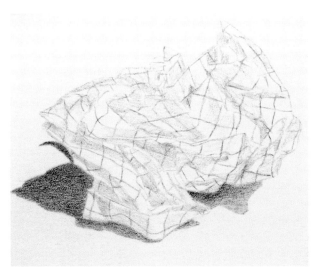 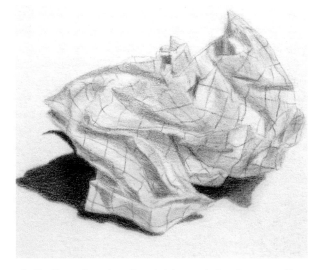

▲ Articulate the square pattern with Verithin true blue, making sure that you are faithful to the lightness or darkness of the lines in the reference. Indicate the shapes of the folds and wrinkles with a greyed lavender with a sharp point. Develop the cast shadow with French grey 70%, using a sharp point and a light touch. Notice that the darkest values are on the left side, where the light is blocked by the crumpled paper.

▲ Further develop the folds and shadows on the paper, using Verithin Tuscan red, Verithin indigo blue, and sand. The facets facing the light will need more yellow, while the areas where the light is blocked will need more blue. Add indigo blue and Tuscan red to the shadow beneath the paper.

Apply an OMS wash to merge the colors, and eliminate the pencil strokes. Because of the complex shape of the crumpled paper, a waterbrush would be the best tool for this task.

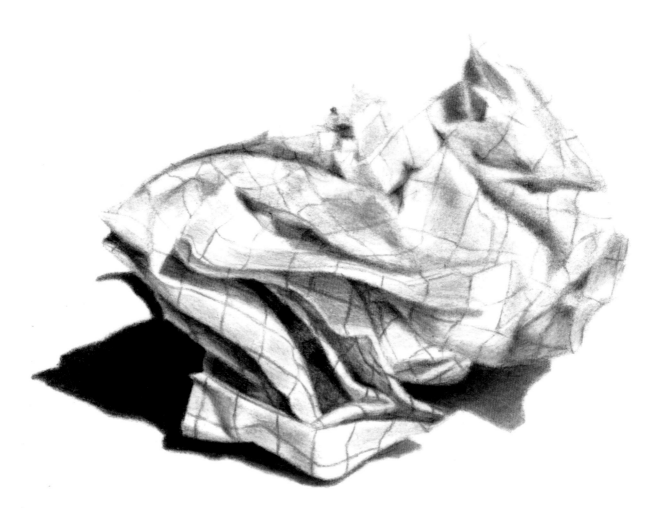

▲ Using black and white respectively, adjust the depth of the shadows and the highlighted areas of the crumpled paper. Use a colorless blender to blend all of the colors together. If necessary, add more color to the blue-square pattern with Verithin true blue.

Two White Eggs

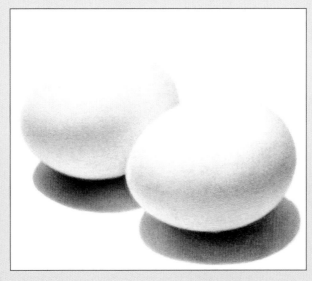

TIP: Using Verithin pencils in the first few layers creates a surface that does not as readily absorb the colored pencil medium as unworked paper. This will allow you to safely use regular pencils for subsequent layers without running the risk of applying too much color.

STEP #1: Apply **cream** to the eggs and shadows, decreasing your pressure at the top of the curves.

STEP #2: Go over the eggs with **cloud blue,** similarly varying your pressure.

STEP #3: Darken the shadows under the eggs with **indigo blue, Tuscan red,** and **dark brown.**

STEP #4: Define the delicate shading of the eggs with **indigo blue, light peach,** and **jade green.**

STEP #5: Develop the most shaded areas of the eggs with **indigo blue, sand,** and **kelp green.**

STEP #6: Add light touches of **pumpkin orange, kelp green,** and **black raspberry** on the cast shadows.

STEP #7: Darken the shadows under the eggs with **black.**

STEP #8: Add touches of **pink** and **canary yellow** to the eggs.

STEP #9: Add touches of **greyed lavender** to the shadow areas of the eggs.

STEP #10: Unify the colors with **white,** lightly burnishing both the cast shadows and the eggs.

STEP #11: Smooth all of your strokes and colors with a **colorless blender.**

A Clear Glass of Water

In this project we will analyze how light, glass, and water can work together to create breathtakingly beautiful colors and reflections.

▲ Let's examine the reference photo. Notice the tremendous range of values in this image—from white to almost black. Sometimes the values invisibly morph into each other; sometimes they just neighbor each other. In addition, many tiny areas on the glass and in the shadow contain a prism effect, with sparkles of yellows, reds, violets, blues, and greens. The water itself is clear and can be detected only by the reflection and the waterline. Reflections also provide critical information about the shape of the glass as well as its patterns.

▲ Transfer the outline of the glass to your drawing surface. Mark all of the basic shapes of the shadows and reflections, paying close attention to their edges and values. The more accurately you render these details, the more convincing your representation of the glass and water will be. Keep your reference photograph handy during your work, and check it frequently. It is easy to get lost in the complicated pattern.

▲ Rendering this subject is similar to depicting any other highly reflective surface with many details. First, we will work on positioning the details and the approximate definitions of values and edges. Begin by mapping shapes, values, and edges, using greyed lavender for the lightest values, black grape for the middle values, and black for the darkest values. Use a sharp point and a light touch for this layer. You can lift the color with mounting putty if you need to lighten it at any time.

▲ Apply an OMS wash, using a waterbrush to unify your strokes. Try to avoid smearing the color into the lightest values. Let the surface dry completely before proceeding further.

TIP: To re-create a prism effect, place unmixed brilliant colors at a very early stage of the rendering and avoid smudging other colors into them with subsequent layers.

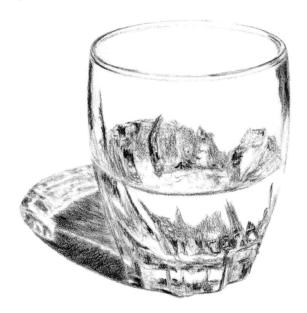

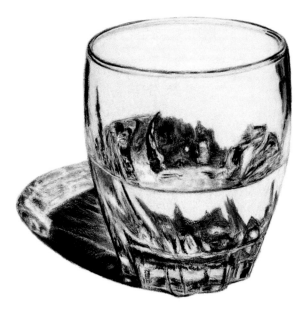

▲ Locate the areas that have sparkles of bright color on the reference. Re-create them in your rendering with touches of canary yellow, poppy red, aqua, true blue, and ultramarine. Use a sharp point and a light touch. To keep the colors bright and clear, place them close to each other rather than layering them. This will represent the prism effect.

▲ With sharp points of indigo blue, Tuscan red, and black, intensify the darkest values. Use a light touch to add cloud blue, light aqua, and greyed lavender to the lightest values. Apply a second OMS wash to merge the strokes together. Pay attention to the dark and light values in the reference image to ensure that they are merging smoothly and are correctly contrasting with each other.

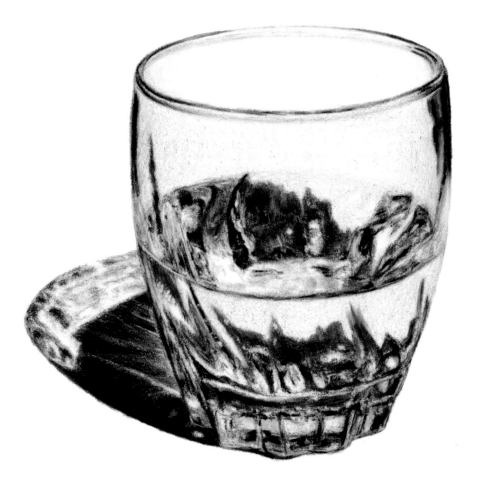

▲ After the surface is dry, burnish it lightly with white pencil. Then restore the colors and values, if needed. Step away from your work, squint, and look at the main shape of the glass. Notice if you need to darken or lighten any areas to create the effect of roundness. With an X-Acto knife, create the tiny highlights as they are in the reference. And finally, use a colorless blender to smooth the strokes and value transitions.

A Multicolored Glass Saltshaker

In this project we will render a translucent object while simultaneously preserving its bright colors and showing its glossy surface.

▲ Let's examine this image—the colors, the texture, the lighting. Notice that the red of the saltshaker's top and the green of its bottom are leaning toward yellow in the lighted areas but that both colors have blue in the shaded areas. In addition, the blue middle part has quite a bit of red, and the yellow contains some orange. The surface appears to be smooth and glossy. Some darker shapes are visible inside the saltshaker's colored parts. The brightest highlights are aligned at the front and along the entire height of the saltshaker.

▲ Transfer the outline of the saltshaker to your drawing surface. You can mask the brightest highlights with masking fluid or just avoid coloring them during the rendering process.

TIP: To faithfully render the transparency of this object, work on this project from the inside out— first placing the shapes visible inside the object, then articulating the outer surface, and finally rendering the glossy effects.

▲ With a sharp point and a light touch, apply black grape to articulate the shapes that are visible through the glass. Next, apply a layer of poppy red on the red section of the saltshaker. Use a sharp point and vary your pressure to sculpt the shape, lighter where it is bulging and harder where it is curving. In the same manner, apply ultramarine to the blue sections, canary yellow to the yellow, and apple green to the green. Follow the curves with your strokes, but make sure to keep the highlights white. Apply French grey 30% to the cast shadow.

▲ Apply an OMS wash with a waterbrush. Develop the red section with magenta, crimson red, and Tuscan red. For the yellow section use canary yellow and pale vermillion, with sienna brown, light umber, touches of Tuscan red, and marine green for the dark shapes. In the blue section use denim blue and true blue, with indigo blue, Tuscan red, and touches of peacock green. In the green section use grass green and true green with canary yellow, Tuscan red, and dark green. Add blue slate and greyed lavender to the cast shadow.

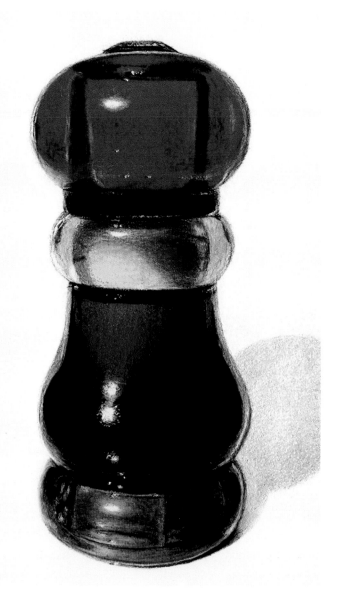

▲ Burnish the saltshaker and its cast shadow carefully with white, using a sharp point and a light touch. Notice that the shadow should be darkest where it touches the base of the salt-shaker. Reapply the colors where they are shiny and bright. Darken the values with black. Then use a colorless blender to merge the colors together. Add more white to the areas where the glass looks glossy and has reflective light. If you used masking fluid to protect the brightest high-lights, remove it now. Use white to blur the edges of the brightest highlights. With an X-Acto knife, scrape away some small highlights to add more shape to the piece.

Three Swirled Marbles

TIP: Even clear glass has a value that is darker than the white of the paper, so don't show the transparency of these marbles by leaving them untouched by your pencils.

STEP #1: Begin by working on the shadows with **warm grey 30%.**

STEP #2: Articulate the farthest marble with **lemon yellow, greyed lavender,** and **Caribbean sea.**

STEP #3: Articulate the middle marble with **peacock green, Copenhagen blue, ultramarine,** and **lemon yellow,** with touches of **dark purple** in the darkest areas.

STEP #4: Articulate the closest marble with **Caribbean sea, apple green,** and **lemon yellow.**

STEP #5: Add touches of **dark purple** in the darkest areas of all three marbles.

STEP #6: Apply an **OMS wash** with a waterbrush.

STEP #7: Add light touches of **canary yellow** on the cast shadow of the farthest marble.

STEP #8: Add **canary yellow, peacock green,** and **Caribbean sea** to the middle marble.

STEP #9: Add touches of **apple green, canary yellow,** and **dark purple** to the cast shadow of the closest marble.

STEP #10: Use **dark umber** to reinforce the darkest areas in the shadows.

STEP #11: Morph the values with a **colorless blender.**

STEP #12: Burnish the marbles with **white.**

STEP #13: Add more depth to the farthest marble with **indigo blue** and **dark umber.**

STEP #14: Give some shape to the middle marble by adding **dark brown** and **indigo blue** to the green and blue areas respectively, then bind the colors together with **true blue.**

STEP #15: Add **indigo blue** and **dark umber** to the darkest areas of the middle marble.

STEP #16: Enhance the dimensionality of the closest marble with **periwinkle** and **grass green,** with **indigo blue** and **dark umber** in the darkest parts.

STEP #17: Use a **colorless blender** to pull the colors together and smooth all of the visible pencil strokes.

EXERCISE #12:

A Decorative Perfume Bottle

In this project we will render a subtly gradated background and a complex object with various reflective surfaces and patterns.

▲ A brief glance at this photograph would make one think that it is some kind of sepia-toned image. However, in our rendering, we will change the color and emphasize the blues. The darkest part of the background is on the bottom, and it brings excellent contrast to the glass. The values of the silver cap on the very top almost blend with the lightest values of the background. Overall, the image contains many bright highlights that contrast with the deep dark shapes on the silver and the glass. Together these create interesting patterns that attract the attention of the viewer.

▲ Transfer the outline of the perfume bottle to your drawing surface and protect the brightest highlights with masking fluid.

TIP: Avoid completely sealing the paper surface with layers of pencil in the intermediary stages. This way you will be able to step back from your work and see where it needs to be lightened at the very end.

▲ Using black, begin working from the bottom of the background with a normal touch, gradually reducing your pressure to a light touch at the very top. With the same sharp-pointed black pencil, create a value map on the glass and silver parts of the bottle. Use a light touch for the lightest values, and increase the pressure for the darker areas.

▲ Apply an OMS wash on the background and the bottle, using a waterbrush on the smaller areas and a cotton pad on the background. Go over the surface using a slightly rubbing motion to merge your strokes together, but avoid creating solid colors in places of value transition on the glass or the silver cap.

▲ Begin working with the indigo blue pencil. Starting from the very bottom and using a normal touch, gradually work toward the area where the background lightens, moving to a light touch accordingly. With greyed lavender, begin working with a normal touch from the top of the background and go toward the end of indigo blue layer, gradually reducing to a light touch. Merge the indigo blue and greyed lavender sections by overlapping parts of the background. This will blend the colors.

▲ With a sharp point and a light pressure, work on the silver cap and the bottle using greyed lavender on the lightest values and black grape on the middle and darker values. Add touches of sand to the silver and glass parts of the bottle to create a sense of light.

▲ To complete the image, remove the masking fluid from the highlights. Add a light touch of blush pink to the top of the background, and smooth the strokes with a colorless blender. Burnish the bottle with white, and reinforce the colors with all of the previously used pencils. Add touches of canary yellow, Tuscan red, and indigo blue to the bottle to create a prism illusion for the glass. Also, add tiny touches of the same color to the cap to create the look of the shiny silver surface. If you need to slightly lighten the center of the glass part of the bottle to emphasize its round shape, roll a small piece of mounting putty across it. Darken or lighten the values of the silver cap slightly to create volume for each of them. Again, smooth your strokes with a colorless blender. Add more contrast to the darkest parts of the bottle with touches of black. Adjust the value of the background to prevent it from competing with the main object.

Afterword

If the history of art shows us any one undeniable thing, it is that artistic evolution progresses in parallel with technology. Before the invention of photography, all visual aspects of human experiences were captured through the skills of artists. They recorded historical events, portrayed important figures, and depicted majestic landscapes. (Even the success of arranged marriages relied on the skills of an artist, as the preliminary view of an individual's personal appearance frequently rested in the hands of the painter.) Furthermore, the secrets of the masters were obtainable only through word of mouth and were limited by, among other things, the speed of one's horse. In addition, the availability of art supplies was very limited. Pigments were expensive and the actual source of many of them was not well known.

The wonders of modern technology—including chemistry, engineering, and communications—have not only helped artists develop new techniques but have also allowed us to quickly share our discoveries and creations with others. Prior to the Renaissance period, reproduction of original artwork required long hours of copying by hand. When printing was developed, it allowed more and more people to own beautiful artwork. Today, artists are blessed with endless ways to create and to share their creations. However, artistic competition has also significantly increased. In the past, artists were few but they developed their skills by practicing their drawing. These days, many artists rely on modern technology to do the creating and do not necessarily feel obligated to spend the time and effort needed to develop real drawing skills. Yet these skills are the real basis for any kind of painting or any other visual art.

When artists work with colored pencil in a representational manner, they show their skills, particularly their innate ability to see and to show what they see. Colored pencil does not allow an artist to cover an error with another layer of paint. Every stroke is plainly visible. When rendering a particular subject, the colored pencil artist shows his or her complete understanding of that subject—no less and no more.

No one begins life with perfect skills in anything, whether walking, talking, or drawing. We all begin our creative endeavors by drawing rudimentary shapes and figures. Some develop artistic skills quickly because they are gifted with a natural hand-eye coordination; others must work hard to achieve the same skill level. We are all different and we all have different abilities. Our success will greatly depend on how much effort and hard work we are willing to put forth.

Experiment and follow your heart and intuition. Develop your own style. Style is your choice of subject. Some of us are attracted to landscapes or architectural drawings and some love portraits or images of wild life. Style is your choice of colors, be they warm, cold, bright, or pale. Style is in your composition. Moreover style is your skill and your method of rendering what you see. Style is you. An artist's style flows from the inside out. Your artwork is not a copy of what surrounds you, but an interpretation of what you see. Even when two people look at the same subject and use the same art supplies, they almost always end up with two very different pieces of art. This is a result of their different personalities, life experiences, and skills.

As you mature as an artist, your outlook on life will change, your vision will progress, and so

too your individual style will evolve. With practice you will master various skills and in so doing you will discover new ways of expressing yourself. These discoveries can be incorporated into your own style. No one is perfect, but working toward perfection is the only way to become a master of your skills. If nothing else, you should endeavor to do something better today than you did it yesterday.

Do not compete with others. Instead, become inspired by others. You should be your own biggest competitor. Live within the continuing process of improving your skills. But don't worry—improvement always comes with a certain degree of disappointment. Enjoy the process. Be happy when you find a good solution to a problem, but always keep an eye out for mistakes. It will help you constantly improve your work.

If you feel discouraged, it can only mean that you are growing. If you feel completely satisfied, you are probably at a dead end and need to reevaluate your work. However, a life of singular self-criticism is not healthy. Off-balanced behavior that brings you no enjoyment is not worth the effort. You must praise yourself every time you complete a project, and you must also look criti-

cally at the result. Find the good in what you have done, admit it, and praise yourself; but also observe your mistakes and make notes for the future. This is a healthy and balanced way to achieve satisfaction in your work. You don't necessarily need to rely on the praise or critique of others to be happy with your own efforts and to grow as an artist.

Make a wish and find your way. Make a plan and follow it. Achieve your goals. You must know what you want before you can make it happen. Don't just do what others want you to and don't lie to yourself. For example, the statement "I want to make a living with my artwork" could mean that you will need to sell two hundred pieces of art per year. To do this you will need to treat your artwork as a product, be prolific, and have efficient sales channels in place. Some artists find this an acceptable way to make money and pursue it very effectively. Personally, this approach was never attractive to me.

My own vision of an artistic career is to prioritize quality over quantity and to bring real value to my work, as it deserves. I have to admit; it is a slow process, takes tremendous effort, and requires the support of my loved ones. However, this is a matter of personal choice and personal situation. You have to make your own success formula according to your own desires and your own circumstances.

Do not be afraid to share your knowledge and techniques with other artists. As I mentioned earlier, because we are all different, we each create different art. This is true even when we are using the same materials, mediums, techniques, and subject matter. The result of your effort will always be your own artwork. When you are sharing and helping others, you are also growing. Your talent, generosity, methodology, and techniques will extend outward with you at the center. Enjoy the process!

Appendix

With the increased popularity of colored pencil as a fine art media in recent years, art supply manufacturers have responded by expanding their selection. This is welcome news, indeed. Not only does it enhance our creative options, but it introduces competition to the marketplace. However, it also adds a degree of complexity to the task of evaluating the tools required to produce a colored pencil painting.

Before you invest a lot of money into your personal stock of colored pencils, you must consider all aspects of each colored pencil line. While pencil quality, color selection, availability, and affordability have always been important considerations, lightfastness has recently emerged as one of the most essential aspects of professional colored pencil painting materials. Independent bodies such as the American Society for Testing and Materials (ASTM) provide lightfastness testing for colorants such as those used in colored pencils. However, since there is yet to be conformity among manufacturers, a true standard has not yet been embraced by all concerned parties. On a practical level, this means that the lightfastness rating system is different for almost every manufacturer. Some manufacturers go with a three-star system, some with a scale of 1 to 8, and some have declined to supply lightfastness ratings at all.

The lightfastness of any color (including the colors of colored pencils) greatly depends on the participating pigments. The Color Index (CI) name is an internationally recognized classification of dyes and pigments, available from the Association of Textile Chemists and Colorists in the United States and the Society of Dyers and Colourists in the UK. According to this system,

each colorant has its own Colored Index name, which indicates the category of the colorant (dye or pigment), its hue (blue, red, and so forth), and an assigned number. For example, in the CI name PW6: "P" stands for pigment, "W" stands for white, and "6" is the assigned number for the particular colorant in the color known as titanium white. The abbreviations for this system are as follows: PB (pigment blue); PBk (pigment black); PBr (pigment brown); PG (pigment green); PM (pigment metal); PO (pigment orange); PV (pigment violet); PW (pigment white); and PY (pigment yellow).

Obviously the Color Index name is valuable information for artists. However, some manufacturers refuse to disclose it, claiming that it could reveal their manufacturing secrets and therefore jeopardize their business. This claim seems absurd, particularly since the CI name does not divulge the chemical formula or even the complete contents of the mix contained within the pencil. It is also worth noting that sometimes very different colors have the same CI name, due to differences in the manufacturing processes and the presence of impurities or additives.

Below is a list of pencil manufacturers and their associated pencil lines with the lightfastness rating and Color Index name. Pencil numbers and names are exactly as provided by the manufacturers. Lightfastness and CI information are provided only for those manufacturers who are willing to disclose it publicly (which is why this list does not include all of the pencil lines that I mention on page 6). Even though this list is by no means complete, it does provide a good starting point for your own investigation. In addition, the Colored Pencil Society of America (CPSA) was

instrumental in establishing the colored pencil Lightfastness Standard D6901 with ASTM, International. CPSA regularly tests colored pencil brands and provides this information to its members. For more information about CPSA, visit www.cpsa.org.

Keep in mind that the master artists of the past knew almost nothing of such standards and many of their masterpieces have survived for hundreds of years. So if you find yourself having to choose between using only lightfast colors and getting the results you want, use your judgment. While lightfastness is certainly desirable, some responsibility for protecting precious artwork from harmful elements rests with the consumer. After all, you wouldn't blame Rembrandt if the owner of his painting left it in the hot sun and ruined a priceless work of art.

Manufacturer: Caran d'Ache
Pencil Line: Luminance
Base: Wax
Available Colors: 76
Notes: In accordance with the ASTM D6901 guidelines, only colored pencils with a rating of I or II are deemed compliant with the lightfast standard.

Pencil Number	Pencil Name	Light-fast Rating	Color Index	Pencil Number	Pencil Name	Light-fast Rating	Color Index	Pencil Number	Pencil Name	Light-fast Rating	Color Index
6901/001	white	I	PW6	6901/065	russet	I	PR101, PR188, PY42	6901/161	light blue	II	PB15:3, PBk9
6901/002	silver grey	I	PB15, PBk6					6901/162	phthalo-cyanine blue	I	PB15:3
6901/004	steel grey	I	PB15, PBk6	6901/069	burnt sienna	I	PR101, PBk6				
6901/009	black	I	PBk6					6901/171	turquoise blue	II	PB15:3, PG7, PBk9
6901/015	olive yellow	I	PBk6, PY3	6901/070	scarlet	II	PR254				
6901/025	green ochre	II	PY3, PY42, PY13, PO62, PBk6	6901/077	burnt ochre	I	PY42, PR101	6901/180	malachite green	I	PG7, PBk9
				6901/083	ultramarine pink	II	PR259	6901/181	light malachite green	I	PG7, PBk9
6901/030	orange	I	PO62								
6901/034	yellow ochre	I	PY42, PY3	6901/093	violet grey	I	PR101, PY42, PV23, PBk6, PBk11	6901/182	cobalt green	I	PG50
6901/036	raw sienna	I	PY42								
6901/037	brown ochre	I	PY42, PBk9 PR101,	6901/095	light aubergine	I	PR101, PV23, PBk6	6901/185	ice blue	I	PB16
								6901/214	beryl green	I	PG7
6901/039	olive brown	II	PY42, PBk9	6901/112	manganese violet	I	PV16				
								6901/220	grass green	I	PY1, PY3, PG7
6901/041	apricot	II	PO61	6901/120	violet	II	PV23				
6901/046	cassel earth	I	PR101, PBr7, PBk6, PBk11	6901/129	violet brown	II	PR101, PV23, PY42, PBk9	6901/225	moss green	I	PY3, PB60, PBk6
								6901/240	lemon yellow	I	PY3
6901/061	permanent red	I	PR242	6901/159	Prussian blue	I	PB27				

Pencil Number	Pencil Name	Light-fast Rating	Color Index
6901/242	primrose	I	PY42, PY195
6901/350	purplish red	II	PR122, PR179
6901/407	sepia	I	PR101, PBr7, PBk6, PBk11
6901/470	spring green	I	PY3, PG7
6901/495	slate grey	I	graphite
6901/504	Payne's grey 30%	I	PB29, PBk6
6901/507	Payne's grey 60%	II	PB29, PBk6
6901/508	Payne's grey	I	PB29, PBk6
6901/548	genuine umber	I	PR101, PY42, PBk11
6901/571	Anthra-quinoid pink	I	PR168
6901/585	perylene brown	I	PR179
6901/589	crimson alizarin (hue)	II	PR178, PV19
6901/599	crimson aubergine	I	PR179, PV19, PB15
6901/630	ultramarine violet	I	PV15
6901/660	middle cobalt blue (hue)	II	PB15, PB29
6901/661	light cobalt blue	I	PB28
6901/662	cobalt blue genuine	I	PB28
6901/729	dark English green	I	PG7, PBk9
6901/732	olive brown 10%	I	PY42, PBk9
6901/736	olive brown 50%	I	PY42, PBk9
6901/739	dark sap green	I	PG7, PBk6
6901/755	grey blue	I	PB15, PB27, PBk6
6901/801	buff titanium	II	PY151, PR101
6901/802	French grey 10%	I	PY42, PR101, PBk6
6901/803	French grey 30%	I	PY42, PR101, PBk6
6901/808	French grey	I	PY42, PR101, PBk6
6901/810	bismuth yellow	I	PY184
6901/820	golden bismuth yellow	I	PY184
6901/821	Naples ochre	I	PY42, PY184, PBr7
6901/832	brown ochre 10%	I	PR101, PY42, PBk9
6901/836	brown ochre 50%	II	PR101, PY42, PBk9
6901/842	genuine umber 10%	I	PR101, PY42, PBk11
6901/846	genuine umber 50%	I	PR101, PY42, PBk11
6901/850	cornelian	I	PO61
6901/862	burnt sienna 10%	I	PR101, PBk6
6901/866	burnt sienna 50%	I	PR101, PBk6
6901/872	burnt ochre 10%	I	PR101, PY42
6901/876	burnt ochre 50%	I	PR101, PY42
6901/902	sepia 10%	I	PR101, PBr7, PBk6, PBk11
6901/906	sepia 50%	I	PR101, PBr7, PBk6, PBk11

Manufacturer: Caran d'Ache

Pencil Line: Pablo

Base: Oil

Available Colors: 120

Notes: Lightfastness ratings are indicated with stars, with three (***) representing an excellent rating; two (**) a very good rating; and one (*) a good rating.

Pencil Number	Pencil Name	Light-fast Rating	Color Index
666/001	white	***	PW6
666/002	silver grey	**	PBk7, PB15
666/003	light grey	**	PBk7, PB15
666/004	steel grey	***	PBk6, PB15
666/005	grey	***	PBk7, PB15
666/006	mouse grey	***	PBk7, PB15, PY175
666/007	dark grey	***	PBk7, PB15, PY175

Pencil Number	Pencil Name	Light-fast Rating	Color Index	Pencil Number	Pencil Name	Light-fast Rating	Color Index	Pencil Number	Pencil Name	Light-fast Rating	Color Index
666/008	greyish black	***	PBk7, PB15	666/053	hazel	***	PY42, PR101	666/139	indigo blue	**	PBk7, PB15:3, PV23
666/009	black	***	PBk7	666/055	cinnamon	**	PR112, PO62, PBk7	666/140	ultramarine	**	PB29, PB1
666/010	yellow	**	PY13	666/057	chestnut	***	PY42, PBk7, PR101	666/141	sky blue	*	PB15:3, PV23
666/011	pale yellow	**	PY3, PY154	666/059	brown	**	PG8, PY3, PR3	666/145	bluish grey	**	PB60
666/015	olive yellow	***	PY3, PBk6	666/060	vermilion	**	PR4	666/149	night blue	***	PB15, PR202
666/016	khaki yellow	***	PY3, PBk6	666/062	Venetian red	**	PR166, PY42	666/150	sapphire blue	***	PB15:3, PB15
666/018	olive grey	***	PY3, PBk6	666/063	English red	**	PR166, PY42	666/151	pastel blue	**	PB60, PB15
666/019	olive black	***	PY3, PBk6	666/065	russet	**	PY1, PR3, PO13, PB15	666/155	blue jeans	**	PB60, PB15, PBk7
666/020	golden yellow	**	PY83	666/067	mahogany	***	PR101	666/159	Prussian blue	**	PB1, PG7, PBk7
666/021	Naples yellow	**	PY83	666/069	burnt siena	**	PR101, PBk7	666/160	cobalt blue	***	PB15:3, PG7
666/025	green ochre	**	PBk7, PY42, PY13, PY1, PO62	666/070	scarlet	**	PR4, PR170	666/161	light blue	***	PB15
666/030	orange	**	PO13, PY13	666/071	salmon pink	*	PR168	666/169	marine blue	***	PB15, PB15:3, PBk7
666/031	orangish yellow	**	PO36, PO62	666/075	Indian red	**	PR170, PR112, PBk7	666/170	azurite blue	***	PB15:3, PG7
666/032	light ochre	**	PY42	666/080	carmine	**	PV19, PR23	666/171	turquoise blue	**	PB15, PG7
666/033	golden ochre	**	PY42, PY151, PO62	666/081	pink	*	PV19	666/180	malachite green	***	PB15, PG7
666/035	ochre	**	PY42	666/082	rose pink	**	PR149, PR57:1	666/181	light malachite green	**	PB15, PG7
666/037	brown ochre	***	PBk7, PY42, PR101	666/085	Bordeaux red	**	PR48:4, PV19, PBk7	666/190	greenish blue	***	PB15, PG7
666/039	olive brown	**	PY42, PBk7, PO62	666/089	dark carmine	**	PR48:4, PV19, PBk7	666/191	turquoise green	**	PB15, PG7
666/040	reddish orange	**	PO62, PR112	666/090	purple	**	PR202	666/195	opaline green	**	PB15, PG7, PBk7
666/041	apricot	**	PO61	666/091	light purple	**	PV19	666/200	bluish green	***	PB15:3, PY3
666/043	brownish orange	***	PR101, PBk7	666/099	aubergine	**	PR202, PBk6	666/201	Veronese green	**	PY3, PG7, PB15:3
666/045	Vandyke brown	**	PR101, PY42, PBk7	666/100	purple violet	**	PV19	666/210	emerald green	**	PB15:3, PY3
666/047	bistre	***	PBk7, PBk11, PY42, PR101	666/110	lilac	**	PV23, PR122	666/211	jade green	**	PG7, PY1
666/049	raw umber	**	PBk7, PY3, PR3, PG8	666/111	mauve	*	PR122, PV2, PV23	666/215	greyish green	**	PG7, PY3, PBk7
666/050	fame red	**	PR9, PO62	666/120	violet	**	PR122, PV23				
666/051	salmon	*	PO62, PR168	666/130	royal blue	**	PV23, PB15				
				666/131	periwinkle blue	*	PV23				

Pencil Number	Pencil Name	Light-fast Rating	Color Index	Pencil Number	Pencil Name	Light-fast Rating	Color Index	Pencil Number	Pencil Name	Light-fast Rating	Color Index
666/220	grass green	***	PB15:3, PY3	666/270	raspberry red	**	PR209	666/407	sepia	**	PB15, PBk7, PY42, PR101
666/221	light green	**	PB15:3, PY3	666/280	ruby red	**	PR170, PR112, PBk7	666/409	charcoal grey	***	PR101
666/225	moss green	**	PBk7, PG8, PY3, PY175								
666/229	dark green	***	PB15:3, PY1, PO13	666/290	empire green	***	PB15:3, PY3	666/460	peacock green	**	PG36
666/230	yellow green	**	PG7, PY3, PBk7	666/300	fast orange	***	PO62	666/470	spring green	**	PY3, PB15:3
				666/350	purplish red	***	PR202, PR209				
666/231	lime green	**	PY3, PB15:3					666/491	cream	***	PY42
666/239	spruce green	**	PB15, PY3, PY42	666/370	gentian blue	***	PB15:3	666/493	granite rose	***	PR101
666/240	lemon yellow	***	PY3	666/371	bluish pale	**	PB15	666/495	slate grey	***	graphite
				666/401	ash grey	***	PY42, PBk7	666/496	ivory black	***	PBk6
666/241	light lemon yellow	**	PY154	666/402	light beige	**	PR101, PY42, PBk7	666/497	bronze	***	PO34, PR188, PY3, aluminum powder
666/245	light olive	**	PY3, PO13, PB15	666/403	beige	**	PR101, PY42, PBk7				
666/249	olive	**	PY3, PBk7, PB15, PO13	666/404	brownish beige	***	PR101, PY42, PBk7	666/498	silver	***	aluminum powder
666/250	canary yellow	***	PY151	666/405	cocoa	**	PR101, PBk7, PB15 PY42,	666/499	gold	***	PY13, PO61, PR112, aluminum powder
666/260	blue	***	PB15								

Manufacturer: Derwent

Pencil Line: Artists

Base: Wax

Available Colors: 120

Notes: Lightfastness ratings are based on a blue wool scale test standard, with 8 being the highest rating. Ratings of 6 and higher are considered to be lightfast. Color Index (CI) information is not available from the manufacturer.

Pencil Number	Pencil Name	Lightfast Rating	Pencil Number	Pencil Name	Lightfast Rating	Pencil Number	Pencil Name	Lightfast Rating
0000	lime	7	0510	buttercup yellow	7	1200	scarlet lake	6
0100	zinc yellow	7	0600	deep cadmium	4	1300	pale vermillion	3
0200	lemon cadmium	1	0700	Naples yellow	4	1400	deep vermillion	4
0300	gold	8	0800	middle chrome	3	1410	bright red	6
0400	primrose yellow	4	0900	deep chrome	4	1500	geranium lake	4
0410	champagne	3	1000	orange chrome	5	1600	flesh pink	4
0500	straw yellow	4	1100	spectrum orange	5	1610	light sienna	8

Pencil Number	Pencil Name	Lightfast Rating	Pencil Number	Pencil Name	Lightfast Rating	Pencil Number	Pencil Name	Lightfast Rating
1620	salmon	8	3610	ash blue	4	5500	Vandyke brown	8
1630	ash rose	8	3620	phthalo blue	7	5600	raw umber	4
1700	pink madder lake	3	3700	Oriental blue	4	5700	brown ochre	8
1800	rose pink	1	3710	midnight blue	6	5710	light ochre	8
1810	Rioja	7	3800	kingfisher blue	3	5720	yellow ochre	8
1900	madder carmine	4	3900	turquoise blue	1	5800	raw sienna	4
1910	claret	5/6	4000	turquoise green	2	5900	golden brown	8
2000	crimson lake	4	4100	jade green	3	6000	burnt yellow ochre	8
2100	rose madder lake	1	4110	cobalt green	4	6100	copper beech	8
2110	plum	6	4120	fir green	4	6200	burnt sienna	3
2120	grape	4	4130	spruce green	6/7	6300	Venetian red	4
2200	magenta	1	4140	distant green	4	6400	terracotta	8
2210	heather	7/8	4150	phthalo green	7	6410	sunset gold	1
2220	soft violet	6/7	4200	juniper green	4	6420	autumn leaf	3
2300	imperial purple	3	4300	bottle green	4	6430	rust	3
2400	red violet lake	1	4400	water green	4	6440	light rust	8
2410	slate violet	8	4500	mineral green	4	6450	mahogany	7/8
2500	dark violet	3	4600	emerald green	4	6460	burnt rose	3/4
2600	light violet	1	4700	grass green	7	6470	Mars violet	4
2700	blue violet lake	1	4800	May green	6	6480	taupe	1
2800	Delft blue	3	4900	sap green	5	6490	bistre	2
2810	royal blue	3	5000	cedar green	4	6500	burnt carmine	3
2820	mid ultramarine	8	5010	green grey	4	6600	chocolate	3
2830	real blue	7/8	5100	olive green	4	6610	Mars black	2
2840	pale ultramarine	3/4	5110	moss green	7	6700	ivory black	3
2900	ultramarine	4	5120	light moss	6/7	6800	blue grey	4
3000	smalt blue	1	5130	chartreuse	8	6900	gunmetal	4
3100	cobalt blue	2	5140	green earth	4	6910	storm grey	7
3200	spectrum blue	3	5150	parchment	4	7000	French grey	4
3300	light blue	3	5160	olive earth	6/7	7100	silver grey	6
3400	sky blue	2	5200	bronze	8	7110	fell mist	3
3500	Prussian blue	3	5300	sepia	4	7200	Chinese white	1
3600	indigo	4	5310	felt grey	8			
			5400	burnt umber	8			

Manufacturer: Derwent
Pencil Line: Coloursoft
Base: Wax
Available Colors: 72
Notes: Lightfastness ratings are based on a blue wool scale test standard, with 8 being the highest rating. Ratings of 6 and higher are considered to be lightfast. Color Index (CI) information is not available from the manufacturer.

Pencil Number	Pencil Name	Lightfast Rating	Pencil Number	Pencil Name	Lightfast Rating	Pencil Number	Pencil Name	Lightfast Rating
C010	cream	8	C250	purple	4/5	C490	pale mint	3/4
C020	acid yellow	8	C260	bright lilac	3	C500	lichen green	8
C030	lemon yellow	8	C270	royal purple	3/4	C510	brown	8
C040	deep cadmium	7	C280	blackberry	5	C520	dark brown	8
C050	yellow ochre	8	C290	ultramarine	5/6	C530	pale brown	8
C060	pale orange	8	C300	indigo	8	C540	pimento	8
C070	orange	8	C310	Prussian blue	8	C550	ginger	8
C080	bright orange	8	C320	electric blue	7/8	C560	peach	8
C090	blood orange	8	C330	blue	8	C570	pale peach	8
C100	rose	8	C340	baby blue	4/5	C580	light sand	6
C110	scarlet	7	C350	iced blue	6/7	C590	ochre	8
C120	red	5	C360	cloud blue	3	C600	mid brown	8
C130	deep red	8	C370	pale blue	6/7	C610	dark terracotta	8
C140	deep fuchsia	2	C380	sea green	6	C620	mid terracotta	8
C150	cranberry	8	C390	grey green	8	C630	brown earth	8
C160	loganberry	8	C400	mid green	7	C640	brown black	8
C170	soft pink	3/4	C410	dark green	8	C650	black	8
C180	blush pink	5	C420	green	8	C660	Persian grey	8
C190	pink	1/2	C430	pea green	5/6	C670	dove grey	8
C200	bright pink	5	C440	light green	7/8	C680	petrel grey	8
C210	pink lavender	3/4	C450	yellow green	6	C690	steel grey	7
C220	grey lavender	8	C460	lime green	6	C700	mid grey	8
C230	pale lavender	8	C470	mint	5	C710	white grey	8
C240	bright purple	4	C480	Lincoln green	7	C720	white	8

Manufacturer: Faber-Castell

Pencil Line: Polychromos

Base: Oil

Available Colors: 120

Notes: Lightfastness ratings are indicated with stars, with three (***) representing maximum fade resistance (100+ years); two (**) very good fade resistance (25+ years); and one (*) good fade resistance (5+ years). The lightfastness test is based on blue wool scale test standard, which is comparable to ASTM D 5383-02 and ASTM D 5383-97. Color Index (CI) information is not available from the manufacturer.

Pencil Number	Pencil Name	Lightfast Rating	Pencil Number	Pencil Name	Lightfast Rating	Pencil Number	Pencil Name	Lightfast Rating
9201-101	white	***	9201-129	pink madder lake	**	9201-276	chrome oxide green fiery	***
9201-103	ivory	***	9201-125	middle purple pink	***	9201-161	phthalo green	***
9201-102	cream	***	9201-134	crimson	***	9201-163	emerald green	***
9201-104	light yellow glaze	***	9201-160	manganese violet	***	9201-162	light phthalo green	***
9201-205	cadmium yellow lemon	***	9201-138	violet	***	9201-171	light green	***
9201-105	light cadmium yellow	***	9201-136	purple violet	***	9201-166	grass green	***
9201-106	light chrome yellow	***	9201-137	blue violet	***	9201-112	leaf green	***
9201-107	cadmium yellow	***	9201-249	mauve	***	9201-266	permanent green	***
9201-108	dark cadmium yellow	***	9201-141	Delft blue	***	9201-167	permanent green olive	***
9201-109	dark chrome yellow	***	9201-157	dark indigo	***	9201-267	pine green	***
9201-111	cadmium orange	***	9201-247	indanthrene blue	***	9201-278	chrome oxide green	***
9201-113	orange glaze	***	9201-151	helioblue, reddish	***	9201-165	juniper green	***
9201-115	dark cadmium orange	***	9201-143	cobalt blue	***	9201-173	olive green yellowish	***
9201-117	light cadmium red	**	9201-120	ultramarine	***	9201-268	green gold	***
9201-118	scarlet red	**	9201-140	light ultramarine	***	9201-170	May green	***
9201-121	pale geranium lake	***	9201-146	smalt blue	***	9201-168	earth green yellowish	***
9201-219	deep scarlet red	***	9201-144	cobalt blue, greenish	***	9201-174	chrome green opaque	***
9201-126	permanent carmine	***	9201-110	phthalo blue	***	9201-172	earth green	***
9201-223	deep red	**	9201-152	middle phthalo blue	***	9201-169	caput mortuum	***
9201-217	middle cadmium red	***	9201-145	light phthalo blue	***	9201-263	caput mortuum violet	***
9201-225	dark red	***	9201-149	bluish turquoise	***	9201-193	burnt carmine	***
9201-142	madder	***	9201-246	Prussian blue	***	9201-194	red-violet	***
9201-226	alizarin crimson	**	9201-155	helio turquoise	***	9201-135	light red-violet	***
9201-127	pink carmine	**	9201-153	cobalt turquoise	***	9201-130	dark flesh	***
9201-124	rose carmine	***	9201-154	light cobalt turquoise	***	9201-131	medium flesh	***
9201-128	light purple pink	*	9201-156	cobalt green	***	9201-132	light flesh	***
9201-123	fuchsia	**	9201-158	deep cobalt green	***	9201-189	cinnamon	***
9201-133	magenta	***	9201-159	Hooker's green	***			
9201-119	light magenta	*	9201-264	dark phthalo green	***			

Pencil Number	Pencil Name	Lightfast Rating	Pencil Number	Pencil Name	Lightfast Rating	Pencil Number	Pencil Name	Lightfast Rating
9201-191	Pompeian red	***	9201-176	Van Dyck brown	***	9201-230	cold grey I	***
9201-192	Indian red	***	9201-178	nougat	***	9201-231	cold grey II	***
9201-190	Venetian red	***	9201-280	burnt umber	***	9201-232	cold grey III	***
9201-188	sanguine	***	9201-283	burnt siena	***	9201-233	cold grey IV	***
9201-187	burnt ochre	***	9201-177	walnut brown	***	9201-234	cold grey V	***
9201-186	terracotta	***	9201-175	dark sepia	***	9201-235	cold grey VI	***
9201-183	light yellow ochre	***	9201-275	warm grey VI	***	9201-181	Payne's grey	***
9201-185	Naples yellow	***	9201-274	warm grey V	***	9201-199	black	***
9201-184	dark Naples ochre	***	9201-273	warm grey IV	***	9201-251	silver	***
9201-182	brown ochre	***	9201-272	warm grey III	***	9201-250	gold	***
9201-180	raw umber	***	9201-271	warm grey II	***	9201-252	copper	***
9201-179	bistre	***	9201-270	warm grey I	***			

Manufacturer: Lyra

Pencil Line: Rembrandt Polycolor

Base: Oil

Available Colors: 72

Notes: Lightfastness ratings are indicated with stars, with three (***) representing an excellent rating; two (**) a very good rating; and one (*) a fair rating. Color Index (CI) information is not available from the manufacturer.

Pencil Number	Pencil Name	Lightfast Rating	Pencil Number	Pencil Name	Lightfast Rating	Pencil Number	Pencil Name	Lightfast Rating
01	white	***	26	dark carmine	***	41	Delft blue	**
02	cream	***	27	light carmine	*	43	deep cobalt	*
04	zinc yellow	***	28	rose madder lake	*	44	light cobalt	*
05	lemon cadmium	*	29	pink madder lake	*	46	sky blue	**
06	light chrome	***	30	dark flesh	***	47	light blue	*
07	citron	*	31	medium flesh	***	48	true blue	*
08	canary yellow	**	32	light flesh	***	49	Oriental blue	***
09	orange yellow	**	33	wine red	***	50	Paris blue	**
13	light orange	**	34	magenta	*	51	Prussian blue	***
15	dark orange	**	35	red violet	**	53	peacock blue	***
17	vermillion	**	36	dark violet	*	54	aquamarine	*
18	scarlet lake	***	37	blue violet	*	55	night green	***
21	pale geranium lake	***	38	violet	*	58	sea green	***
24	rose carmine	**	39	light violet	*	59	Hooker's green	***

Pencil Number	Pencil Name	Lightfast Rating		Pencil Number	Pencil Name	Lightfast Rating		Pencil Number	Pencil Name	Lightfast Rating
61	viridian	***		74	cedar green	***		90	Venetian red	***
62	true green	***		75	dark sepia	***		91	Pompejan red	***
63	emerald green	***		76	Van-Dyck-brown	***		92	Indian red	***
65	juniper green	***		80	raw umber	**		93	burnt carmine	***
67	sap green	***		82	brown ochre	***		94	purple	***
68	moss green	**		83	gold ochre	**		95	light grey	***
70	apple green	**		84	ochre	**		96	silver grey	***
71	light green	***		85	light ochre	***		97	medium grey	***
72	grey green	***		87	burnt ochre	**		98	dark grey	***
73	olive green	**		89	cinnamon	***		99	black	***

Manufacturer: Prismacolor

Pencil Line: Artstix

Base: Wax

Available Colors: 48

Notes: Lightfastness ratings are not available from manufacturer. Color Index (CI) information is not available from the manufacturer. Please check my Web site, www.brushandpencil.com, for future updates.

Manufacturer: Prismacolor

Pencil Line: Lightfast

Base: Wax

Available Colors: 48

Notes: In accordance with the ASTM D6901 guidelines, only colored pencils with a rating of I or II are deemed compliant with the lightfast standard. Not all Color Index (CI) information is available from the manufacturer.

Pencil Number	Pencil Name	Light-fast Rating	Color Index		Pencil Number	Pencil Name	Light-fast Rating	Color Index		Pencil Number	Pencil Name	Light-fast Rating	Color Index
LF116	canary yellow	II	PY1		LF142	orange ochre	II	n/a		LF145	English red light	I	PR101
LF203	gamboge	I	PY42, PY1		LF118	cadmium orange hue	II	PO36, PW6		LF195	thio violet	II	PR202, PW6
LF140	eggshell	I	n/a							LF285	light oxide red	I	n/a
LF114	ivory oxide	I	n/a		LF127	rose peach	I	n/a					
LF197	beige	I	PY42, PR101, PW6		LF126	carmine red	II	PR112, PW6		LF209	manganese violet	I	n/a
					LF124	cadmium red	II	PR170, PO16					
LF139	light peach	II	PY42, PR101, PR112, PW6		LF122	permanent red	II	n/a		LF260	cold grey 2	I	n/a
										LF287	blue silver	I	n/a
					LF129	madder lake	II	n/a		LF224	pale blue	I	n/a
										LF133	cobalt blue hue	II	PB29, PW6

Pencil Number	Pencil Name	Light-fast Rating	Color Index	Pencil Number	Pencil Name	Light-fast Rating	Color Index	Pencil Number	Pencil Name	Light-fast Rating	Color Index
LF132	dioxazine purple hue	II	PV32	LF112	phthalo yellow green hue	II	PY3, PG7	LF147	Van Dyke brown	I	n/a
LF208	indanthrone blue	II	PB15:3, PV23	LF120	sap green light	I	n/a	LF148	sepia oxide	I	n/a
LF101	Prussian blue	II	PB27	LF109	Prussian green	II	PY1, PY42, PB27	LF2051	neutral grey 2	I	n/a
LF222	iron blue	II	n/a	LF189	cinnabar yellow	II	n/a	LF2054	neutral grey 5	I	n/a
LF103	cerulean blue	II	PB15:3, PW6	LF115	lemon yellow	II	PY3, PW6	LF2063	cool grey 50%	I	PBk7, PB15, PW6
LF105	cobalt turquoise	II	n/a	LF143	burnt ochre	I	PY42, PR101	LF150	gold metal	I	n/a
LF108	phthalo green	II	n/a	LF137	terra rose	II	PR101	LF149	silver metal	I	n/a
LF110	titanate green hue	II	PY3, PG7, PW6	LF141	brown ochre	I	n/a	LF138	white	I	PW6, PB29
LF289	grey green light	I	n/a	LF146	raw umber	I	PR48:2, PR101, PBK7, PW6	LF135	black	I	PBk7, PB27

Manufacturer: Prismacolor

Pencil Line: Premier

Base: Wax

Available Colors: 132

Notes: Lightfastness ratings are not available from manufacturer. Color Index (CI) information is not available from the manufacturer. Please check my Web site, www.brushandpencil.com, for future updates.

Manufacturer: Prismacolor

Pencil **Line:** Verithin

Base: Wax

Available Colors: 36

Notes: Lightfastness ratings are not available from manufacturer. Color Index (CI) information is not available from the manufacturer. Please check my Web site, www.brushandpencil.com, for future updates.

Manufacturer: Talents

Pencil Line: Van Gogh

Base: Wax

Available Colors: 60

Notes: Lightfastness ratings are indicated with plus signs, with three (+++) representing the highest degree of lightfastness (100+ years under museum lighting) and two (++) representing a good degree of lightfastness (25+ years under museum lighting).

Pencil Number	Pencil Name	Light-fast Rating	Color Index
105	titanium white	+++	PW6
222	Naples yellow light	+++	PY42, PW6 PR101
254	perm. lemon yellow	++	PY3, PW6
283	perm. yellow light	+++	PY154, PW6
284	perm. yellow medium	++	PY154, PO43
285	perm. yellow deep	++	PY154, PO43
374	flesh tint	+++	PR101, PY154, PW6
235	orange	+++	PO43, PY154
311	vermillion	++	PO43
370	perm. red light	++	PR254, PO43
377	perm. red medium	+++	PR254
334	scarlet	+++	PR254
348	perm. red purple	++	PR179
371	perm. red deep	++	PR254, PW6
331	madder lake deep	++	PR179, PW6
556	lilac	+++	PV15, PW6
567	perm. red violet	++	PR122
577	perm. red violet light	++	PR257, PW6
323	burnt carmine	+++	PR257
537	perm. violet medium	++	PV19

Pencil Number	Pencil Name	Light-fast Rating	Color Index
568	perm. blue violet	++	PV19, PB15
507	ultramarine violet	++	PV19, PB15
583	phthalo blue red	++	PB15, PV19, PW6
504	ultramarine	++	PB15, PW6
551	sky blue light	+++	PB29, PW6
527	sky blue	+++	PB29, PW6
517	king's blue	++	PB15, PW6
576	phthalo blue green	+++	PB15, PW6, PY154
640	blue green	++	PB15, PW6, PY154
526	azure blue	++	PB15, PW6, PY154
522	turquoise blue	++	PG7, PW6
658	Sèvres green light	+++	PG7, PW6
661	turquoise green	++	PG7, PW6
659	Sèvres green deep	+++	PG7
616	viridian	++	PG7
615	emerald green	++	PG36, PW6
673	phthalo green light	++	PG36
674	phthalo green deep	++	PG7, PY154
619	perm. green deep	++	PG7, PY154, PBk7
614	perm. green medium	++	PG7, PY154

Pencil Number	Pencil Name	Light-fast Rating	Color Index
618	perm. green light	+++	PG7, PY3
633	perm. yellowish green	+++	PG7, PY154
228	yellow ochre light	++	PY42, PW6, PY154
227	yellow ochre	+++	PY42
231	gold ochre	++	PY42, PY154, PR101
234	raw sienna	++	PY154, PBk7
411	burnt sienna	+++	PR101
339	light oxide red	+++	PR101
347	Indian red	+++	PR101
343	caput mortuum red	+++	PR101, PBk7
410	greenish umber	++	PR101, PY42, PBk7
620	olive green	++	PG7, PY154, PY42, PBk7
403	Vandyke brown	+++	PR101, PBk7
728	warm grey light	++	PBk7, PW6
729	warm grey deep	+++	PBk7, PW6
738	cold grey light	+++	PBk7, PW6
739	cold grey deep	+++	PBk7, PW6
727	bluish grey	++	PBk7, PR254, PW6
708	Payne's grey	+++	PBk7, PR254, PW6
701	ivory black	+++	PBk7

Index